George Reid
A Biography

George Reid
A Biography

by

Muriel Miller

Summerhill Press
Toronto

© 1987 The Estate of Muriel Miller
Published by Summerhill Press Ltd.
Toronto, Ontario

Canadian Cataloguing in Publication Data

Miller, Muriel 1908-1987
 George Reid, a biography

Rev. ed.
First ed. (1946) published under title: G. A. Reid, Canadian artist
Bibliography: p.
ISBN 0-920197-30-2

1. Reid, G. A. (George Andrew), 1860-1947.
2. Painters - Canada - Biography. I. Reid, G. A. (George Andrew).
1860-1947. II. Title. III. Title: G. A. Reid, Canadian artist.
ND249.R4M54 1987 759.11\ C86-094387-9

Edited by Ian R. Coutts

Distributed by: University of Toronto Press
 5201 Dufferin Street
 Downsview, Ontario M3H 5T8

Printed and bound in Canada

Contents

List of Illustrations

PART 1
FROM FARM TO EASEL

AVE! WYCHWOOD PARK

The street lights gave me little help that blustery mid-February afternoon in 1936, as I stood looking in from the road at a low-eaved, cottage-like house of many gables. Having lost myself in the windings and curvings of Wychwood Park, I was late; but, at last, I had found 81 Wychwood Park, or Upland Cottage, as it was called on the letter box beside the door, the home of Canada's premiere painter-teacher, George Agnew Reid.

I rang, the door opened promptly to my ring and I was shown into the dimly lit entrance hall of the studio-house by the artist himself, a white-haired man of middle stature with a dignified, detached manner. In his mid-seventies, his full moustache and pointed Van Dyck beard of earlier days made him look older than he was.

I had come to interview this ex-farm boy who, in 1912, had become the founding principal of the Ontario College of Art, on that other Ontario farm boy who had become a force in Canadian art as a landscapist and semi-mystic, Homer Watson. To my amazement, my host not only pinpointed the significance of Watson and his work in the development of Canadian art, but put the whole art history of fifty years into perspective for me. I was impressed — almost awed — by it all, since Mr. Reid hadn't even needed to refer to notes.

Yet, even so, none of this impressed me as did the big stone fireplace which dominated the far side of the room and radiated a friendly warmth on that cold winter afternoon. And, over the next hour or so as we sipped English tea from a blue-and-white set of Canton china, I was doubly impressed by his two-story studio with the gallery stretching across the breadth of it.

As I was gathering up my notes to leave, Mrs. Reid — an English woman of dignity and reserve — arrived home from shopping. An artist in her own right, I had known her only through her work as a miniaturist and landscapist. But, that afternoon, a sort of instantaneous rapport sprung up between us even though she was as sparing with words as her husband.

That first visit of mine to the Reid home in Wychwood Park had been the winter of 1936 to ask Mr. Reid about his colleague Homer Watson. It was not until two years after Watson's death in June, 1936, that the artist-commissioned official biography, *Homer Watson: The Man of Doon*, appeared. At that time, Mr. Reid had phoned

my publisher stating that he and his wife had decided they wanted Miss Miller to write his biography as she had Mr. Watson's. In passing on this offer to me, Dr. Lorne Pierce of the Ryerson Press, Toronto, asked me to go and interview the painter and his artist wife about this subject. My only instructions from Dr. Pierce were that I write a prologue for the book and put myself in it so that the reader would be drawn into the action.

After that first interview Mrs. Reid phoned to set the date for *dinner a trois* later that week. Once again, I simply stood there absorbing the half-rural, half-historical atmosphere of the place as Mrs. Reid graciously showed me into the living room where she left Mr. Reid and me to talk while she put the dinner on the table in the under-gallery dining room.

As I brought out my notebook, I remembered how impersonal and detached the artist had been when briefing me on Watson and art in general, and, if I had expected he would talk about himself and his own world now, I was sadly mistaken. In fact, it did not take me long to discover that one had virtually to use a crowbar to pry any personal information out of him at all. He was imbued with an intense interest in things and in what people were doing, but it was those things themselves (not who did them) which interested him. Since this impersonal detachment bewildered me, I fell back on my usual habit of asking questions and doing most of the talking while I looked at the pictures which hung everywhere. First, there was the row of portraits above the face of the fireplace inglenook which seemed to be done in a style reminiscent of the European schools of the middle-nineteenth century.

"Copies?" I asked, pointing across at the paintings.

"Velasquez," Mr. Reid nodded. "From the time I first saw reproductions of his work in Philadelphia, my ambition was to get to Madrid to study his work. He is one of the world's great portrait painters."

Built into the wall, directly across from where I sat in the fireplace-alcove was a large low-toned portrait of a woman. The woman, young and beautiful, stood out against an almost black background. She was holding something blue in one hand. Below this life-size study stood a large hand-carved walnut chest. It was highly ornate but not obtrusive. Mr. Reid explained that it was sixteenth-century Spanish.

Having crossed the studio to study "The Lady in the Wall", as I called her, I noticed a group of oil paintings — landscapes, a portrait or two, several genre and semi-historical scenes and, then, a landscape done in swirling brush strokes suspiciously like van Gogh's. It reminded me of nothing else of Reid's I'd ever seen. I bent closer to study it.

The artist, noticing that I paused in front of it, said, "We had a van Gogh exhibition in the club some years ago. That was my imitation."

Beyond "The Lady in the Wall", was a large lake scene in which a gnarled tree trunk caught my eye. Not only did this large painting show a marked difference in style from the other works in the room, but some below it were small pictures done in a different medium altogether. They reminded me of Japanese woodcuts. Perhaps, I ruminated, Mr. Reid had changed styles between his earlier and later periods. I was perplexed.

I stepped closer to read the signature. They were signed Mary E. Wrinch. I had always thought of her as miniaturist and landscapist, but these were prints, somehow reminiscent of the Japanese woodcut. I mentioned this to the artist.

He smiled — a slow, happy smile — and there was a note of pride in his voice as he said, "Yes. Those are Mrs. Reid's colour block prints. It is only in the last few years she has taken up the medium and devised her own method of painting in watercolour on linoleum and running them through a painting press. That large oil over there is hers, too, and these," he pointed to the wall at the left of the inglenook, "are her miniatures."

Crossing back to those delicately wrought portraits hanging by the fireplace, I saw they were done in watercolour too, but on ivory plaques. As I studied them, Mr. Reid continued with that quiet reserve of his, "The middle one is Mary's portrait of my first wife, Mary Hiester Reid, done back in the early 1900s."

The one thing I had learned so far that day was that my best hope of getting George Reid to reveal his inner self and his thinking was to get him talking about one or both of his two Marys and their work. By the time I left Upland Cottage that night, armed with this approach, I was committed to writing the Reid biography.

That had been in January 1940 and, after two years of concentrated research and writing, the Reid biography was completed in the spring of 1942. By that time, too, Upland Cottage had become a second home to me since, each summer, I had returned to beautiful Wychwood Park to live on the job so to speak. It was only in those months that I had discovered such surprising things about Mr. Reid as his whimsical sense of humour and the indomitable will hidden behind that quiet-voiced, unassuming manner. To my delight, too, I found he had the same self-absorption in — almost obsession for —
art which had characterized Homer Watson, that other Ontario farm boy who by sheer force of will made a famous artist out of himself.

The artist-commissioned George Reid official biography was completed, edited and approved for publication in the autumn of 1942, but wartime restriction on the publishing of *belles lettres* books to save newsprint forced the Ryerson Press to put it on hold. It was not until after the end of the war that its first edition appeared in July, 1946.

Chapter 1

EARLY DAYS

It was high summer, 1868, and the Reid family were on their way to visit with the Agnews, the parents of Mrs. Reid. As they drove along the road in their old ox wagon, the rolling countryside of Huron County, Ontario, stretched before them in its mid-summer lushness. On the crest of a steep hill, Adam Reid — a large-boned, powerfully built man whose reddish hair and beard were prematurely tinged with white — halted the oxen for a rest.

He gazed down into the valley and beyond to a rambling log house which nestled comfortably at the end of a long line of poplars. The Agnew farmhouse and its connected, surrounding outbuildings had been built like a miniature fort — or so it seemed to the children of Adam Reid. To them, the long woodsheds joining the different buildings on Thomas Agnew's farm were like passageways between ghostly dungeons, and the boys loved to imagine themselves brigands and pirates of the past.

As the youngest of these boys — George Agnew Reid — looked down into the valley, he was filled with excitement. A visit to Grandfather Agnew's farm was a very important event. Adam Reid drove down towards the Agnews, and as the wagon emerged from the poplar-lined lane into the spacious yard, one of his little sisters squealed with delight at the sight of a gaily plumed peacock strutting out as if to greet them. These birds were the special pride of Thomas Agnew, who had brought their ancestors from the farm in Kingston on which, almost thirty years before, he had been a gardener. A greenhouse was another of his farm's novelties and it was a ritual to explore the greenhouse's flower beds when one came to Grandfather Agnew's house. Flowers, like peacocks, were a hobby of the old country gardener.

By the time the wagon reached the barn, Thomas Agnew — a tall, grey-haired man with aquiline nose, high cheek bones, trimmed beard, and moustache — was coming out to greet them. The boys called "Good day, Grandpa" as they leaped from the wagon and were off to the stream which led to the pasture — their favourite playground at Grandfather's.

In the kitchen doorway stood Jane Agnew, a small woman with a round, wrinkled face and deep furrows in her brow. She smiled affectionately at her daughter and son-in-law, then bent to kiss the

little girls before they scampered off to the yard to play. The men set out to make an inspection of the farm and, left alone, mother and daughter sat down to spin and chat about household affairs.

Later that evening, when the supper was over and the chores done, the family gathered to talk in the parlour. The older boys — John, aged twelve, and Thomas, ten — were planning a fishing trip involving all three boys for the next morning. But, once the plans were made for it, George — a curly black-haired, sturdily built lad of eight — decided to get at something else. This was to become a lifelong trait of his — a passion for getting on with the next job once the former one was arranged.

Crossing quickly to the book shelves, he lifted down a large illustrated book. It was an English publication full of engravings of castles, bridges and cathedrals. For a time as he leafed through the pages, he said nothing, but then, looking across at his grandfather, he asked, "Were you ever in these places?" The two looked at the pictures, but they found only a building here and there which Thomas Agnew remembered.

At last he admitted, half-apologetically, "I didn't do much travelling in the old country."

"How many years ago did you leave Ireland?" asked George.

"Let's see... it's 1868 this year and I'm near seventy," he pondered. "I was about forty when I first came to this country, so seems it must have been about 1840 then. 'Twas before the railway was built from Stratford to Goderich, I recollect. It was a good bit different in these parts from what it is now to be sure," the old man continued. "Most of the country was wilderness then. Trees and rivers and wild animals and blazed trails."

"How was it you came here, Grandpa?" asked George.

"I'm sure I've told you all that before, lad. I came to this country to be a gardener for a gentleman in Kingston. After I'd been workin' there some time, I heard a railway was bein' put through from Goderich and that people could get land for homesteading. I had quite a bit saved up, so I started out with the other settlers who'd come from Stratford by way of the cutout made for the new railway. I got this land as a Crown grant. Concession nine it is. Being not more than twenty miles from Goderich, it wasn't too far from a town. So I set out to make ready for your grandmother to come and soon I got enough land cleared to grow food and build a place."

The old man went on to explain how that first log cabin had been enlarged with a room built on first here, then there for each new child. He told about the poplars he planted close together as a windbreak along that two-hundred-yard lane leading up to the house. He told about the roots and bulbs, seeds, and peacocks brought from the farm at Kingston, and how he had tended them with care. The grandson, however, was only mildly interested in these things; the illustrated books were more to his liking. He wanted to find out about life in Ireland, not how fields were tilled.

That night, when his mother went to the big attic to say good

night to her sons, George asked "Where did Grandpa come from, Ma?"

"Old records," replied his mother, "say that the Agnews were the hereditary Sheriffs of Galloway in Scotland, but later they were persecuted for their religion and left the country. It would be the early 1600s when the Covenanters escaped to Ireland. The Agnew family settled in County Sligo, Ireland after that. That was where your grandfather was born." She smiled understandingly as she said, "I don't think your grandfather puts much stock in remembering such things. They don't matter much when you're busy clearing land and building homesteads. Far away times and places don't stick in your mind like the everyday things that happen."

The boy sighed. It was those faraway things which interested him, and he could not see why neither his grandparents nor his parents could tell him about them. They seemed to have forgotten about their lives in England, Ireland and Scotland and now thought only of things in the new land he already knew about.

Fortunately for George, when he had started school three years before, he had found one unfailing source of information on the old world — his first teacher Elon Snell. Snell used to tell him about English life and history. Apart from that, he encouraged George's flair for drawing. In fact, in that old log schoolhouse at East Wawanosh which had been built in 1862, Reid did a great deal of drawing on the blackboards over the next few years with successive teachers giving him as much assistance as they could. Once or twice, alas, he got into trouble because of his caricatures.

For all that, no one took his flair for art seriously, least of all his father who had jokingly nicknamed him "Kithog" — Irish for left-handed. Yet although Adam Reid paid little attention to his son's drawing, he did encourage him to read. In fact, sometime just before this, Mr. Reid had been instrumental in getting a travelling library to tour their part of Ontario, where it was kept in different farmhouses and schools for months at a time. It included copies of *Venice, The City of the Sea, Arabian Nights, History of the Girondists; Eddystone Lighthouse* by its builder Smeaton, and the travels of the naturalist Audubon. These books made a deep impression on the boy — especially *Arabian Nights*, which he was forbidden to read but which he contrived to sneak off to the hayloft. This experience formed the basis of his later autobiographical genre picture *Forbidden Fruit*.

During these years, George also continued to study the engravings in the English books and magazines he found at home and at his grandfather's place. He copied them meticulously, reproducing even the minutest lines and slightest bits of shading. But it was scenes from the life around him and barnyard animals such as turkeys, horses and cattle which were his favourite subjects.

It was at this time, too, that the annual visits of Jamie Young — an itinerant bookseller — to his parents' home, The Homestead, became a big event in George Reid's life. Young — a man in his

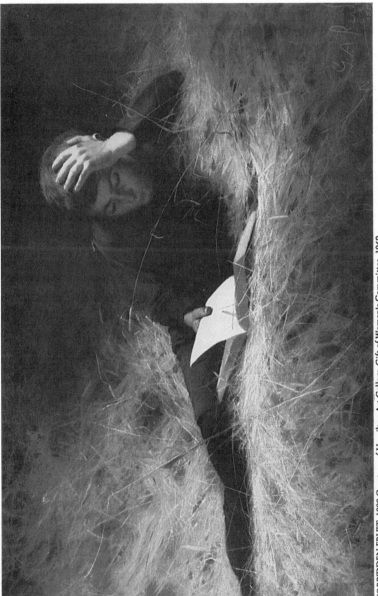

FORBIDDEN FRUIT, 1899 Courtesy of Hamilton Art Gallery, Gift of Women's Committee, 1960

middle years, spare and of medium height — had many stories of his own travels and adventures to relate and these stimulated young Reid's desire for similar experiences. Young always stayed at The Homestead for a day or two on his spring trips through rural Ontario, and during these visits, George would spend hours on end rummaging through the piles of books and illustrated magazines from England in Young's box-wagon.

When the bookseller realized George's passion for art and pictures was so deep-seated, Young fell into the habit of bringing special books on art with him each trip. It was in this way that George became acquainted with the then-current reproductions of Landseer and other contemporary English painters of the 1860s during the first ten years of his life from 1860 to 1870.

Even at this time, four characteristics which were to mark the artist throughout his life had become apparent. First, there was his passion for drawing and for the study of art. Secondly, there was the great curiosity about distant places which later took him to Europe six different times. Thirdly, there was the thrall of the past which led him to delve into the history of Canada and reproduce it on canvas. Lastly, there was his propensity for painstaking, patient labour.

By the age of ten, George had made the most momentous decision of his life. For months he kept this decision to himself but, one night in the winter of 1871, when his parents and older brothers were seated about the kitchen table at family prayer, he burst out earnestly, "I'm going to be a painter of pictures."

His father looked at him sharply. His mother seemed surprised, but her dark eyes were sympathetic when she noted her husband's stern disapproval.

"Making pictures", Adam Reid announced, "is a girl's work. Not any kind of occupation for a robust man. The men who came to Canada, men like your grandfather Agnew, were pioneers. They worked hard to make farms; and it is up to the boys of this generation who don't have such hardships to bear to cultivate that land, not just sit at home doing drawing and colouring."

This announcement did not move George to give up his ambition, however, even when Adam Reid (in seeking to convince his son that he had a pioneering tradition to live up to) told them of his own early days in this new land. He explained how he had come from the old land at the age of twenty-four and, after working for a time on a farm near Weston, had joined a party of settlers going on the railway to Stratford to stake land for himself. He told how he had trekked along the unfinished railway to Goderich and continued by ox team to the township of East Wawanosh, settling eventually on this upland tract of land near Wingham and Marnoch.

His first summer there, he had built a roughly hewn shanty facing the highway and, to this, he had brought his bride a year later. Then, in 1863, he had built a new log house on a bend of the Maitland not far from the shanty. This new house he and Eliza Agnew Reid had called The Homestead. And he made it clear to George again that his

sons were expected to build homesteads of their own and make names for themselves in the new land as nation-builders.

When his father insisted that George give up his dream of painting, however, George gave no promise. He decided, instead, that he must never again speak of his ambition to his father until he was ready to leave home. He became quiet and secretive and developed the trait of silence which was to mark him throughout life. From there on, in fact, he became a doer not a sayer, a dreamer and a worker not a talker.

Over the next few years, George went on assiduously copying illustrations from papers and books. Usually he drew secretly but sometimes he would sketch his brothers, who were amused at his ambition, or his three young sisters, who sat for him delightedly. His mother was quietly interested in all this work, but no mention of his future was ever made to her either.

Although Adam Reid, like Thomas Agnew, was much too preoccupied with the job of clearing land and building a homestead to be interested in the romantic ruins of great castles and historic forts, George found an ally in his paternal grandfather. John Reid was a dour Scotsman with bright blue eyes, a clear complexion and high cheekbones. His hair was white, and he wore a beard around his throat although his face was closely shaven. He was dignified, severely correct in his old country dress and much more interested in history and the arts than he was in the soil.

John Reid and his wife had immigrated a few years after their sons Adam and William had come to Canada to farm. Some time after his wife's death in 1870, John Reid had come to live in Wingham with his son Adam's family. In George he found a kindred spirit and many were the stories he told his fascinated grandson of the old country and of their Reid family past. George found out, for instance, that the Reids belonged to the Clan Robertson of Strathlock — the cadet family of the Robertsons of Struan which is supposed to be the oldest family in Scotland and the sole remaining branch of the reigning Scottish house of the eleventh and twelfth centuries.

John Reid's influence on the boy was significant although their association was brief: John Reid died in 1872 and, before that, in the autumn of 1871, at the age of eleven, George left home to live with his maternal grandfather Thomas Agnew. Agnew upon turning over the management of his farm to his son James, had arranged that George come to live at the Agnew farm to help with the chores and get in an extra year of education at the log school nearby.

Here an important event occurred for George. An Englishman named John Orr had started a juvenile singing class at Wawanosh in which the children were taught the rudiments of music. George, who had shown a great love for music from childhood, was trained in part singing and taught how to transpose music from one key to another. He also developed a habit of singing little snatches of songs as he worked. With his instinctive love of music and this initial training, he learned to play various musical instruments, including

the flute, the concertina, the guitar, the organ and the piano.

In that year at the Agnew farm, George also made progress in his drawing, and, back at The Homestead in the autumn of 1872, he fixed up his attic bedroom as an artist's studio. Here he worked early and late copying pictures and doing original drawings and sketches.

Chapter 2

THE SISTER ARTS

One of the most romantic incidents in the boyhood of George Reid was the winter spent by Joseph Shuter at the Reid farm. Shuter had been a trusted employee of the distiller Gooderham and Worts in Toronto before his love of liquor had got the upper hand. He decided, thereupon, to take a walking tour through rural Ontario to cure "the thirst." Collecting clocks had long been a hobby of his and, now, he turned his hobby into a vocation as — carrying a bottle of buttermilk to quench his thirst — he tramped from village to village cleaning clocks.

It was approaching autumn when he arrived in Wingham and called at the Reid home. Adam Reid soon discovered that the old clock cleaner was a distant cousin of his by marriage, and he sympathetically invited him to spend the winter at The Homestead, a place where buttermilk was more common than spirits, in order to cure "the thirst." Shuter did odd jobs about the place and took a great interest in the boys — particularly in George. To the boy, the old clock cleaner and flute player was a romantic figure like a character from Dickens and he later became the subject of two genre paintings by the artist.

During adolescence, when George was going to school and doing chores on the farm, he learned to know animals and how to draw them authentically. Not only was his draftsmanship accurate, but he gained such an intimate knowledge of the morphology and habits of both wild and domestic animals that sixty years later, Curtis Williamson, the Canadian portrait painter, said: "No Canadian artist, with the exception of Horatio Walker, can draw a horse or a cow as can George Reid."

Adam Reid was a jack-of-all-trades. As well as making ox-bows, harnesses, and horse-collars, he made shoes for his family and was an efficient builder, stone mason, and carpenter. In these years, George used to assist his father at building. Barns, in the 1870s, were built with stone foundations and George would mix mortar, carry hod and help in the building of the superstructure. While doing such mundane jobs, he was obtaining material for his real life's work, and as he did the glazing and house painting, he was thinking of that other kind of painting he would do one day.

In the early seventies, Adam Reid had been forced to put a mortgage on his property and, now, there was danger that the

mortgage might be foreclosed. With this hanging over the family, the father announced that he was going to set out to find land farther north where they could settle. Hearing this, George put in some restless days. The prospect of going farther away from civilization was appalling to him, but he hid his fears and waited.

Adam Reid went north by boat from Goderich to Bruce Mines to find a place suitable for homesteading. At the end of Lake Huron, near its junction with Lake Superior, he found what he considered to be the ideal place. He returned home to tell his family about the discovery, and showed them samples of copper he had found. His plan was that all three boys go there and work with him.

But George protested.

"We are already far enough away from Toronto," he said. "When I finish school I'm going there to study painting. If you go north, I'll stay here and work for Uncle James or someone else."

"I thought you'd given up that idea, son," his father replied, surprise and chagrin in his voice.

"I'm not going to be a farmer or a settler or a prospector," his son answered in a calm but determined voice.

As Adam Reid hesitated, his oldest son John, offered to take over the running of the farm next to theirs to raise the money due on the mortgage. The father agreed to this plan and all thought of further pioneering was given up. Adam Reid was, however, still determined to make his youngest son a pioneer, and he stated again dogmatically that he would never allow George to become an artist. With the immediate battle over, however, a truce was called between son and father and, over the next two years, neither mentioned the ambition which drove the youth although neither forgot the other's stand. Whenever one of George's drawings brought him special attention, his father would look upon him with bewilderment. George decided that if he could not get his father's consent, he would run away to study art.

One can see from George Reid's early sketches that he had profited from copying the pictures in the English periodicals and from studying the books which Jamie Young had got for him. He had also done original and realistic studies of the life about him and idealized pictures from his own imagination. In these works are seen the forerunners of two types of his later work — the pioneering and genre scenes of life in rural Ontario (done in the eighties and nineties) and the idealized figures symbolizing the arts themselves.

When Reid was fifteen, Jamie Young brought him his first set of watercolours. At first, George looked despairingly at the hard cakes of colour and the soft brushes and wondered how he would ever get the colour applied to paper where and how he wanted it. Used to the hard point of a lead pencil or the harder point of a slate pencil, it took him some time to work out a way to keep the colours from running into one another and from going outside the pencilled lines of his drawings. Gradually, he learned to use the new medium adroitly and to apply washes. In those days, he still drew scenes in black and white and then laid the colour afterwards.

Having stopped school the spring of 1875, he decided that the time had arrived for him to go away to study art. But that July an accident occurred which thwarted his plans. His older brother Tom crushed his hand in a straw cutter. Although Tom's hand healed, his ability to do farm work was impaired and he returned to school to prepare for the entrance exams for normal school. As George's father was suffering from a wrenched back and John was still running the adjoining farm, Tom's departure meant that George had to stay at home to take over the heavy work on the farm.

The following summer, in 1876, George read that an art school was being opened in Toronto by the Ontario Society of Artists. Overnight, his plans became clearer. Now, he was going to Toronto to study at that school. He decided he must first go to see William Cresswell, a landscape painter from England who had settled on a farm in Seaforth, a village about twenty miles from Wingham. Accordingly, George and Jim Kerr, a chum of his who had artistic ambitions too, set out one morning to walk to Seaforth.

At the artist's home, the boys were shown into a spacious hall and great, high-ceilinged studio with a huge fireplace. The painter — a stout, burly figure — wore a full beard which made him look much older than his fifty years. He was dressed in the old country manner of the time and, in appearance and profession, presented a contrast to the local folk the boys knew.

George stated his case briefly. "I'm going to be a painter," he said. "I want to talk to you about what an art student has to learn. I'd like to look at your paintings."

Cresswell answered in a kind, but gruff, tone. "Art's a damn bad trade. It's hard work, and it takes years of study to get anywhere in painting."

George, however, was not at all moved by this warning. He knew that art meant hard work but he liked hard work — he was used to it. Cresswell then talked about art and showed the boys around the studio. This was the first time George had ever seen original oil paintings and the experience made a deep and lasting impression on him. He decided that he would learn to work in oil himself and, far from being dissuaded by Cresswell, that trip simply spurred him to get to Toronto at once and get started on his real life's work.

That autumn, George made arrangements to leave home. It would have to be a runaway escape, since his father was still determined not to allow his son to become an artist. He laid his plans stealthily and was almost ready to go when his mother suddenly fell ill. To run away to study art when his mother was not well seemed cruel, so he decided that he must wait until she recovered. However, he made up his mind that this second delay must be the last and he went to his father and told him flatly that he was going to Toronto to study art as soon as his mother was better. Adam Reid did not exactly agree to his plan, but he grudgingly conceded that they would talk about it as soon as his wife was well. With that George had to be content.

At this time, Adam Reid decided to build a new frame house for his wife and he set George to drafting plans, seemingly with the idea of stimulating an ambition in George to become an architect. Making pictures for no purpose was something Adam Reid could not understand and would not tolerate in one of his sons, but he was enough of a builder himself to appreciate drawing when used to make up plans.

George completed the plans by spring, and he and his father worked over them carefully. The youth loved gables, so the house was built with three of them — two at the ends of the house and one in front. By midsummer, the superstructure was completed.

That spring and summer, Eliza Agnew Reid's health grew worse, and the family gradually realized that she would never be well again. In the autumn her condition worsened further, and, in October 1877, just about the time the house was completed, she died.

Adam Reid sent for his youngest sister, Maggie. She came from Toronto, and settled with them, becoming an immediate ally for George. Having lived in the city for several years and knowing something about art, she was convinced that her nephew must go to Toronto to study at once. She encouraged and abetted him in his efforts to get away, and made plans for him to live in Toronto with her niece, Mrs. Laughlin Stewart.

By this time George was winning prizes at the local fairs in the Wingham vicinity for his drawings — especially for his studies of horses — and he had had some small commissions from his uncle, James Agnew. As soon as the family was settled in the frame house, he told his father that he was leaving for Toronto at once. But Adam Reid had other plans: he had already apprenticed George to J.B. Proctor, a local architect.

Astounded by this high-handed disposition of himself, the fif-teen-year-old George stated flatly that he would not go into the architect's office. Adam Reid told him that he was under age and that he, his father, had the legal right to apprentice him. He passed George a copy of the written agreement.

With his natural flare for building, it was true that he could learn something of value from the study of architecture, but the idea of being trapped for three whole years in an architect's office was almost more than the youth could bear. He had, however, to accept this compromise between farming and painting or make a complete break with his father. He accepted the compromise. Adam Reid softened, saying, "It'll be as good as painting, son. You can be a draftsman. Your drawings for the house showed you know how to shape things and you build well."

Although not at all happy, George went at this enforced work with the same determination he did everything. His job was to keep the architect's office open and do routine tasks while Proctor was away at the planing mill he owned. This left him with a great deal of time on his hands to study, and he buried himself in architecture books of all kinds. Apart from drafting, he began working on perspective as well.

All that winter he kept at his architectural studies by day and, by night, tried to apply this knowledge to his painting. As a result, his pictures began to show directness of design and symmetry in composition.

Three years trapped in a job you don't want would seem an eternity at the age of seventeen, but luckily for George Reid — although unluckily for his employer — Proctor's planing mill failed in the spring of 1878. This forced the closure of the architecture office and Proctor himself moved to the United States to get work. George — automatically released from the agreement which his father had made — packed up his belongings and returned home to tell his father that he was now going to Toronto to study painting.

Back at the farm, Adam Reid made one last attempt to turn his son from painting. He suggested that he go back to school for the spring term to brush up on his education before doing anything about his chosen life's work. George considered this proposition. He had been away from school for about two years. He decided it would be wise to review past studies, and John Anderson, the teacher, agreed to give him advanced senior work. Realizing also that he would have to earn his own living while putting himself through art school, George decided that in addition to taking the fifth book, the top grade then, he would also have Anderson teach him bookkeeping.

That summer, while he was still at school, the people of Wingham decided to build a large exhibition building for the annual agricultural fair. George's uncle, Thomas Agnew — who was on the board of the agricultural association — hired him to draft the plans for the large circular building.

Adam Reid, having failed in his last attempt to turn his son away from painting, offered him the proceeds from a load of wheat, some twenty-six dollars, to pay for his trip to Toronto and to keep him until he could get a job. In the autumn of 1878 — after a lot of self-training and much self-discipline — George Reid arrived in Toronto to attend art school.

Chapter 3

STUDENT DAYS IN TORONTO

In Toronto, George went directly to the Portland Street house of his cousin Mary Jane Reid, or, to use her married name, Mrs. Laughlin Stewart. From there he set out for the Ontario School of Art, run at this time by the Ontario Society of Artists at 14 King Street West. Since he had to earn his living while he studied, George knew that he could only take night classes and he enrolled in these for the rest of the autumn term.

That done, he searched for a job in an art establishment which would give him an opportunity to learn something practical about painting while he worked. First, he applied at the Notman-Fraser photographic studio. He explained that he wanted a job in a field akin to that of his chosen field. Unfortunately, any vacancies there had all been filled by that time by assistants from the art school.

Next, he went to see Bridgman and Forster, portrait painters who had several students working in their joint studio. But the answer was the same. He hadn't any training and there were a numbers of youths in the city with previous experience in professional studios.

The lithographing houses refused him, too. The printing offices were also filled up with helpers and any experience he had had in building was not considered sufficient to get him into an architect's office. After a month of job hunting he had exhausted the possibilities in the art-related fields and he realized that he must now take work of any kind in order to stay in Toronto at all.

That winter of 1878-1879, many people with formal training and experience in different fields of work were idle in the city and, although he tramped the city streets for another month hunting for any kind of office job, he was unable to find one. By this time he had run into debt at his cousin's, where his board was three dollars a week. Finally, in January, Mary Jane Reid's husband, Laughlin Stewart, managed to get George a job in the machine shop at Toronto Foundry, where he was a foreman. There, George ran a machine which tapped nuts and put threads in them and helped in the tempering room where they cut the lengths into strips of iron for bolts. This simple mechanical work was not much akin to art, but he earned a dollar a day or six dollars a week for a ten-hour day (from seven in the morning to six at night). This enabled him not only to begin paying off his accumulated board bill but to pay the three-dollar fee for his second term at the night school and buy materials for painting and drawing at the cost of almost ten dollars.

At the night classes in the art school, his subjects of study were rudimentary drawing and outline, drawing from objects, design, and copying the heads, hands and feet from antique casts. There were no examinations at the night school and there was no formal teaching, but the instructors criticized the work of the students as they drew.

More inspiring to Reid, than the art-classes, however, were the pictures in the galleries of the Ontario Society of Artists (O.S.A.). He had seen no paintings before except those in Cresswell's studio in the summer of 1876 but, during that winter, he familiarized himself with the work of the early Canadian painters and that of contemporary artists. The spring exhibition at the O.S.A. rooms was a great inspiration to him, and he learned much from close study of the paintings. He studied the work of each artist and poured assiduously over the sketches in the portfolios of the Art Union. He determined that he, too, would some day have paintings and sketches to enter in these competitions. (This early dream reached its full flowering when his *Call to Dinner* was sold in 1888 for one hundred dollars to J.W. Ross, D.D.S.)

From January to the end of April, when the art school session ended, he carried on with the evening classes after the ten-hour day at the foundry. Rain or blizzard, he never missed a class. On his free evenings he studied and worked at home. Despite what one might think, Reid did not consider his life dull. For seven years he had dreamed of this, and he was happy that he was making progress in his chosen field at last.

Early in May he returned home for the summer. George was determined to earn enough money to enable him to study full-time at art school the following winter, and so he agreed to work for his father. Adam Reid had remarried that winter and, leaving The Homestead to be run by John, rented a small farm near Bluevale.

Arriving back in Toronto the autumn of 1889, Reid found great excitement there. Robert Harris, who had been studying in Paris, had just returned to Canada and taken over the antique class at the art school. Almost at once, he introduced French ways of working, considerably changing the teaching methods in the school.

Robert Harris was a romantic figure in Toronto in those days. Apart from the fact that he was an able artist who had achieved recognition abroad, he had a gift for imparting both his knowledge and his enthusiasm to his students. He soon became an ideal to the aspiring artists under his eye. In fact, it was Harris' influence which, almost from the outset of Reid's career, made him a follower of the French Impressionist School of painting. Reid had, by this time, advanced sufficiently in technique to be ready to start painting oils. Now, he was fired by the originality of Harris' method and knew that in it, after eight years, he had found exactly what he wanted.

In fact, the Toronto Art School (later the Ontario School of Art) made more progress during this session than it had since its inception. But disaster loomed. In the winter, it became known that the school was in danger of losing its annual provincial grant of four

hundred dollars. The school might, as a result, have to be closed, since the only revenue left would be the annual six-hundred-dollar grant from the city and the tuition fees from the students which were almost nominal.

To George Reid, who had worked so long to get to Toronto, it was unthinkable that the art school should close. He brought up the problem with his fellow students and they decided that the only thing which could save the provincial grant would be to get the voters so stirred up that the government would not be able to veto the grant.

Accordingly, they drew up a petition and, so armed, set out. Walking the streets, they stopped everybody who came along as they canvassed shop after shop in the business section. They asked barbers, labourers, shoppers, storekeepers and anyone else they could find for their signature, and within a few days, they had such an imposing list of names that, when the petition was sent to the government, the officials recanted and the Ontario School of Art's annual grant was continued.

Two events stand out in Reid's work at the art school that year. First, he had done his first charcoal quick or time sketching. Since he had a flair for chalk drawing and liked the soft rather than the hard paint, he found this medium congenial. Secondly, he had joined the painting class, and progressed so rapidly that he was now working in oil.

To paint in oil, Reid had to have a palette and oil paint. Finding that he couldn't buy a left-handed palette, he went to a wood yard, picked out a piece of walnut about ten by fourteen inches and carved a left-handed palette with his jack knife. Then, he went to the E. Harris Company, which is believed to have been the first artist supply shop in Toronto. It was run by "Father" Burden, a genial and helpful friend to the young art students who frequented his shop. Here Reid picked out his first set of oil paints and brushes.

At the end of the school year, he did a copy in oil of Harris' own *Newsboy* which had caused such a sensation in the Canadian art world. This half-length figure with its low-toned background and realistic treatment represented the last word in art. In copying it, Reid made a sketch in pencil on the canvas and then painted the outline in boldly with a broad brush stroke similar to that of Harris himself.

When Charlotte Schreiber, the teacher of painting, saw it, she announced that he would get a full year's certificate for oil painting even though he had only a few month's tuition. Then, she took the copy to Harris who, after looking at it, asked for the student to be sent to him. The artist remarked on Reid's broad brush work and the assurance with which the student had copied both subject and style. (This copy, after having hung in The Homestead, the old Reid farmhouse, for over fifty years, was brought to the artist's Wychwood studio in 1935 and later sent to Charlottetown to become part of the permanent Harris Memorial Collection there.)

Other artistic endeavours occupied Reid's time, too. Not far from the Stewart home, where Reid still lived, was a Methodist church which he began to attend that winter. It was his natural love of music which took him to church rather than any religious inclination, for even in these days, he was more a worshipper of goodness through beauty and art than through orthodox religion. He used to linger and listen to the organist and choir leader, J.B. Baxter, playing voluntaries. Several times Baxter came down to talk with him and finally invited him to join the choir. Later, he asked him to do part singing at the Baxter home, and Reid was thus able to sing and talk about music to his heart's content.

In the art school, he and fellow student W.A. Langton became staunch friends during the winter of 1879. Through Langton, Reid began to do pen-and-ink drawings and by applying himself seriously, learned the technique of pen-drawing also.

A portrait sketch of Reid done by Langton that winter shows him bent over his task; and, although at this time Reid was nearly twenty, he looks much younger in the picture. Langton playfully ascribed to it the title: "A chiel amang us takin' notes." (This study was reproduced with an article on art schools in a Montreal magazine. Langton kept it until, forty years later, he presented it to Reid, with mock ceremony, upon the latter's retirement from the Ontario College of Art in 1929.)

On the 24th of April, 1880, Reid returned to Wingham, having won second place in the school for time sketching and the school's silver medal for drawing from the antique. The subject of his drawing was the mythical figure of *Jason and the Golden Fleece* done strictly in the method taught by Harris.

During that summer he again worked on the farm with his father, but that autumn he found that he could not finance a second year at the school since painting in oil cost so much more than drawing. He cast about for a solution to his financial dilemma.

In Toronto that spring, he had done a study in oil of Lena Stewart — one of his young cousins — and, back home during the summer, he did a conte crayon sketch of his youngest sister, Harriet Ann. He also made companion studies in oil of his father from life and of his mother from a photograph. Now, with these four portraits and his copy of the Harris *Newsboy* for display, he daringly opened a studio in Wingham to take orders for crayon and oil portraits.

His cousin, Frank Buchanan, a successful harness maker in Wingham, offered him board in exchange for doing oil portraits of himself and his wife. This gave Reid his first commission. Then the people in the village, who had been impressed by his success at the art school in Toronto, flocked to his studio, and when they saw the samples of his work, particularly the two Buchanan portraits, commissions began to pour in. As well, several students started coming for lessons.

Reid made his list of prices for portraits dependent on the size of the picture and the medium in which the picture was to be done. For

example, crayon portraits were set at ten dollars; head and shoulders painted in oil twenty-five dollars; three-quarter length portraits came at forty dollars each, with a reduction when both husband and wife were being painted. Reid gave his subjects a choice of position (whether full-face or profile) but he suggested the poses he preferred and the sitters usually accepted his recommendations. This way he avoided doing profiles of Roman noses and receding chins, and on the whole, the portraits were highly successful.

After that winter's work, Reid had made a local reputation for himself and had done at least fifty commissioned portraits. The most outstanding of these was of C.T. Scott, a banker, who had been so pleased with it that he had told his friends in Kincardine about the new young artist. Having received this publicity, Reid decided, with the clientele of Wingham having been exhausted by this time, to pack up and move on to Kincardine. There he did the Presbyterian clergyman and his wife, the mayor and his wife, and many of the leading citizens of the town.

All Reid's Kincardine portraits were done in oil and, from each, he received at least twenty-five dollars. Since living expenses were low in rural Ontario, he had accumulated a sizeable bank account by the end of 1881. Then, that spring, he received what was to be his most important commission. A wealthy lumberman, Carpenter by name, approached him to do portraits of himself, his wife and three children and offered Reid two hundred dollars for the commission. Reid set to work blithely, putting much time and thought into these portraits.

Reid had not, during this period, concentrated only on portraits. While in Wingham, he had struck out and done some figure pieces and still lifes as well. He had sent one of these, *Fruit*, to the 1881 O.S.A. exhibition, where it had been hung. In the spring of 1882, he entered two small autobiographical pictures — *The Last Load* and *The Chorister* — in that year's O.S.A. show. *The Last Load* is a study of rural life and might even have been a transcript of the twenty-six dollar load which had paid his way to Toronto in 1878. *The Chorister* — a figure study for which his cousin Lena Stewart had posed — is a half-figure showing the girl's long fair hair hanging down her back. These pictures were realistically painted and brought him into notice at the annual exhibition.

In March 1882, with a bank account of four hundred dollars, Reid set out for Toronto again and was able to get in two months at the art school before it closed for the summer. He had progressed noticeably in his art during the twenty-two months of independent work, and now he decided that he must have tuition in life painting. That subject, however, was not given at the Ontario School of Art. One day that spring, he came across an article in an art magazine about the Pennsylvania Academy of Fine Arts in Philadelphia. What caught Reid's attention was that Thomas Eakins, the head of the academy, had just returned from France and was said to be causing much commotion in the school because of his new, radical, French method of teaching.

The word radical sounded promising to Reid. Harris had been considered radical when he returned from France — too radical for the other artists in Toronto — and he had become the inspiration of the school. So, at the end of the school term — with only four months in which to earn his fare to Philadelphia and save enough money to put him through a year at the academy — Reid set to work painting. By this time, he was being accepted as a coming student artist, so he found it easy to get commissions for portraits back home and in Toronto as well.

Chapter 4

STUDENT DAYS IN PHILADELPHIA

Arriving in Philadelphia about seven o'clock on an early October morning in 1882, George Reid — with five hundred dollars in his pocket — walked to the Pennsylvania Academy of Fine Arts, where he registered as soon as the office opened.

Then, after taking a hurried look over the academy building and the gallery on the second floor, he went out in search of living quarters. He decided on a boarding house on Arch Street, within walking distance of the academy.

Next morning, Reid saw Eakins for the first time and was immediately struck by his bearing. Middle-aged, the art teacher was a man of stout build and average height, with greying brown hair and moustache and a medium complexion. Rugged in appearance and rather abrupt in manner, he had a forceful personality. Having been a pupil of the great Gérome in Paris, he had set out, upon returning to America, to develop a thorough knowledge of anatomy and feeling for form in his students. His radical teaching method was to start all his students at modelling for painting as well as sculpture. Such an unorthodox departure from conventional teaching methods had brought Eakins into disfavour with the academic American painters of the day, but it found immediate favour with the students at the school. Reid himself would be greatly impressed by it.

The subjects Reid was to take at the academy were perspective, painting from life, modelling from life and — most revolutionary of all — anatomy. There was very little painting from the antique under Eakins' teaching, but new students were routinely sent to the antique room the first day to test their ability and training. Hence, on his first morning at the school, the young Canadian was sent to the antique room. Each candidate was allowed to choose his own subject and so Reid selected a figure and set to work. In mid-afternoon, as Eakins was strolling through the antique room, he noticed the new student still hard at work and stopped to look over his shoulder at the drawing. Immediately, he said, "You've had experience. Where did you study?"

"Toronto, Canada," replied Reid.

"Very good. You needn't bother completing that study. You may go on to the life class at once."

Thus it was that George Agnew Reid jumped the first stile in his

career at the academy, and, the following day, he began the regular school routine.

His first morning in the modelling class, from nine to twelve, turned out to be a real experience. Eakins' method was practical and direct. He gave assignments and made the students teach themselves, although, during the period, he would walk around the studio, correcting and criticizing their work. Reid had never thought of sculpture as being essential for painting, but he soon realized (as Eakins put it) that modelling did give the picture a real feeling of depth. Also, in shaping the subjects in class, he found that he did get a sense of their rounded contours which helped to make the figures stand out realistically on the canvas.

That day, after the morning session, Reid attended his first life class. His fellow students were all mostly advanced workers used to painting from models. In Toronto, he had had a thorough training in technique and in painting from the antique, but it was his own experience as a professional portrait painter which now made it possible for him to compete with these other, more advanced, students.

He met Eakins' innovations here as well. Eakins' students were not allowed to sketch in a guiding outline. The student must not only paint direct from the model without using pencil or crayon but keep the composition in a state of balance until completed. That meant brushing in the outlines and carrying the picture along as a whole, by a complete laying-in of form, colour and tone simultaneously. This departure was bewildering to Reid at first, but it immediately caught his interest.

It was the evening anatomy lectures, however, which made a deeper impression on him than either modelling in clay or direct life painting. In fact, his first class was a breathtaking experience for him.

First, some animals were brought up to the schoolroom by elevator and these were used for demonstration as Eakins gave a discourse on mammalogy. Then, after the lecture was concluded, and while Reid sat watching and wondering what would happen next, he heard singing. He looked towards the door in surprise. There, coming through the entrance in procession were eight or nine student demonstrators.

(The system of using demonstrators from the student body figured prominently in the work of the academy. In addition to gathering for lectures and observation classes in the clinics, these demonstrators prepared the subjects in the dissecting rooms, brought them to the lecture room, and assisted in the lectures as well, although probably the ceremonial aspect of the processions was an innovation on the part of the students themselves.)

The demonstrators were singing lustily as they carried a dissected subject into the lecture room. They were marching to the tune "John Brown's Body" and then as they set the subject on the lecture stand with much ceremony, they broke into "The Death March in Saul."

At this point, Eakins introduced a medical doctor from the University of Pennsylvania as the speaker of the evening. These dissecting classes were usually conducted by a visiting professional from the University of Pennsylvania or in general practice. Eakins also had an arrangement with medical clinics in the city by which his art students joined the medical students at demonstrations — especially those in the clinics of Doctors Agnew and Gross — to observe the surgeons at work.

Eakins himself would sit on medical conferences and watch important operations by surgeons and then instruct his students on what he had seen. In fact, during one of these demonstrations, he painted a scene showing the medical students ranged in front of the subject with him sitting beside the doctor-lecturer. Eakins' art students got the same teaching on the formation of muscle and bone and nerve in the human body as did the medical students — the same method by which the great Leonardo da Vinci had learned anatomy.

By the end of Reid's second day at the Pennsylvania Academy of Fine Arts, he knew that he had made no mistake in coming to Philadelphia. He had expected to find Eakins a radical and had not been disappointed. Life at the academy was an adventure for him and each day's work a new source of inspiration.

Another interesting feature of work at the academy were the outdoor sketching tours. On these jaunts to parks and into the country, Reid became accustomed to painting figures against landscape backgrounds. Formerly, his portraits had all been indoor studies and his animal studies had been done almost irrespective of background.

The students, while on field classes, often carried out experiments in perspective, too. For example, one day a student took a photograph of Reid in a field with another student standing on a hill at a calculated distance from him. This picture, when developed, showed Reid in the open field holding his fellow student balanced in the palm of his hand. Scarcely a day passed without some spontaneous experimenting on the part of the students, and this original method for teaching perspective made such a lasting impression on Reid that he was to follow it through his own forty years of teaching.

The academy programme was radical in still another aspect. It was co-educational. The men and women had separate classes in the mornings and usually painted independently in classrooms, but the costume class was mixed and the women students joined the men on field tours and at the anatomy lectures.

The co-educational approach carried over to an important part of out-of-school student life. The students were in the habit of listening, in mixed groups, to the rehearsals of the Philadelphia Orchestra held once a week at the academy.

Reid, who loved music second only to painting, would sit on the

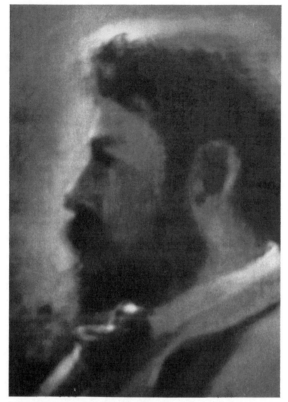

REID: SELF PORTRAIT, 1884 Courtesy of Art Gallery of Ontario

stairs and listen to the symphonies being played or rehearsed in the concert hall. He thus became familiar with much of the great music of the world. Also, there were occasional concerts and plays to which the student body would go en masse. Being reticent, however, he did not, during his first winter in the academy, strike up an acquaintanceship with any of the girl students. But in his second year at the school, after he was made a demonstrator, he would find himself quite often choosing a sketching ground beside the brilliant young Mary Hiester — a young painter who was taking part-time work at the academy while teaching in a girls' school.

Upon her arrival at the academy, Mary had quickly become the darling of the campus. She had sparkling brown eyes, arched black eyebrows, a dusky complexion with high colouring and black curly hair. Even so, it was her vivaciousness more than her beauty which made her so popular with her fellow students. Born in Reading, Pennsylvania, in 1854, she was the second daughter of John P. Hiester, M.D. — a member of an old Silesian family which had emigrated to America in 1832. Her mother, also of German extraction, was related to the Muhlenbergs, who had come to Pennsylvania very early in the history of the American colonies. One of her

kinsmen, William Muhlenberg, had been the founder of St. Luke's Hospital in New York and a descendant of George Clymer — one of the signers of the Declaration of Independence.

When Mary had been eight, and her sister Carolyn, twelve, their father had died. At this time, their mother, who had been suffering from congestion of the lungs, took the two young girls to Beloit, Wisconsin. There, they lived at the home of their cousin Harry McLenagan for the next ten years while Mary continued school in Beloit. But, just as she was finishing, her mother died, so she returned east to live with the family of another cousin, John McLenagan, in Reading and to attend the School of Design in Philadelphia, fifteen or twenty miles from Reading. In the winter of 1883-84, she was completing what had been several years of study under Eakins.

That same year, Reid returned to Philadelphia from Toronto and Wingham where he had again done portraits to earn enough money to take him back to the academy. This time he was accompanied by two of his former fellow students from the Ontario School of Art — W.E. Atkinson and Donald McNab. The three of them moved into a rooming hotel on Market Street, where their apartment consisted of two small rooms as living quarters and a large joint studio. There, the three "bached" it in rough and ready style.

McNab, Atkinson and Reid made a strange threesome — and they were nearly always seen together in the halls of the academy. McNab was of a tall, powerful build and could be recognized anywhere because of the Scottish cap he invariably wore perched on the top of his head. He was a general favourite because of his jaunty air and hail-fellow, well-met manner and, even in the halls of the academy, he walked with long swinging strides as if more used to striding along country roads than being cooped up in a city. Atkinson, on the other hand, was a serious, thoughtful type like Reid, but even more retiring and silent by nature.

During the 1883-84 academic year, Reid worked on several canvases, and he completed three of them in time to send back to Toronto for the O.S.A. exhibition that spring. The three were *In the Gloaming, Meditation,* and the *Head of an Old Man.*

In the Gloaming is a memory transcript of the Maitland River and was Reid's first landscape in oil. In describing this twenty-four-by-thirty-inch canvas, a Toronto critic at the time wrote that it was: A study of somber greens showing in a pool and the low falling branches of a forest...relieved by a bit of faint rose-colour from the western horizon. The colouring is very peculiar.

Another reviewer said:

> *In the Gloaming* is a good painting of a well-chosen subject, but is badly marred by a frame that is positively unsightly.

Of *Meditation* a figure-study done against an outdoor landscape setting — another reviewer said:

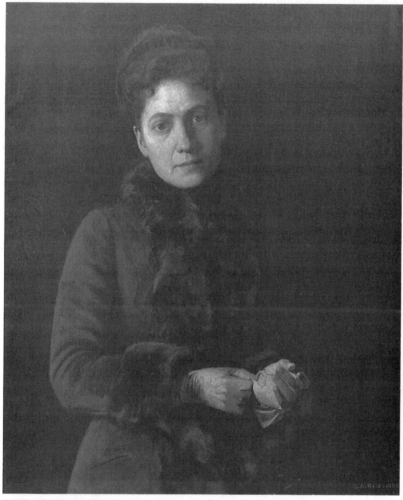

PORTRAIT OF MARY HEISTER REID, 1885 Courtesy of National Gallery of Canada

> *Meditation* by G. Reid will be found a venturesome effort to put a great deal in very little space. The figure of a girl is represented, but the picture is too small for anything but a watercolour sketch.

After these two indifferent critiques in the Toronto press, the *Head of an Old Man* was to bring Reid welcome acclaim. A character study that later became part of the Ontario Government's collection, it was the product of a careful study of anatomy, and the effect of modelling in it was commented upon both in Philadelphia and in Toronto. With the success of *Head* and the favourable press comment on it, the Toronto papers showed more warmth towards Reid's work than they had earlier. Now, in a review of *Head* one critic referred back positively to his *In the Gloaming:*

The admirably drawn head by Mr. Reid (a young pupil from Philadelphia) is painted in natural flesh tints. While referring to Mr. Reid, whose production we have not before noticed, attention is directed towards a small landscape with two goats in the foreground. One of the best bits of animal painting in the exhibition.

In adopting the Eakins method of painting direct from nature without a sketch, a study or even a drawing of the subject in pencil, Reid found that his work had a new sense of depth. He still used oil or pen-and-ink sketches for reference as a check to memory although much of the old detail was lost now since he was using a broader, more authoritative brush stroke in giving a more general treatment to his subjects. Eakins' emphasis on the study of form and dissection also had their effect: his animal studies and figure work as well as the nude studies painted in Philadelphia show an intimate knowledge of the anatomy of the human body.

During the days of his self-teaching, his years at the Toronto art school and his time portrait painting, indeed from the start, Reid had shown a particular flair for design and composition. Now, during his second year in Philadelphia, all the modelling done to aid his painting triggered an interest in sculpture proper, and he completed several bronze casts for exhibition, among them *Study of a Figure* and *The Zither Player* shown there in 1884. For a time, indeed, it seemed that he had become as interested in sculpture as in painting. Charles Grafly, who later became one of America's eminent sculptors, was a friend of his and the two often worked together over their clay models. Although painting remained his first love, Reid would continue to dally with sculpture. In fact, as late as 1903, he entered a bas-relief of a mural panel in an exhibition, and he continued to model figures for painting all his life in order to get the chiselled or sculpted effect one finds in his pictures.

From the very start, the school sketching trips had been a source of inspiration to Reid. Now, quite apart from their artistic value, they gave him the opportunity to single out the beautiful Mary Hiester on their expeditions. Eventually, he worked up the courage to ask the popular Miss Mary Hiester to go sketching with him alone. After that, it had become a habit for them to work together and, that winter, Mary invited Reid to go home with her to Reading for a weekend of sketching on the beautiful Schuykill River. That visit, by the artist's own estimation marked a definite point of departure in his life as well as in the course of his career.

Simply put, Reid had to ask himself what to do next. By the end of the 1883-84 academic year, Reid had been accepted by Thomas Eakins as a talented, completely trained young artist. Reid decided that his next step must be Paris to enroll at the Academie Julian to continue his studies. Some years before, Robert Harris had gone to Paris, as had the Canadian Paul Peel, whose work was to cause sensation internationally. Both had developed individual styles and

vigorous techniques there. But the thought of leaving Mary Hiester was unthinkable. Yet if he married, he would not possibly be able to go to Paris to study; and yet to go alone was too dismal a prospect to consider. Finally, he asked Mary Hiester to marry him — or, rather, offered her a life-itinerary all worked out and taken for granted.

Although Mary had shown a marked partiality for the quiet young Canadian from the first and had become deeply attached to him by this time, she was not easily won. His proposal was a matter-of-fact proposition, the urgency of which had to do with overseas bookings, not emotions. She temporized.

Reid looked at her in puzzled wonder.

"You know I have sought you out in classes and sketching trips on every possible occasion since I first saw you," he said, "and you must be aware of my feelings towards you."

"But," she argued, less convincingly this time, "you have been planning all this time to go abroad to study and marriage would mean giving that up."

"We can go over for a few months on the honeymoon and see the London and Paris galleries," he replied in the same matter-of-fact manner. The urgent thing as he saw it was giving a two-week notice to the steamship company to assure their bookings for Liverpool in late April at the end of the college year. That, he explained, would give them four months abroad before returning to Toronto to set up a joint teaching studio and begin their life's work. Also, in being married in a fortnight, they might have time to go to Spain to see the portraits done by the great Velasquez, whom they both admired, and to visit Mary's sister Carolyn who, at nineteen, had joined a party of travellers to Paris and Spain where she later entered a Roman Catholic convent.

Getting married, he admitted, would mean that he would have to postpone plans for studying abroad, but a characteristic of Reid's nature was that it was needless to waste time discussing matters which he saw as self-evident. He knew which was more important to him — studying abroad or marriage.

Chapter 5

ON TOUR

In early May, 1885, George Agnew Reid and Mary Hiester were married in St. Luke's Church, Reading, Pennsylvania. Immediately after an impromptu reception, the bride and groom left for New York and embarked for Liverpool on the S.S. *City of Chicago.*

The weather was good, and the artists sketched daily on deck. This being Reid's first exposure to the wide expanses of ocean, he attempted some marine subjects for the first time. The greater proportion of his work, however, was studies of fellow passengers. From childhood, he had always taken graphic notes of the different places and the different types of people he saw. His sense of humour also showed up in caricature and, now, these fun pictures provided a source of constant amusement for the bride who was herself apt with her pencil in such work.

Many of the studies done by Reid at this time were later worked up in oil, watercolour or pastel, but the principal value of this quick sketching was that it heightened his already keen powers of observation and gave him excellent practice in applying the lessons on perspective he had learned so well under Eakins.

Docking in Liverpool one morning late in May, the two artists took a room in the station hotel and set out for the Walker Art Gallery. As they wandered through the gallery — which was a moderately new structure of Classic design — the *Annunciation* of Dante Gabriel Rossetti and the exceptionally fine collection of Pre-Raphaelite pictures caught and held their attention. After a day in Liverpool, they set out for London, intent upon seeing the Royal Academy exhibition, the National Gallery and the British Museum.

In London, they took a room on Craven Street just off the Strand, within easy walking distance of those points of interest. Besides seeing London sights — read and dreamed of from childhood — they spent hours each day in the British Museum and various galleries, feasting on famous paintings known till then only through reproductions. Busy and happy here, the couple was loathe to leave London but the Salon and the galleries of Paris beckoned. They entrained for Brighton and crossed the English Channel to Dieppe. On their way to Paris, they stopped off at Rouen to see the famous Gothic cathedral since Reid was still almost as interested in architecture as he was in painting. Then Paris and the Paris galleries.

They put up at a small hotel close to the station and set out for

the Salon where the 1885 exhibition was still on. The Salon itself — famous the world over since its inception in 1740 — was the realization of their dreams. And the work of the great French contemporaries, Jean-Léon Gérome, Cabanel, Bastien-Lepage, Tony Robert-Fleury, Lefebvre, Courbet, Renoir and Merson, reassured both of them that it was the French type of painting which gave the modern artist the greatest possibilities.

From observing the most current work at the Salon, they went on to the Luxembourg galleries to view the work of other contemporary painters and then to the Louvre itself to view the Old Masters. Paris — long-dreamed of and now stretching out before their eyes — had an instant and electrifying effect on both Reid and his wife.

Yet, even as a convinced devotee of the French School, Reid remained true to the great Spaniard, Velasquez; and both George and Mary knew that without seeing the Velasquez originals, no trip to Europe could be quite complete. So, after ten days in Paris, they counted their money to find out whether they could afford to go to Madrid. They could, but only if they travelled third class, not first or second as travellers to Spain at that time were advised to do.

Arriving in Irun on the frontier, they encountered some difficulty because they could not speak Spanish. They could not understand why the Spanish officials kept shaking their heads when asked about Madrid. Finally, finding that no train went from Irun that night, they took a room at a near by hotel.

On the train the next morning, a Spaniard who spoke English explained that there were rumours of a cholera epidemic spreading through the country, and he told them that it would be inadvisable for them to stop in the north of Spain. He explained that he was arranging to go through to Cadiz without making any stop other than to change trains and advised them to do the same.

This was a blow to the artists, but they decided to go to Malaga on the south coast to visit Carolyn Hiester, the mother superior of the convent there, whom Mrs. Reid had not seen for fifteen years.

Arriving on the coast, the painters took a room in a hotel near the harbour of Malaga and strolled up to the convent to see the stately mother superior. Because of their swarthy complexions, dark eyes and dark hair, both of them were taken for Spaniards, but they found it very difficult to get along in the village, or in the hotel for that matter, without knowledge of Spanish. Mrs. Reid decided to study the language, and picked up enough to help them get by.

The real job and pleasure of this sojourn, of course, was the sketching. Day after day the painters walked about the picturesque old city with its fine Moorish castles and bastioned walls. Their hotel faced the Mediterranean, and the sea, dotted with fishing vessels, gave them studies for many of their pictures. They strolled on the beach, too, and painted the fishermen who brought in the catches, dressed in such strikingly bright clothes that they might have been on their way to a costume ball. It was the colour, life and spirit of Spanish life which impressed them most, and they sought

to capture both the mood of the people and the beauty of Spain's storied architectural ruins in, at least, pencil sketches.

During their stay in Malaga, Reid did a portrait of Mother Carolyn in her severe purple and white habit. She made a striking subject with her dark eyes, swarthy complexion and stately bearing.

One day, after the couple had been in Malaga for some time, the streets suddenly became plastered with signs bearing huge pictures of bulls in fighting regalia. Everyone in town seemed to be getting ready for the great bull fight. When even the sisters in the convent advised them not to miss it, they went.

It was a bright summer afternoon and, with the Spanish sun as hot as molten metal in the open arena, they took seats in the shade and waited. With some trepidation, they watched as a procession entered the arena. First, the scarlet-cloaked picadors came into the ring on horseback followed by the common fighters. Then the toreadors, in their gorgeous apparel, brought up the rear of the procession and when the toreadors saluted the royal box, both Mr. and Mrs. Reid were captivated by the beauty and pageantry of the spectacle.

The spell, however, was broken sharply when the first bull entered the ring, his shoulders bearing the gaily decorated darts which had been thrust into him as he rushed through the entrance gate. The picadors now surged forward and teased the great bull to fury with lance thrusts, while the toreadors attracted it with their scarlet cloaks.

Before long the bull had unhorsed several picadors and gored one or two of their horses. The picadors themselves were hastily rescued when the toreadors diverted the bull's attention from the victims by flaunting their red cloaks in its face. After several such encounters, Mrs. Reid said, "I don't think I want to see any more, George."

"The colour effects are superb, Mary," Reid said, "and, if this is a national Spanish sport, I suppose while in Rome we should do as the Romans do." They stayed.

After the first killing, however, the disgusted artists escaped as unobtrusively as possible through the uproarious shouting, jostling and applauding audience of frenzied onlookers in the crowded arena.

The two of them still hoped to get to Madrid to see the works of the great Velasquez before leaving Spain, but again they were advised not to — the cholera danger had not passed. Instead, they decided to go to Italy. Before leaving Spain, they stayed in Barcelona for two days to see the Fortunys in the City Hall and the ornate Gothic cathedral, then they returned to Marseilles and went on to Italy by train. At Pisa, they stopped off to see the Leaning Tower and, at Florence, they spent three or four days viewing the pitti and Uffizi galleries, the beautiful cathedral and the bell-tower of Giotti. In Rome, they visited the great landmarks of the Vatican, studying particularly the decorations by Michelangelo in the Sistine Chapel and the frescoes of Raphael.

When they arrived in Naples, Vesuvius was giving an unusual

display of action and, from their hotel window, they saw streams of lava pouring down the sides of the mountain which the dull red glow from the top of the crater was reflected in the smoke screen above. Going on to Pompeii, they studied the remains of the Classical architecture there, and the human drama revealed by the excavation of this city fired their imaginations.

After leaving Naples, they crossed Italy to Foggia on the Adriatic side of the peninsula, they went north to Ancona and continued to Venice where they stayed for the next five weeks — the five weeks they had planned to spend in Madrid.

Venice proved so entrancing to them that they sketched continuously even though it was uncomfortably hot in August. They spent much time sketching the water, the palaces and the gondoliers in their boats, and Reid himself did a large marine work, *The Breaking Wave at the Lido, Venice*, which still stands as one of his best early pictures.

Painting so much, the two had not seen many of the sights of the city. But, in the last three days before they were driven north by the great heat, they visited St. Mark's, The Doge's Palace and the Accademia itself.

Going north to Milan, they viewed the great cathedral and Leonardo da Vinci's *Last Supper* before continuing on to Paris where they stopped off only briefly before leaving for London. Then, from London, they hurried on to Liverpool to sail immediately for America, their money almost gone. Arriving in Reading in mid-September, they stopped off to visit Mrs. Reid's cousins for a fortnight before going on to Toronto to start their joint professional careers.

PART II

OUT OF THE SOIL

Chapter 6

FOLKLORE IN PAINT

Arriving in Toronto, Reid and his wife found an apartment in a building next to the old Post Office on Adelaide and Toronto streets. It included two large rooms, one of which would provide living quarters and the other, a studio. They bought furniture, set up their easels and began to paint.

Shortly after this, Reid discovered that various professional artists in Toronto — members of the Royal Canadian Academy life class — met two or three evenings a week, to paint from life and discuss one another's work. In this group were Cruikshank, Gagen, Redford, Jones and others who had been friends of Reid's while he had been at the Ontario School of Art, and he was invited to join.

Reid offered his new studio as a regular place to meet and, over the next year, the senior artists met there two evenings a week. The artists in this group were all O.S.A. members as well, and they put Reid up for membership in the provincial society. He had exhibited in the society for three years previous to this, and the following spring was elected to membership.

It was during that winter of 1886 that Frederick Challener, a young English lad then about sixteen, came to Reid's studio for special help. He had shown great artistic talent and, prior to this time, "Gus" Fraser had paid his tuition fees for night classes at the art school. As a result of this training, he had won first prize for drawings at the Industrial Exhibition (later the Canadian National Exhibition) in the summer of 1883.

When the wiry, bright-eyed lad appeared at the Adelaide Street studio-apartment and introduced himself, Reid remembered the trip he had made to William Cresswell's studio nine years before and greeted young Challener enthusiastically. Challener's remarks on Reid's pictures showed real discernment, and he asked animatedly, "You have artists who come here to paint. Could I come, too, to watch you teaching?"

Reid smiled, "I should think you come to watch, but there is no teaching. We just paint and criticize each other's work. I'm afraid it would be too advanced to help you much."

The youth's face fell and his eyes lost their animation. "I thought maybe I could learn something," he said slowly. At this, Reid — seeing that he had a serious purpose — suggested he come in the daytime to study with him.

"Oh, could I?" asked Freddie, brightening again, but then he went on regretfully, "I have to work in the daytime to help my mother keep the family. I have a job at the Lithographing Company."

Reid remembered the unsuccessful jaunts he himself made to lithographing firms seven years before when he had come to Toronto. He said now "Then you may come evenings when the artists aren't here."

Challener hesitated, and finally answered with reluctance, "I can't pay for it, and I guess it'd put you out too much."

"Not at all," replied Reid. "I'd enjoy it. Have you any drawings with you?"

The youth brought out his studies and sketches, and Reid was impressed. "You have talent and you draw very well," Reid said, and then he agreed to teach Challener free of charge.

From this arrangement with Challener, Reid evolved the idea of opening regular classes and carrying on a private art school. As the teaching method for these classes, he introduced the Eakins way of working and so great was the interest roused by his unconventional methods that he decided to open an outdoor life class for students as well.

There were about fourteen pupils in Reid's class. He gave regular and supervised study both in perspective and life work and some antique drawing. In his studio, the students found a combination of freedom and discipline without the rigidity of art-school classes. The informal hospitality of the studio also made it a popular gathering place for the students. These classes had benefits for Reid, too. Since painting itself was not bringing in enough money to keep Reid and his wife, the new private classes made it possible for them to make ends meet.

Concerning his own art, Reid himself showed no tendency to specialize in any field, although Mary had developed such a marked preference for flower painting by this time that she was concentrating on still lifes. Reid did portraits and worked on easel compositions of many types — landscape, marine, figure studies of unusual characters and re-creations of life on the farm. And, as in the early days of his freelancing, he continued doing portrait commissions.

The class — which had started with one student the autumn before — had, by the summer of 1886, grown so much that the artists found it necessary to give up their Adelaide Street studio and move to 31 King Street, East — later the site of the King Edward Hotel. Here, in their larger quarters, they carried on private classes, both day and evening, and their studio became the gathering place not only for Toronto's professional artists but also for art students and art lovers in general.

After that change of quarters, the artists went to Wingham to visit Adam Reid and get in some sketching. Here, in fact, Reid painted his first large farm scene, *Call to Dinner*.

The first few days at Wingham, Reid had strolled about in search of the ideal subject. Then, suddenly, it gripped him. His sister Susan

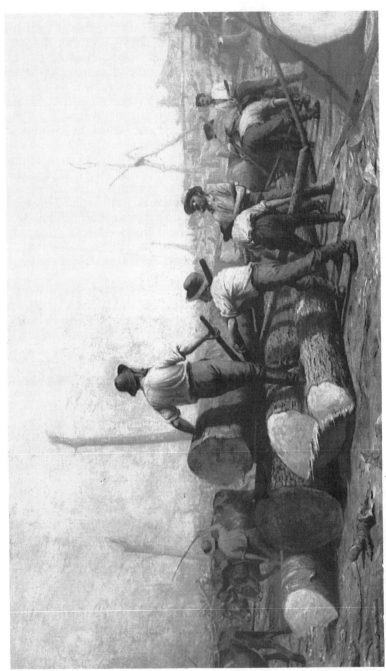

LOGGING, 1889 Courtesy of Canada House, London

was standing in a field, hands cupped at her lips, calling the workmen in to dinner while cattle, lying in the shade of distant elms beyond the narrow stream which divided the field, were placidly grazing.

This was of the soil! This expressed the drama of farm life! After dinner that day, he stretched the canvas and set up his easel directly in front of the house overlooking that field. The day was hot and sultry and, while the artist worked at his picture, the atmosphere of misty heat crept into the painting.

Before the summer of 1886, Reid had several times portrayed moods of nature, as seen in *The Last Load, In the Gloaming* and *On the Grand Canal, Venice* and he had always shown great interest in figure work. By the time he had completed this scene, however, a definite change, whether conscious or unconscious, had occurred in his choice of subject. *Call to Dinner* carried him into the field of genre work and, after completing it, he settled down to depicting Canadian contemporary and pioneer life in his native county of Huron, Ontario, beginning what we may call his folklore in paint period.

From here on, the artist's memory transcripts of life on the farm began to assume a more and more important role in his painting. For example, returning to Toronto after the completion of *Call to Dinner*, Reid brought with him his mother's spinning wheel and reel. His two sisters, Susan and Leticia, who had come back to the city with him, and Mary posed at the spinning wheel for *Gossip* — the studio having been converted into a typical farmhouse room of the era. His other sketches and studies reconstructed various scenes from the past and took practically all phases of rural life in mid-century Ontario. These subjects included: *The Apple-Paring Bee, Maple Sugar Making, Threshing with a Flail, Mowing, Carrying Hod, Sowing, Milking, Logging, Making Straw Hats, Going to Church, Spinning, Shingle-Making* and *Sugar-Making*. Reid had an intimate knowledge of all these occupations, ensuring his works' authenticity, and it was from this reservoir of knowledge, that he was to draw inspiration for his painting over the next twenty years or more.

In the autumn of 1887, also, he had realized an old ambition. For years, he had been promising himself he would one day paint Joseph Shuter — the old clock cleaner. Shuter was delighted to see Reid again and agreed to pose for a picture by him. The living room of the Shuter cottage held a weird collection of old clocks, indeed, it was virtually a museum, and it was there that the old man posed with his beloved flute at his lips. The first sketch showed the potential of the subject and in the finished version of *The Flute Player*, Reid realized that potential — the old man's figure stands out in bold relief as if sculpted.

By 1888, the critics had come to realize that, in Reid, Canada had at last produced a genre painter of its own who could do vital and dramatic work. Said one critic of him in a Toronto paper at this time:

The main characteristics of Mr. Reid's work are boldness and truth and a thorough acquaintance with anatomy, the laws of perspective, and rules of composition, a great facility of execution and breadth of treatment. His best known work, apart from those on exhibition, are *The Call to Dinner* exhibited last fall and the portrait of his wife first seen at the O.S.A. rooms two years ago.

As well as showing locally, Reid sent paintings to the Colonial and Indian Exhibition in London in 1886 and, after excellent notices there, he was represented at the Walker Art Gallery in Liverpool. He also exhibited for the first time at the Royal Canadian Academy of Art in 1885 and, in the spring of 1888, was made an associate of the academy itself.

By June, 1887, Reid's private art class included such students as Will Alexander, William Bland, F.S. Challener, George Coleman, Alfred Francis, C.W. Jefferys, James Laughlin and Owen Staples. Besides painting, during the spring of 1888, a new venture was occupying the attention of these students. An art fair was to be held in Toronto under the auspices of the R.C.A. for which a catalogue was needed. In May, Reid had been given the task of making up the catalogue along with A.H. Howard, its designer, and Professor Keys of the University of Toronto, its literary editor.

Reflecting on this project, Reid, returning to the studio one day, said to his wife, "I've talked over the situation with Howard and he and I have sketched a rough draft for the catalogue. He's to do the important lettering and decoration, I, the drawings and reproductions. It seems to me it would be a good idea to get the boys at work on it. It would be their first professional work and should be good experience."

"That would be excellent," his wife agreed. "Let's go through the dummy now and mark out what each one would do. The front cover — that beefeater — you will have to do yourself and the old English scene on the back cover. The rest they could do."

So it happened that the first group effort ever by art students in Toronto was undertaken.

The fair itself was a great success, and, from the proceeds, a fund was established for the construction of an art gallery in Toronto. Over the next few years, the committee in charge of building the art gallery purchased a lot on the corner of Victoria and Shuter Streets for that purpose.

In the spring of 1888, Reid and his wife decided that it would be good to have an auction-sale of their own paintings, since several large canvases and scores of small pictures had accumulated in their studio in the two-and-a-half years since they had started their school. They had another object in view, too. They wanted to go abroad again to continue their studies. So, in May of 1888, they held a joint exhibition at the dealer Oliver, Coate and Company, at 57

King Street East. The sale brought them nineteen hundred dollars, a great deal of solid gold-backed money in those days, and secured their European trip.

Mary Hiester and George Reid arranged for the transfer of their students to the O.S.A., and started out on their new European study trip.

Chapter 7

STUDENT DAYS IN PARIS

Reid and his wife sailed for Liverpool from New York in June, 1888, reaching London before the Royal Academy annual exhibition closed. There, they saw the current pictures by Sir Frederick Leighton, George Frederick Watts, Holman Hunt, Sir John Everett Millais and James Abbott McNeill Whistler. They also visited the National Gallery again before going to Paris in order to see the works at the Salon before it closed for the summer. Settling at a hotel in the Latin Quarter on the Rue Lambe, they toured the Paris galleries.

In one of these, Reid met the Canadian Paul Peel. Peel had preceded him to Philadelphia from Ontario and then, after several years under Eakins, had gone to Paris in 1881. In the collection of paintings which Peel had sent to Toronto in 1884, Reid had been especially struck by a vivid self portrait of the painter. On meeting now in Paris, the two men quickly struck up a friendship, and Peel introduced Reid and Mary into the artists' colony at 65 Boulevard Arago in the Latin Quarter.

The studio-house captivated Mary. A picturesque structure, it was built around a spacious centre court containing a fountain and masses of flowers. Although the building had only one main floor, the bedrooms were built over the kitchens and dining rooms of the apartments. The studio which they took overlooked the court. At the first glance, they felt at home.

George and Mary purchased a coke stove from their neighbour Eugene Grasset, of poster fame, and then toured the small shops of the district to find furniture. Within a few days, sufficient furniture had been gathered to equip their new quarters and they themselves had made two "finds": an ornamented chest of Venetian design and a mirror with a wide, carved Florentine frame. So beautiful were these that they brought them back to Canada after their year and a half in Paris. Mary Hiester Reid had a great fondness for old brass and copper too, and she collected jars, vases, and platters which gave the rooms a much-lived-in appearance.

The studio was such an ideal setting for a picture that, almost before it was settled, Reid decided to do an interior of it. At the back of the dining room was a fireplace, and in front of that big open fire he began his famous *Dreaming*. It is a study of his wife seated pensively before the fire, the dim firelight accentuating the mood of the sitter and giving the picture an atmosphere of mystery.

When Reid told Peel he was planning to enroll at the Julian, Peel shook his head. "Not the Julian. Constant. He's the man." For some time after his own arrival in Paris, Paul Peel had studied with the great Gerome at the Julian, but he had been attracted by the work of Benjamin Constant. Constant — a portrait painter of great power — had worked out practically the same kind of technique as Eakins, another pupil of Gerome's. Reid went to Constant's studio the next morning where Peel was painting his celebrated *Tired Model*. There, as he worked, Peel described Constant's method.

Constant himself was in New York at the time doing portraits, but was expected back later that autumn. Fortunately for Reid, he would not be forced to choose between the Julian and Constant. Some time before this, Boulanger — one of the instructors at the Academie Julian — had died, and, now, Constant was appointed as his successor. As a result, his class was being moved en masse to the Julian.

Reid was impressed by the academy as he wandered through it, gazing at the studies on the walls by former and contemporary students. In the institution were ten large studios, each accommo-dating between one hundred and one hundred and fifty students. In each studio there were two instructors and included among them were the famous Jean Paul Laurens and William-Adolphe Bouguereau. Reid found a most cosmopolitan group of students at the central academy. From Europe, Great Britain and Canada, from the United States, Mexico and South America, from New Zealand, South Africa and Asia, from China and Japan they had come to work side by side under the great French masters.

Most of the instructors were traditionalists and not at all in favour of new methods. So there was some surprise among the students when, while they were working painstakingly in charcoal and still outlining their subjects meticulously and shading of the subject for the first few days, Reid and Peel were painting direct from life in oil.

Seeing the Canadians sit down before the subject, take up their brushes and set to work, laying in both figure and background the first day, the other students were bewildered and grouped around them to talk about this startling new method. Said one of the students "That is not our French way of painting. It must certainly be the Dutch method, for they do not paint the way we are taught."

Peel and Reid were more or less objects of curiosity and several of the teachers turned their attention to the work of the two. Reid's first composition at the Julian was *Hannibal Crossing the Alps*, but it was one of his female nudes which attracted the most attention. This was a half-profile of a woman with black hair streaming over her bare shoulders, in which the model is seen bending forward leaning over a chair, and the rhythm of line, the subtlety of tone and the chiselled effect of the figure drew special attention to it.

Constant, having completed his New York portrait commis-sions, arrived back in Paris about Christmas. His first remark about

Reid's work (specifically his female nude) was "La jolie tone! La jolie tone!" He went on to say "It is like a Rubens in the Louvre. Go see it."

With Constant at the Julian, the direct method became almost instantly popular among students and they progressed rapidly. Reid did a study of *Job and His Three Friends* for the composition class. It was given first place in its group and, when hung, brought much comment. Constant, on noticing it, asked: "Who is this by?" When he was told it was by the new Canadian student, he went to Reid and said, "Je vous donne tous mes compliments. You might do that for the Salon."

Reid, however, did not do *Job* for the Salon since he was hard at work on *Dreaming* at this time.

Reid spent only his mornings at the Julian. For three afternoons and several evenings a week, he attended l'Academie Colarossi for costume and life classes. The Colarossi was also in the Latin Quarter near the Boulevard Montparnasse and, since it was co-educational, Mary Hiester Reid joined the costume and life classes there.

Before Reid had been long in Paris, he had made interesting contacts among his fellow students at the Julian, some of whom were Canadians. Four of these — William Brymner, Cullen, the French-Canadian Franchere St. Charles and Curtis Williamson — were later to become contemporaries of his back home in Canada. Apart from the Canadians, he met Charles Grafly, Louis-Paul Dessar, Robert Reid, Charles-Courtenay Curran, Robert Henri, F.E. Duvond, H.O. Tanner, William Thorne and Augustus Koopman — all Americans, most of whom were from Philadelphia. Two Englishmen with whom he became friends were Reginald Frampton, the sculptor, and Richard Jack, the portrait painter. It was at this time that Jack — the winner of many prizes at the Julian — was coming into the limelight as one of the outstanding younger British artists.

During this winter of 1888-89, Reid — when not attending the Julian or the Colarossi, spent much time scouting about the city in search of subjects. While browsing one day on the wharves, he came upon an extraordinary log yard piled high with birches, beeches and maples. It looked like a Canadian logging scene of pioneer days and he went at once to the proprietor of the yard to ask if he might pose models among the logs to paint a picture of it. It was arranged quickly, and Reid set to work making studies in full colour of the scene. One early study shows the foreground filled with logs and the ground roughly strewn with branches and twigs. Bright-shirted workmen stand with picks raised, injecting a feeling of action and reality into the picture.

Although these logs in the Paris log yard were not destined to be burned as in pioneer land-clearing in Canada, Reid gave them a smoky background and stumps of trees as a setting, such as were seen when the great virgin forest had been cut unmercifully in pioneer logging-bees.

Once the studies were completed, Reid began to paint. By spring

the picture was completed and, since he was showing *Dreaming* in the Salon, he sent this six-foot canvas directly from Paris to the R.C.A. exhibition in Toronto. There it was purchased by Colonel Sweny and was later to hang in Canada House, London, having been presented in 1938 to the government by Brigadier-General Sweny, C.M.G., D.S.O., as a memorial to his father.

While attending the Colarossi, Reid did several costume studies which were also well received. But it was a male nude, done at the Julian, which brought him his greatest recognition in Paris.

Each spring the students at the Julian entered the annual competition for the Concours — a prize awarded for figure work. That spring of 1889, in sitting in on the scene, Reid said "It was a strange world as we worked shoulder to shoulder, looking at the model over the heads of those seated in front and those looking over the heads of others on lower seats, some even sitting on the floor."

As it happened, he did not have too good a position behind the model and was quite a distance away, but the posture of the figure from that angle caught his imagination and he set to work.

When the judging was finished, Reid tied for first place with Paul Dessar of New York. Both were declared winners of the first prize of the combined academies and their studies were hung on the walls of the Julian where they still remained in 1924 on Reid's last trip to Europe.

His twilight fantasy, *Dreaming*, which he had begun almost immediately upon his arrival in Paris had been submitted to the Salon in 1889, and hung under the title of *Revant*. It had been illustrated in the Salon catalogue — a real achievement for a student of the academy — and later, when sent to Canada, had been purchased by the Royal Canadian Academy for the National Gallery of Canada.

In early summer 1889, when the academies closed, the Canadian artists stayed on in Paris for an exposition which was to open in June. The building of the Eiffel Tower was going on at this time and, as it grew, they sketched it in different stages of construction. They visited the Cluny Museum frequently also and occasionally went out to the country to sketch in the suburbs of Paris. They spent most of the time, however, in Poissy and the Latin Quarter where they lived.

After a thoroughly delightful summer, they returned to England in October 1889 to have another look round the London galleries and then set sail for America.

Chapter 8

STUDIOS AND SETTINGS

It was November 1889 when Reid and his wife arrived back in Toronto. They needed a place to live and work, and, after much scouting around, they found two large rooms at the end of the staircase on the top story of the Arcade Building on Yonge Street. As a combined studio and housekeeping rooms, this apartment was ideal and they settled here with the furniture, copper and brass pots, vases and trays brought with them from Paris.

The Arcade Building had a large tower. This tower was inaccessible at this time, but, by putting a ladder out on the roof, Reid was able to climb up and look inside. The tower was eighteen by twenty feet in size and two storeys in height, and its four large semi-circular windows let in a great deal of light. George decided it would make an excellent studio.

Reid told Mary that, if he could rent the tower on a five-year lease, he would make the alterations needed to turn it into a studio at his own expense. Thus, when the trust company gave Reid a five-year lease on the whole tower at five dollars a month, heated, he agreed to connect the steam-heating for it and put in a staircase.

Luckily, he found a complete staircase for sale at a builder's supply shop and further searching yielded doors which could be fitted at the top and bottom of the stairway. Soon the carpenters had the staircase placed and were hanging the doors.

Within a week the big loft-like tower was both accessible and heated, and Reid was using it as a studio for a brand new kind of semi-autobiographical painting he had in mind. Because of its heavy brick walls, his tower studio did not look unlike the interior of an old stone barn. Its rustic appearance captured his fancy, and both he and his wife realized its potential as a background for pictures re-creating pioneer life in Canada.

With his mind filled with picture ideas, Reid set to work on three epics of the farm. The first of these, *Mortgaging the Homestead*, was autobiographical in origin, harking back to the time when his father had been forced to mortgage their farm. The other two canvases — *The Story* and *The Other Side of the Question* — were group studies, the former going back to his boyhood, the latter being a memory transcript of fathers grouped around a council table.

In order to carry these three paintings at once, Reid had to divide the tower into a "best room" in a farmhouse, a "town council chamber" and a "loft."

First, Reid placed a scaffold across the stairway in front of the semi-circular front window, creating a kind of second story. Then, he made a roughly hewn ladder of unpeeled small logs which served as a staircase to the improvised loft. Hay was pitched up and spread over the scaffolding to complete the loft.

After having converted the upper part of the tower studio into a barn loft, he set to work creating the other settings needed. Dividing the tower studio in half, he made a farm room on one side and on the other side, he built a long table for the council scene. When the carpentering was completed and the three easels placed, he set out to obtain models for all three pictures.

Without any loss of time, *The Story* was begun. In it, four little boys are grouped around a ladder in a hayloft while a fifth one tells a story. Models for the two adult group scenes were also engaged, and, thereafter, came several months of hard but absorbing work on the three large canvases. As the artist progressed with the pictures, he decided that *The Story* must be in Paris for the spring Salon exhibition; *Mortgaging the Homestead* he selected for the R.C.A. exhibition; and *The Other Side of the Question* was to go to the Pennsylvania Academy of Fine Arts exhibition that spring.

There wasn't much time to get *The Story* to Paris but, by working on it night and day, he completed it in early March. Almost before the paint was dry on the canvas, Mrs. Reid had a quick reception for the picture in their studio apartment. That same evening, Reid rushed the picture down to Matthews' Art Studio on Yonge Street to have it boxed for the two-week transatlantic crossing to Britain and the Channel crossing to France. While the crate was being made, Matthews left the painting in the window, where it was seen by Sir Edmund Osler, who was immediately interested in it.

Reid was delighted at Osler's offer of a thousand dollars for the picture — and he needed the money, too — but the idea of having nothing in the Salon spring exhibition was a terrible disappointment. He explained the situation to Osler and asked if he would allow it to go to the Salon first.

"As my picture, yes," Osler replied.

So it happened that *The Story* was sent off to Paris that day as Sir Edmund Osler's possession.

Unfortunately, it arrived in Paris two days too late to be entered for the judging and was put down in the basement. It was, however, mentioned to the jury, whose members — in hearing that it had travelled so long and so far — went down to see it. Waiving the deadline, they accepted it for hanging and *The Story* was admitted to the Salon, where it brought its Canadian artist excellent notices. (Five months later it was returned to its owner, Sir Edmund Osler, and is now on permanent loan to the Winnipeg Art Gallery.)

As soon as *The Story* had been sent off to Paris, Reid had returned to the other two pictures, completing both within a month. On Saturday, the twelfth of April, Mrs. Reid arranged a private showing

MORTGAGING THE HOMESTEAD, 1890 Courtesy of National Gallery of Canada

THE STORY, 1890 Courtesy of Winnipeg Art Gallery, from Hugh F. Osler Estate

of the two in their studio-apartment. The Toronto critics were loud in their praise of these genre studies of rural Canadian life, which included life-sized figures in arresting and individual postures.

Mortgaging the Homestead was said to depict faithfully the "trials and vicissitudes of Canadian agricultural life" and was considered to be a "strong work, well drawn, finely coloured and having its characters delightfully grouped." The deft effect of light and shade was commented on widely. The presentation of its somber but realistic subject was dramatic and compelling; while *The Other Side*

of the Question — somewhat akin in theme to the Dutch *Syndics* — was received as:

> A strong work, well-drawn, finely coloured, delight-
> fully grouped and realistic... [and] one of the strong-
> est works which Mr. Reid has yet painted.

The light and shade effects in *The Other Side of the Question* were commented upon by one reviewer who wrote:

> The pose of the figures, the composition of the
> picture, and its marvelous management of light and
> shade, combined with its forcible and workmanlike
> drawing and colouring, make this work linger in the
> memory.

In the spring of 1890, Reid — who had been an associate of the Royal Canadian Academy for two years — was elected to full acade-mician status. Each painter, upon election to the academy must donate one of his important paintings to the R.C.A. collection. As his academy diploma picture, Reid chose *Mortgaging the Homestead*, and the picture was shown in the spring exhibition before being placed in the National Gallery of Canada collection.

As soon as these three paintings were completed, Reid started work on his *Forbidden Fruit*, which was to be another autobiographi-cal work or, at least, a memory transcript of his youth. Because of the restrictions imposed on the books he could read during his child-hood, he had fallen into the habit of sneaking up to the barn loft to read certain of the books brought to him by Jamie Young.

For this picture, he re-engaged one of the boys he had used for The Story and began to paint the lad lying in the hay, head propped on one elbow and book in hand. The book in his hands was *The Arabian Nights* — one of the first "forbidden" books George had spirited out to the loft to read.

By early summer this canvas was complete; within five months Reid had done four large paintings, all of which were significant works. These genre or story pictures became instantly popular, and the artist was recognized as Canada's foremost genre painter.

In July of 1890, George and Mary closed their city studio and went out to Lambton Mills, where they rented an old mill as a summer studio and living quarters. Not long after their arrival there, Reid was gripped by an idea for an out-of-doors study of rural life. In front of the old mill ran the Humber, and behind and above them was the highway. Along this highway, people would come from the nearby village to pick raspberries on the Lambton Flats. Reid, from his studio window, could see the adults and children wandering back and forth with their berry pails, and he decided to paint them. He selected two girls and a little boy as the principal characters for his *Berry Pickers*, a rural study that not only suggests holiday making

THE BERRY PICKERS, 1910 Courtesy of Nipissing University Art Collection, Gift from Government of Ontario, Reid Collection

but is bathed in an atmospheric glow of sunshine. The picture was shown in Toronto that autumn and the following spring was sent to the Paris Salon. Then, two years later, after a showing in Chicago, it was reproduced in *Masterpieces of Modern Art* and, upon its return to Canada, was purchased by the Ontario Department of Education.

Upon completion of the *Berry Pickers*, Reid painted three little boys who came to him as a self-appointed deputation to get their pictures done. All this time, while Reid was painting these genre studies, Mary Hiester Reid — whose still lifes were making a name

for her — wandered through the fields doing outdoor scenes on the spot or picking wild flowers to paint back in the studio.

During the summer of 1890, the Ontario School of Art was reorganized by the Department of Education and effective control of the school was given back to the O.S.A. At the same time it was transferred from the Normal School building where it had been housed for the last six years to the new galleries of the O.S.A. at 165 King Street West over the Princess Theatre. By this time, too, Robert Harris was retiring from the school and Reid's name came up as a possible successor to the veteran teacher of painting since two of his former students — Frederick Challener and Owen Staples — had focussed attention on the Gerome-Eakins painting method Reid had taught in his studio class.

When the school opened that fall, now renamed the Central Ontario School of Art and Design — a new curriculum was in place, intended to train art teachers as well as artists and architects. The lecture method now played an important part in the school and on Tuesdays, Thursdays and Saturday mornings Reid gave lectures on perspective, composition and the history of art as well as on advanced painting from life.

Chapter 9

A PAINTER'S HOBBY

In the summer of 1891, Reid and his wife had decided to tour the Catskills for some sketching. They settled in at the mountain village of Tannersville, where, for the next fortnight, they stayed at the home of Thomas Dunbar, a carpenter. Dunbar told them that there was an art settlement at Onteora, a mile and a half from Tannersville and about nine miles from the village of Catskill. This settlement — it was a club, actually — had been organized by Mrs. Wheeler, president of the Women's Art Association of New York City.

Dunbar also told some of the club members that there were two Canadian artists staying at his house and, a few days after this while Reid and his wife were sketching, they met a group of artists on the road. One of the group invited them to the clubhouse that night for dinner.

That evening, George and Mary Hiester Reid were invited to join the club and spend the remainder of the summer in the artists' colony. They accepted and began their twenty-five year affiliation with the group. Several of the Onteora club members had bought land and built studio cottages in the colony, and, before the Reids returned to Toronto in the autumn, they themselves had chosen a site for their own summer cottage.

Arriving back in Toronto in early September, they began making plans for this summer home which Reid was to design and partially build himself. In designing this house, Reid drew on his past experiences drawing up plans for his family's farmhouse, working for J.B. Proctor, the architect, and helping his father build barns and houses for their neighbours.

Reid and his wife spent much time that winter perfecting the plans for the studio cottage which was to be their home for at least four months out of every year. When the art school closed in 1892 and *Lullaby* — the first of Reid's mother and child studies — had been sent off to the Salon, they set out for Onteora.

They again boarded at Thomas Dunbar's house and Reid and Dunbar began working on the cottage. Every morning the two men worked on the construction and, in the afternoon, the artist sketched with his wife in the surrounding countryside. In an amazingly short time, the actual building was underway and Reid himself laid the massive stone fireplace in the combination studio-living room and built the chimney. Owen Staples, who had come to Onteora to

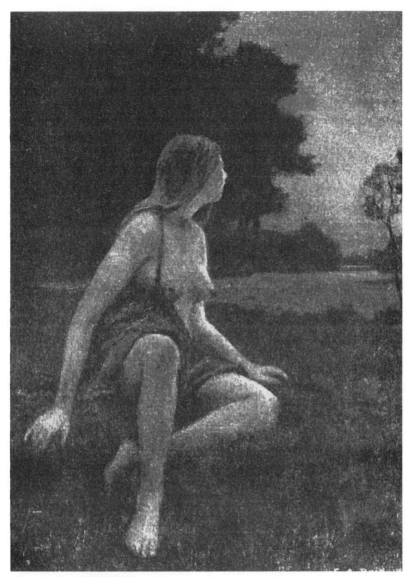

EVENING STAR, 1895 Private Collection

continue his studies with Reid that summer of 1892, also boarded at the Dunbar home and worked on the building.

Within six weeks the superstructure was completed, and the artists moved into the unfinished interior. Over the course of the summer, George and Mary made various trips to nearby villages to hunt for furniture which would harmonize with the setting, and by the time the interior was completed in early autumn, people were commenting on how the cottage's simple artistic style fitted in with its Rip Van Winkle setting.

One thing which the building of this studio-cottage had done for Reid was to clarify in his mind the tenets of his own two-part artistic philosophy. The first part of this was that simplicity, fitness and utility must mark any artistic work if it is to achieve truth and harmony. The second was that, since art penetrates all life and should not be divorced from it, the artist's surroundings must interpret his individuality in order to achieve that sense of unity and identification with life which is essential for him.

Upon returning to Toronto in September 1892, George and Mary decided to hold another joint auction of their work. Accordingly, on the 13th and 14th of December, a sale was held in the Oliver, Coates & Co. Gallery. From this, they realized about two thousand dollars, and, at the close of this sale, they had sold practically every painting they possessed.

Starting now with a clean slate, Reid began working on at least four large genre paintings at the same time. In subject matter, two of these paintings went back into his own past again while the other two centred on different aspects of then-contemporary life.

A Modern Madonna, which he completed in time for the Salon exhibition the spring of 1893, is of a typical Canadian pioneer wife. For it, he had used one of his favourite models (Mrs. Jung by name), a brunette who was not unlike the biblical Madonnas of the Old Masters. The picture itself — still considered to be one of Reid's outstanding figure pieces — represents a high-water mark in Canadian painting.

Soon after this picture was sent to Paris for showing, Reid learned of the death of Joseph Shuter — the flute player and clock cleaner who had wintered at the Reid home years before to cure "the thirst." Before he died, Shuter had expressed the wish that George Reid be given the grandfather clock which he had admired so much while painting *The Flute Player*. When this clock came to Reid, he visualized a picture tribute to this colourful old man who had played such an important role in his early days on the farm. He sketched ideas for the picture and, in remembering how the old man had loved youngsters, decided there must be children in the picture.

Thus it was that *The Visit to the Clockmaker* took shape. In the painting a group of children are seen watching a patriarchal old man working on an antique clock. This picture not only has a historical significance showing us early pioneer life in Canada, but also provides insight into both old age and childhood.

While this picture was still on the easel, Reid conceived the idea for what was to become the most outstanding of all his genre compositions — *The Foreclosure of the Mortgage*. In this painting, he achieved the greatest single success of his life and, when it was sent to the World's Fair in Chicago in 1893, he was awarded a commemoration medal, sharing honours with the *Breaking of Home Ties* by Hovenden and *Alone* by Israels. The technical finesse and tonal values of Reid's style were widely commented upon by critics, but it was the human element and story value which captured the popular imagination.

Returning to their new Catskill studio after the art school closed in April 1893, Reid decided to build another cottage and carry on summer classes in Onteora. He chose a site near his own studio-house and started building a six-room cottage with a large studio and living quarters for ten students. For this the gabled style was used and, when the building was under way, Charles H. Russell — a New York lawyer — approached Reid to design a summer cottage for him. Although Reid did not want to spend his time on architecture, he was finally persuaded to develop plans for Russell.

While in the Catskills that summer, Reid managed to complete *City and Country* — a contrasting study of rural and urban life later purchased by the Ontario Legislature — and, once back in Toronto that autumn, he started on his first musical canvas. For it, he borrowed a spinet from the Nordheimer Company and set it up in the studio, where Mrs. Jung posed at the instrument. The finished picture depicts a contemporary drawing room of the 1890s, and the lighting effect is deftly handled with a beam of sunlight falling on the dark-haired player while the other girls in the picture appear in the dusky background.

Back again in Onteora in the summer of 1894, Reid held his first painting class in the Catskills and, to it, came summer vacationers from New York and Onteora and students from Toronto. Among the latter were Alice Carter, F.S. Challener, Carrie L. Hillyard, Ethel Miller, Ida Rupert, Rex Stovel, Mary E. Wrinch and painter Harriet Ford.

After the Chicago showing of *The Foreclosure of the Mortgage* in 1893, that epic picture had been chosen to go to the Midwinter Fair of 1894 in San Francisco and, there, it was awarded a gold medal. So marked was its success in the United States that on its strength Reid was invited to join an exhibition at the American Art Galleries in New York in the autumn of 1894 featuring five American artists — Robert W.W. Sewell, A. Brewster Sewell, W. Hamilton Gibson, Hubert A. Olivier and Elihu Vedder. Reid was represented in this six-man show by sixty works, including his large genre painting *The Other Side of the Question*, which was sold there.

Reid was again drawn back into architecture around this time, when he was approached to make designs for a church in Onteora. In the spring of 1895, he returned to Onteora with his completed drawings, and by autumn, the general superstructure was completed. Built of native fieldstone, it followed simple Gothic lines, making use of buttresses, a square tower, a steep roof and lancet windows. The panelled and raftered treatment of the interior, one of massive simplicity, created spaces for the mural decorations which were to complete the design.

This architectural work is of special significance in George Reid's life since it both supplemented and elaborated his ever-developing individual philosophy of art. This philosophy was elaborated upon, when after completing the church, he gave speeches in 1898

on "The Summer Cottage and Its Furnishings," which were later published in *The Canadian Architect Builder*.

He stated:

> There can be no right consideration of any art which does not link its extremes together, and does not realize the dependence of the greater upon the lesser. This is a truism in both art and life. We are all idealists when it comes to building our homes, and, whatever state of development we may be in, we seek to beautify them even if they are barely habitable.

Concerning artistic economy and universality, Reid said:

> Our faculties are such that the first requirement, when once satisfied, demands the satisfaction of another and another, and never leaves off making demands. It is thus that art grows. Growth in art... should in fact be the refinement of parts and the elimination of the unnecessary. Thus the purest form of art may show a tendency towards economy. Certainly it is opposed to ostentation and pretence. ...Right appreciation should seek intelligently to discover merit in every form of art and, when not admiring it, at least respect it. This, however, can only be found when there is wide culture and consequent universality of thought. Lack of unity in the arts and breadth of culture and appreciation bring in a whole train of anomalies in architecture as well as in the arts.

In acknowledging the interdependence of the arts, he stated:

> Whether we esteem architecture as the mother of all arts from which she cannot be separated, or regard it not as an art but as that unifying principle which binds together the greater and the lesser arts, it is all one in the interest of true art, the love of which should make for unity of purpose all the efforts of its votaries.

Reid, although vitally interested in his vocation, said of this work, "However much I like building, I like to paint still more." And, certainly, his painting was not suffering from this other interest, which claimed so much of his spare time. Indeed, with his unlimited energy and enthusiasm, he was forging ahead at both.

The class Reid had held in his tower studio in 1890-91 had become an outdoor class for student painters by this time, and many

of its members were exhibiting and painting professionally. From 1895 to 1897, among his regular pupils were Owen Staples, W.A. Fraser, the writer, Rex Stovel, Henrietta Vickers, and Mary E. Wrinch, all of whom were taking advanced work after having completed their courses of study at art school.

Three of these young painters also had studios in the Arcade Building. Rex Stovel, a colourful figure and talented young artist, had the studio on one side of Reid's where he kept guinea pigs in a box and made studies of them in all kinds of positions. On the other side, Henrietta Vickers and Mary E. Wrinch had adjoining studios. Henrietta Vickers was herself twice painted by Reid before she went abroad in 1897 and made Tangiers her adopted home.

After Henrietta's departure, Mary E. Wrinch took a studio with Clara Hogarty, the flower painter. It was on Imperial Lane off Yonge and Shuter Streets, next to the old Scholes Hotel. At this time, Miss Wrinch was known principally as a painter of watercolour miniatures. Formerly a student at the art school in Toronto as well as a private student of both Reid and Laura Muntz, she had worked under Walter Donne at the Grosvenor Art School in London and with Alyn Williams in London and Alice Beckington in New York.

Chapter 10

THE OLDEST PICTORIAL ART

Reid's interest in mural painting dated from his Paris days of 1888-89. The French enthusiasm for beautifying town halls, public institutions, and churches through art had been at its height, culminating with the announcement in Paris that commissions were to be given out through the Ministry of Fine Arts for the decoration of the *Hotel de Ville*. Over the next year, ninety-six artists had been selected to depict on the walls of the city hall the history and progress of Paris through the ages, and each painter had been given work to do according to his special qualifications.

Before Reid and his wife had left Paris in 1889, so great had been the enthusiasm that "La decoration pittorale de l'hotel de Ville" had become a general password. And, later, after they had left Paris, they had been gratified to find the names of both Constant and the famed Puvis de Chavannes high on the list of artists receiving important assignments. (Of all the work of modern mural painters he had seen, Puvis de Chavannes had moved Reid most profoundly and it was Chavannes who had been commissioned to do the great staircase and ceiling for which he had chosen the subject *The Apotheosis of Victor Hugo*.)

Reading about this in the papers had given Reid the idea that a group project like the Paris one should be carried out on the then-unfinished Toronto City Hall. Then, as usual with him, action followed quickly as he lost no time in getting in touch with the architect of the building and procuring a blueprint of it. Yet, although he talked over the group scheme he envisioned with his fellow artists, nothing decisive was done about it until much later.

Consideration of mural painting had led Reid to the realization that, although genre scenes reveal the life of the people, mural decoration is a still more comprehensive field. He decided that a mural scheme gives greater scope than an easel picture and, for him at least, would be much more absorbing than other kinds of painting. Also, in having studied the history of art from the days of the early Egyptians to the present, having analyzed the technical methods of the great mural painters and having viewed the friezes and frescoes from the aesthetic point of view, he was already equipped to work in the field.

In mural decoration — the oldest of all branches of pictorial art — the artist has to follow certain rules, rules which are less elastic

than those in other kinds of painting. In three comprehensive addresses delivered at the University of Toronto, the Ontario Teachers' Association and the Women's Art Association of Toronto, Reid worked out the musts and must nots which were to govern his own painting in this specialized branch of the art. He expressed the musts he considered from both the aesthetic and technical standpoints as follows:

> Aesthetically, the mural must harmonize in colour scheme and line with its setting; and it must successfully cover its space with a well-balanced and unobtrusive composition, which, no matter how extended in length, must present unity. Technically it, of necessity, must be light in weight. That is, it must have light, not heavy, impasto: so that the picture will appear to rest easily on the surface of the wall and not leave the observer in doubt as to whether or not the wall can bear its mass. Moreover, it should take the light evenly from any point of view.

His must nots were equally exacting:

> A mural is not an easel painting on a large scale, painted without reference, either in technical treatment or subject, to its future destination. Its essential essence is in its fitness to its surroundings, both in aesthetic effect and "pictorial interest." It should not require much verbal explanation; it must not force itself upon the attention of the viewer as though it, and not the object it beautifies, were the main consideration. If it does give the impression that it is the raison d'etre for the building then it helps to perpetuate an architectural falsehood.

With his artistic creed worked out, the artist did his first mural panel in the summer of 1892. This misty atmospheric study of an apple harvest in the Catskills signalled a gradual change in his style of painting. There was a transition from the realistic to a more impressionistic presentation of his subjects. This change seems to have been due more to the change in the type of painting than to any mental change in the artist himself since, in the early years when he had been doing different types of work, he had always adapted his technique to suit each particular picture or subject. Also, throughout the nineties, a plein air atmosphere had been gradually coming to pervade all his work.

The critics of the day believed this atmospheric change to be due either to foreign influences upon the artist's work or to the maturing of the painter's powers. They did not feel that it stemmed from the

rigid requirements of mural decoration. It was noted, however, that all Reid's subjects had become more generalized and imaginative than either his portraits or genre paintings had been and that the backgrounds and the whole pictures were being done in higher and softer tones.

There may well have been another reason for the change. At the time of their 1888-1889 trip abroad, the Reids had seen pastels for the first time as well. It is true that a type of hard pastel stick had been used in England for some time, but it was the French crayon-like soft pastels he and his wife were seeing in the galleries of Paris which had really interested them in the medium. By the time of their 1893 trip to Paris, Reid was using the new pastel medium with technical skill and tonal finesse in achieving the desired atmospheric effects of light and shadow or chiaroscuro in his pictures.

Although he had been absorbed in his own painting in these years, Reid had not given up the idea of a group project for the mural decoration of the Toronto City Hall. General interest had been stimulated in mural decoration since two famous expatriate American artists — John S. Sargent and Edwin Abbey — had come back from Britain to undertake the mural decoration of the Boston Public Library. Their series, *The White City*, had caused interest in mural decoration to spread throughout the United States when constructed and shown at the World's Fair in Chicago in 1893. In fact, the Congressional Library in Washington was the first public building built on the principles of art laid down at Chicago and sixty sculptors and painters had been employed to decorate it under committees appointed for each respective field of activity. A board of art commissioners had been put in charge of the enterprise made up of representatives from all the societies of artists in the country.

After having seen *The White City* himself and having learned of the Congressional commission which had been the outcome of it, Reid had returned from Chicago in 1893 determined to press his scheme for the decoration of the Toronto City Hall. Because neither George nor Mary decided upon any work without first talking it over with the other, Reid discussed the idea with his wife. He said to her, "It strikes me that mural painting is the best way to promote public interest in art. The authorities didn't get roused from the artistic point of view so I'm going to attack them from the educational and historical angles."

"It would be wonderful," Mary had replied, "but what about getting mural painters for a group scheme? In Canada there are only Huot in Quebec, Plamondon and Bourassa in Montreal, and yourself who have done mural work."

"I've talked it over with Cruikshank, Challener and Grier. The four of us can get a scheme lined up and work together on it."

Mrs. Reid asked how he planned to proceed, and he said, "I thought I'd go to see Alderman Lamb. I know him, and he's usually interested in artistic enterprises."

Alderman Daniel Lamb was interested in the idea and the artists drew up a tentative plan for consideration by the city council. The theme to be elaborated was the progress in art and industry in Canada from pioneer days to the 1890s and the first room selected for decoration was the council chamber itself.

The room would be divided into eight sections. On the south wall would be the city motto portrayed in three panels representing Industry, Integrity and Intelligence. The west wall would be decorated by a rural council scene such as Reid had used in his *The Other Side of the Question*. The west wall of the corridor, facing the entrance to the chamber, would be given over to larger single panels dealing with the arts and sciences. Of these, each of the four contributing artists would do two panels.

A meeting of painters and art lovers was called to discuss the mural scheme and, since enthusiasm prevailed, the matter was put before the city council. But although the city fathers were theoretically in favour of the idea of mural decoration, they decided they were not in a position to make an appropriation of eight thousand dollars for permanent decorations in their new million-dollar City Hall.

The decoration plan had thus failed to materialize again, but a positive result of getting various art enthusiasts together was the establishment of the Toronto Guild of Civic Art to supervise civic art and town planning in order to increase and maintain the city's beauty spots. The guild was incorporated into the City Planning Ways and Means Committee and R.Y. Ellis, J.P. Hynes, Professor James Mavor, Colonel H.M. Pellatt, G.A. Reid and B.E. Walker were appointed to study the questions of sanitation and transportation, and to deal with purely artistic problems.

Although this committee had no immediate results, the artists persevered and, gradually, the city council began to pay more attention to their suggestions. It may be said, however, that most people in Canada were still too preoccupied with transportation and colonization problems to give much attention to anything as intangible as art. And, up to this time too, mural painting in Canada had been an unexplored field except for the French-Canadian Huot's work, and the religious decorations by Bourassa and Plamondon in Montreal.

After Reid had failed to interest the municipal authorities in mural work, he evolved a plan of approaching the railway companies. With their ambitious programmes for sending settlers west, he felt that they should be interested in a mural scheme which would show pioneer railway builders at work. Accordingly, Cruikshank, Challener, Williamson, Tully, Ford and he went to work on sketches for the decoration of the new Union Station. The subject chosen was the history of transportation. After working out and submitting plans and sketches for this project, the artists waited for the report of the railway officials. All they got was another rejection, however,

with the reason given being that there was no money to be spent on artistic projects.

Thanks to the work of the Committee on Ways and Means, some of the apathy towards the arts was beginning to pass and, again, the question of decorations for the City Hall was revived. This time, Professor Mavor, Donald Bain, B.E. Walker, Frank Darling, W.A. Langton, Allan Cassells, Wyly Grier, William Cruikshank, F.S. Challener, W.S. Allward and Bernard McEvoy (a newspaperman) met in Reid's studio and formally outlined a plan for the Toronto City Hall.

The plan met with general approval, as had the former scheme, but again was refused for financial reasons. Even after this new rejection, Reid and Walker continued to push the idea of co-operative decoration for public buildings but, although Walker's influence was great in art matters, there were no results. At that, after having put several years of planning into co-operative schemes, Reid decided that, if he could work up and exhibit panels at the current exhibitions, interest might be developed. So, although by no means giving up on group projects in his own mind, he postponed action on them for the time being.

In the spring of 1895, with the art school closed for the summer and the Toronto City Hall proposal indefinitely postponed, the artist and his wife left for Onteora to decorate the Gothic stone church which had been completed the preceding autumn. In designing that church, Reid had planned the interior to blend with the architectural design of the edifice, and had developed the plan for its mural decoration when designing the structure itself. Of this union of the arts which he considered must be the ruling principle of all mural painting, he later wrote:

> As in music the symphony is the most elevated
> form, or in literature the epic poem the supreme
> effort, so decoration is, to the arts of colour and form,
> the crown. While all art is but the expression of
> human desires and needs, the avenue of expression
> through the senses subdivides it in subtle ways, the
> subdivisions becoming more and more ramified as
> each sense comes to the aid of the other and as all
> branches of art are interwoven to form the great
> fabric of expression.

It is in Reid's joint work as artist and architect that one finds the secret of his success in mural painting and, certainly, with the completion of this Onteora church, he had established himself both as muralist and architect. The whole scheme for the decoration of the church is "inspirational" in character. Not only does it elaborate the motto "Holy, Holy, Holy," which is inscribed above the chancel, but the columns of trumpeting angels ascending on either side of the pointed arch carry the eye along the nave to the apse and to the

stained glass windows behind the altar. Under these angels, an inner circle of seraphim with wings uplifted carries the original theme to the windows while groups of cherubs float in clouds to right and left around the base of the altar.

The wings of the angels are pointed down, and this leads the eye from the inscription down to the centre of interest — the chancel. But even while the wings carry the eye down, the angels' floating draperies also carry the eye up to the inscribed motto. In this way, the unity of theme is subtly and deftly achieved, and it is impossible for the observer to look at the decoration piecemeal.

In addition to this decorative series, Reid carried on his private classes that summer in Onteora and worked out the studies for another decorative scheme — that of the living room of the Russell studio-house which he had designed and built the previous summer.

The theme for this room was pastoral and included a continuous landscape frieze stretching the length of the gallery while studies of spring, summer and autumn fill the other three walls. Spring is represented by a boy shepherd piping to his sheep while the view from the house forms the theme for summer and, in the autumn panel, a girl is seen resting from her task of apple picking.

With the completion of these two mural series, Reid had definitely deserted the genre and portrait fields for that of mural decoration; in so doing, he felt that he had found his true metier at last.

PART III

WIDENING HORIZONS

Chapter 11

WANDERING THROUGH SPAIN

Reid's early professional painting at Wingham and Kincardine had been almost exclusively portrait work and, during the summers while he had been in Philadelphia, he had continued doing portraits to pay his way through college. Whether or not his original interest in Velasquez had been inspired by the fact that he had been working in the portrait field, his intention to go to Spain to study the work of the great Spaniard remained after he had practically deserted the field for genre and, then, genre for mural painting.

One of Reid's outstanding characteristics was that, having made up his mind on a course of action, he never relinquished the idea until he had exploited it thoroughly or realized his ambition. For example, in 1885 he had, while on a trip through Europe, been going to Madrid to see Velasquez when an epidemic in Spain had stopped him. Now, in the winter of 1895, he made up his mind to go back to Spain to view the works of the Spanish master.

When Reid announced he'd like to return, Mary agreed readily. She expressed an interest in writing about the trip, a sort of travel diary, and George contacted the editor of Massey's Magazine to see what he thought of the idea.

The editor contracted for three illustrated articles on Spain, and the art school board gave Reid leave of absence for the spring term, his old student F.S. Challener taking his classes.

On the eighteenth of January, 1896, the artists left for New York and, after rambling around the galleries of the great metropolis for a fortnight, sailed to Gibraltar on the *Kaiser Wilhelm*.

On board ship was William Chase, the celebrated American painter. Chase was taking a band of students to Madrid to copy Velasquez and, since this was also Reid's plan, the two artists spent much time together discussing the great Spanish master.

On the last day of the journey, when the ship came into view of the coast of Spain, an excited ripple passed through the company on board. Ahead lay the ancient Moorish town of Tarifa with its clusters of white houses along the shore, its old walls and towers and its Guzman castle silhouetted against the blue Mediterranean sky — an almost unbelievably fantastic picture.

As they strained their eyes towards land, they waited with feverish anticipation for the first glimpse of Gibraltar, Britain's great rock fortress in the sea. At last, a faint blue shadow appeared against the

horizon. It grew larger and took on shape and substance. Gibraltar — majestic and aloof — loomed grey and rugged in the distance. The mighty bulwark of the Mediterranean — the concrete proof of the majesty of Britain and Britain's mastery of the Seven Seas — stood out against the blue.

Although Gibraltar is not as sheer or precipitous on the Atlantic side as on the Mediterranean and African sides, it still has a solemn grandeur as one approaches from the west. Because the narrow neck of land connecting it with the mainland is visible from that angle, its three peaks seem to soar to the sky in splendid isolation. At that time an old Moorish castle, seeming to grow from the crevices of the rock itself, hung on the side of the rock and, as the ship grew closer to land, its tunnelled openings gaped wide.

In the harbour, ships rode at anchor and the dark shapes of coal hulks could be seen at the docks. In the misty afternoon light, the scene was enveloped in a purple haze. Then, gradually, the outlines of the gaily coloured houses of the town which cluster at the foot of the giant rock stood out in sharp contrast against the green-black of the cypress trees.

As the ship docked, dark-skinned, wide-hatted Spanish vendors and agents — picturesque in their colourful attire and insistent in their requests — crowded the deck. A man from Cooke's suggested a hotel in the Irish quarters.

"Irish Town!" exclaimed Mary Hiester Reid. "Ye gods of sea and land! Have we come all these weary miles to find ourselves in Irish Town?"

The agent laughingly explained that Irish Town was Irish in name only. Many nations, he mentioned, were represented in this quaint section and its local colour would certainly appeal to the artists. On that advice, they settled in Gibraltar's Irish Town. A population of twenty-five thousand was crowded into this garrison town built under the shadow of the great rock where the Atlantic and Mediterranean meet. Apart from its unique situation, Gibraltar offered bright houses with tiled roofs, dark cypresses and ivy-coloured walls; its shrubs and flowers, old gateways and masonry enticed the artists up the narrow winding streets with their successions of steps leading up the steep mountainside. The colourful street-scenes caught their eye, too, the native men lounging about in bright attire, the women carrying water jars, baskets of violets and narcissi, and the donkeys plodding along with loads of oranges and lemons, onions and lettuce. In the early morning, herds of silky haired goats were driven through the streets and milked at people's doors. The markets, both Spanish and Moorish, claimed their attention as well. Behind the village, "the Rock" rose fourteen hundred and thirty-nine feet into the sky.

Gibraltar certainly provided a potential wealth of material, and the weather, uncertain at this time of the year, was mild and showery but not too cold for outdoor-sketching. Gibraltar, however, was a military town, and to sketch in Gibraltar, application had to be made

to the colonial secretary. After applying, they were granted permits signed by Governor Sir R. Riddulph. In exploring the caves or galleries in the rock, the excavations fascinated them and the mouths of the tunnels, spiked with many calibre guns, made a fearsome sight. The passages leading from one gallery to another were dark and dank with water dripping from above and both sides of St. George's Hall and the other galleries which took them to the fine old Moorish castle-prison.

From Gibraltar, the couple sailed across the bay to Algeciras and then entrained for Ronda. The trip to Ronda was a circuitous one up through the mountains, and they passed through at least fifteen tunnels before they finally arrived. Ronda is twenty-three hundred feet above sea level and, on all sides, are snow-peaked mountains.

Built over a chasm three hundred and fifty feet deep in the gorge through which rushes the Guadiaro, the fortress of Ronda is awe-inspiring. Originally a Moorish stronghold, Ronda was isolated and heavily armed. Reid sketched at the point where the two ancient bridges at the entrance of the gorge unite the two parts of the town. From Ronda, he and his wife went on to Malaga to visit Mother Carolyn Hiester, who was still abbess of the convent there, and after a time with her they took the eight-hour journey to Granada. In Granada, as they jolted up its steep hills and stony streets to the Washington Irving Hotel and the Alhambra, they knew that at last they had found a painter's paradise.

They were awakened the next morning to the soft splash of a fountain below in the courtyard and to the songs of birds — a novelty in Spain where the lack of trees results in a scarcity of birds. Granada, like Gibraltar, had many dark green cypresses and these, along with the town's white houses, stood picturesquely against the deep blue sky. The romance of the past clung to Granada and, in fact, water carriers still filled their jars at the same wells the Moors had used. Although Granada had a frostiness in the air because of its altitude and its proximity to the snowy Sierras, they were still able to do outdoor sketching. It was, however, the wonder and beauty of the Alhambra itself, the ancient Moorish palace, which most claimed their attention.

Were this not history enough, across the street from their hotel was the house in which Fortuny had lived in 1869 and 1870 and, farther down the street, the place where Regnault had lived just prior to his untimely death at Bazenval in 1871. The memorials to these two brilliant young artists in the square gave an air of melancholy and drama to the narrow street.

From Granada the artists travelled down the coast to Seville to attend the annual Lenten Carnival there. Then, after the pageantry of the carnival had been caught by brush and pen, they explored the cathedrals, palaces and cloisters in the city. The famous collection of Murillos was the finest in Spain, but the one thing which had brought them to Seville was missing: although this was Velasquez's

birthplace, the town contained no authentic examples of his work, nor even any record of his life there.

After a quick stop at Cordova, where they visited the mosque, they hurried on to Madrid, passing through the barren treeless stretch of Mancha so closely associated with Don Quixote and his exploits. Their objective was the Prado Museum of Fine Arts where Velasquez originals were hung in numbers seen nowhere else in the world.

"Sixty-four Velasquez portraits in one museum!" exclaimed Mary Hiester Reid as they walked through the gallery. "A gold mine in itself not to mention the Titians, Tintorettos, Raphaels we'll see or those Veronese, Rubens and Van Dykes."

As Reid stood gazing at Velasquez's powerful portraits and saw the life of Philip IV's court taking shape and form before his eyes, he said, "It's worth all the waiting and the expenditure of time and trouble just to see Velasquez alone. Something no artist can afford to miss even though he has to wait eleven years for it."

His wife nodded. "His handling of his subject is masterful. His tone-perfection and beauty of colour are unequalled. Some of Whistler and Sargent approach him but, in the former, one finds often a certain lack of colour which is popularly called 'refinement of colour'; while in the latter, one finds the suggestion of paint. A Velasquez picture is just a bit of life reenacted for you."

During their time in Madrid, the Canadian artists also went to Toledo and took several other short trips, but they spent most of their time studying and talking about the art of Velasquez. Reid did a copy of the *Dwarf and Dog*, which, illogically enough, is entitled *El Ingles — The Englishman*, and he copied several other heads from *Las Meninas* and numerous other portrait heads and studies.

As the month drew to a close, they went to Segovia and Burgos — the ancient capital of Castile — and then, leaving the marvellous towers and fairy pinnacles of Burgos behind them, crossed through the Pancorbo Pass to the Basque country.

The Basque country captivated them, but they had to hurry to get to Paris by the first of April. Crossing to the extremities of the Pyrenees, they travelled through beautiful mountain villages and over softly rolling slopes where sheep grazed. Passing rocky defiles and ruined castles to get to San Sebastian and the frontier with France, they left Spain behind them. In France, after having viewed Tour, Blois and Chartres, they arrived in Paris at three-thirty P.M., the thirtieth of March.

Sadly, their thoughts turned to the Canadian Paul Peel who had died there four years before at the age of thirty-two. Before Peel's brilliant career had been cut off, however, he had won a gold medal at the Salon in 1890 for *After the Bath*, which had subsequently been purchased by the Hungarian Government. Remembering Peel, their footsteps turned almost involuntarily towards the old studio on Rue delambre. Finding it unoccupied, they rented it.

During their busy two-month stay in Paris that spring, Reid

signed up at the Julian and his wife at the Colarossi so that they could brush up on their art training and get first hand knowledge of the new "impressionist" method of painting coming into vogue at this time. (The French painter Edouard Manet had brought French painting a new stimulus in his *Olympia* by the early 1880s although it had been from Claude Monet's *L'Impression* that the painting style had taken its name.) By the middle 1890s, the Impressionists had practically revolutionized painting in Paris, and the influence of men like Manet, Monet, Sisley and Renoir had reached England and New York.

The work of the Impressionists was congenial to Reid in resembling the direct-nature cult foreshadowed by the English Turner and Constable and the French Millet, Corot, Diaz, Rousseau and Daubigny.

While in Paris, Reid exhibited (at the spring Salon) a self-portrait done with his wife seated in the background, writing. Towards the end of May, they set out for Amiens. Although Reid had spent many hours studying Chavannes' decorations in the Pantheon, the Sorbonne and l'Hotel de Ville, he had never seen the Chavannes series in the Amiens Museum, the motif of which was the Province of Picardy. And no one interested in architecture could afford to miss seeing the Amiens Cathedral which Ruskin had called "The Bible of the Gothic."

After that short visit in Amiens, the Canadian artists sailed from Boulogne on the *Sparndaam*, a Dutch liner, for New York in early June. They reached Tannersville on the eighteenth of June, in time for Reid to open his summer class in Onteora and to complete the Russell house frieze which was placed before the opening of the autumn school term.

Chapter 12

"THE ELIMINATORS"

After his 1896 trip to Spain and Paris, a storm of disapproval broke over Reid's head. He was damned by some of his artistic confreres and lamented by others. There had been criticism of his work, particularly after his earlier studies in Philadelphia and Europe, but now he was labelled as radical by some, and reactionary or worse by other orthodox painters.

L.R. O'Brien, the veteran watercolourist, put it tersely at this time: "He's one of the eliminators. He could easily ruin Canadian art; but, there's one thing, no one will ever want to buy his pictures."

It looked for a time as if O'Brien might be right about the buyers. People in Canada were accustomed to viewing a picture from a distance of eighteen inches to three or four feet at the most. They had gained this habit because the detail and the fine brush stroke in the painting of the Raphaelite painters were seen to better advantage close-up than at a distance. So accustomed, they now complained that Reid's current pictures were painted in broad brush stroke and almost shorn of detail. But Reid had reasons for this. In his work, a generalized treatment was used to give more distance, depth and atmosphere than can be achieved in a detailed portrayal of a subject. There was a focal point in each picture of Reid's to lead the eye to the centre of interest and give the observer a general impression of the whole thing and its meaning. Happily, once the newness of this impressionistic handling of subject matter began to wear off, both public and critics began to realize that Reid's new pictures showed both maturity and breadth of vision.

It is difficult to say whether Reid's impressionistic plein air effects were the result of his viewing of the works of the new Impressionists in Paris and of his recent studies at the Julian or whether they were not the result of his study of Puvis de Chavannes and his choice of mural decorations as his milieu. But the change of style was both permanent and striking.

But whatever resistance there was to Reid's new style, various factors were at work which would gain it general acceptance. Other Paris-trained Canadian artists such as Curtis Williamson and J.W. Beatty were returning to Toronto bringing their individual interpretations of new techniques, and although academic Canadian artists were conservative, they weren't afraid to pick up something new if they found it satisfying. So before twelve months had passed, most

of them were becoming "eliminators" themselves, preferring the impressionistic handling of a subject to a stereotyped presentation of a scene.

The outstanding example of this was, in fact, the veteran painter Lucius R. O'Brien. The greater freedom of the impressionistic treatment with its broad brush stroke and the lengthening of the vantage or focal point turned out to be exactly suited to his temperament. In fact, after he became one of the "eliminators" himself, he did the best work of his entire career. Thus, the late 1890s and the early 1900s saw the acceptance of Impressionism in Toronto art circles.

Works done in his new "eliminating" style were not Reid's only interest at this time. Once again he was trying to get a new group effort mural scheme off the ground. General interest in mural work had been awakening as early as 1897 when a competition for the decoration of the Russell Theatre, Ottawa, had been announced. F.S. Challener — whose first mural commission had been McConkey's Restaurant in Toronto — won the assignment. Reid and Challener also revived interest in the group-scheme for the mural decoration of the Toronto City Hall but again, the attempt failed for financial reasons.

This was certainly one of the greatest disappointments of Reid's early years, but he decided he would not let the idea die. So, in the autumn of 1897, on his own initiative, he offered to decorate a part of the lobby of the Toronto City Hall at his own expense. The decoration of this section of the building would in no way interfere with the master-plan which he and his confreres had worked out for the council-chamber since he would merely be doing his own panel ahead of time to stimulate interest in art.

On the sixteenth of December, 1897, Reid's offer was accepted by the Toronto City Council and, in the following months, he made his pastel studies for the two master-panels and the four figures for the spandrels of the arches over the entrance.

These spaces between the spandrels on the pillared entrance of the City Hall show winged figures symbolizing Discovery, Fame, Fortune and Adventure who, hold up a scroll bearing the inscription, "Hail to the Pioneers — Their Names and Deeds Remembered and Forgotten — We Honour Here." On the east and west walls were the master panels around which were inscribed the names of famous Canadian explorers. The first, *The Arrival of the Pioneers*, presents the rugged pioneers — pack-laden and equipped with handspikes — making their way indomitably in the new land, while a mother stands holding her infant in her arms. The second, *Staking a Pioneer Farm*, shows a pioneer seated on a log pointing to a lake as the chief surveyor and his assistants adjust the instrument. To the left, other pioneers are seen laden with packsacks and axes.

The panels were completed and ready for mounting by the twenty-first of March 1899. A ceremony took place on Tuesday, the sixteenth of May, at which B.E. Walker, president of the guild,

accepted the gift on behalf of the guild and presented it to the city, corporation, and citizens of Toronto. Alderman Daniel Lamb, who had been lobbying for the City Hall decoration plan for years, acted for the aldermen and the Property Committee.

By the autumn of 1897, Reid had been elected president of the O.S.A., and the flurry of criticism over his modernism had died. Reid's accession marked the beginning of a great period of activity for the society. In 1898, the Rosedale Ladies' League (which had proposed a plan to encourage art appreciation in Toronto's public schools through mural decoration) appealed to the O.S.A. for cooperation. An immediate response to this was given by Reid and his executive and, in a short time, the Central School Art League was formed to assist in the organization of a number of local leagues in city schools for the purpose of disseminating information on art as widely as possible.

In 1901, reconstruction of a kindergarten room was undertaken by architect C.H. Acton Bond based on a mural series done by Paris-trained J.W. Beatty under the supervision of a committee from the O.S.A., of which Reid was chairman. This meant that, at last, a scheme of decoration was under way in one public building in Toronto, at least, even if it was not the ambitious scheme for the city hall.

Other advances were also made in the general art life of the city during the years around the turn of the century. In 1897, Reid had overseen the publication of a pamphlet setting forth the need for a local art gallery. This had been distributed among art lovers and, in 1900, a meeting was called to consider the proposal with the result that the Art Museum of Toronto was inaugurated with B.E. Walker as chairman and Reid as secretary, while W.A. Langton, Frank Darling, R.Y. Ellis, Professor James Mavor, J.P. Murray and Donald Bain made up the rest of the committee. The purposes of this museum were to bring together a collection of works of art — principally pictures and sculpture — and provide premises for housing such a collection.

That same year, the first exhibition of applied art to be seen in the city was organized and shown at the O.S.A. gallery. The Canadian Society of Applied Art grew out of this exhibition the following year and, by 1901, so great had become the interest in applied art that a regular course in the schools was introduced with Reid as chairman for the staff at the Central Ontario School of Art and Design.

So, although the Guild of Civic Art had not been able to achieve its major ambition, much had been accomplished in the sphere of city planning and, with a representative from their society on that art council, the O.S.A. was playing a decisive role in the artistic and educational life of the city and province. Also, women artists had, at last, been admitted to membership in the society during Reid's tenure of office with the vivacious Mary Hiester Reid quickly becoming an influence on the art life of the society generally.

While engaged in so much public service and so many co-operative ventures between 1897 to 1902, Reid had carried on with both his mural commissions and his architectural sideline. In these five years, he completed about ten houses for the Onteora settlement and did mural decorations in several of them. During these years, too, he had written a study on mural decorations for the *Canadian Architect and Builder* and had given lectures on architecture, the history of art and mural painting.

In his own painting, he had concentrated almost exclusively on murals, and two of his "fugitive" panels (panels painted but unmounted) — *Music* and *Repose* — had brought him international recognition. The former, a presentation of a nude boy as the spirit of music, shows a youth leaning against the slender trunk of a poplar and piping on a reed as he gazes down at the limpid surface of a tiny lake. After having been shown in Glasgow, *Music* had won a medal at the St. Louis Exposition in 1904, and *Repose* — a decoration for a Toronto house — had been at the Pan American Exhibition in Buffalo in 1901 for which Reid was appointed Canadian representative on the Jury of Fine Arts.

Another outstanding mural scheme which he was to complete during these years was *The Scroll of Life* — a continuous frieze around the library walls of Dr. B.E. Walker's 99 St. George Street home in Toronto. This composition has, as its background, a continuous pastoral scene representing certain times of day — morning, noon, afternoon, and evening — with the key concept behind it being the development of life itself. Against a landscape background dotted with trees, three figure groups appear. In the first, a mother and child dominate the foreground while to the right a piping figure reclines. In the second, five youths are seated on the ground engaged in ardent conversation. In the third, "The Philosophers," a group of seers is disclaiming on esoteric subjects of great import.

Chapter 13

THE OLD AND THE NEW

During these busy years of the late 1890s and early 1900s, Reid and his wife had decided they wanted to move out of the centre of town to a more rural environment. Accordingly, Reid bought property on Indian Road and began working on plans for a studio-house there. By March 1900, he and his wife had moved into their new Indian Road home — an Elizabethan style gabled house set among old pine trees and surrounded by a high wall for privacy. Then, in mid-summer 1902, while summering at Onteora, Reid decided they should take a brief trip to England and Scotland to brush up on British art since, on their former travels, Spain and France had really come in for most of the attention.

Accordingly, he and his wife drove into Catskill on the Tannersville stage and sailed down the Hudson on the night boat. They reached New York on Reid's birthday, the twenty-fifth of July, and embarked for Glasgow, where they planned to stay for a few days in order to visit the Glasgow Art Gallery to see James McNeill Whistler's famous portrait of Thomas Carlyle.

Arriving there on the fifth of August, they put up at the Old Waverley Hotel on Buchanan Street and went immediately to the gallery. A blank space on the wall greeted them. It read, "Portrait of Carlyle by Whistler lent to Wolverhampton Exhibition."

After a tour of the gallery to see what the new men were doing, they returned to their hotel. Reid had brought a letter of introduction from Professor James Mavor of the University of Toronto, addressed to James' brother, Henry. (Before emigrating to Canada in 1897, Mavor had been editor of the *Scottish Art Review* and had done much to develop interest in the Scottish Group of Painters.) Henry Mavor was a member of the Glasgow Group of Painters of which Reid had been hearing of late. The following morning, he met Henry Mavor himself, and he and Mary were invited to go to the City Hall to see recent murals of Alexander Roche, McTaggart and the portrait painter George Henry.

After a brief inspection of those decorative schemes, Mavor took them to the studio of George Henry. While they were there, a discussion of the phenomenal success of Sargent came up.

"Sargent is the greatest portrait painter of the time," Henry Mavor said authoritatively.

One of his friends — a painter unknown to Reid — refuted that

just as authoritatively, saying, "George Henry is superior to Sargent."

Mavor smiled, but answered firmly. "Not at all. Sargent is the superior of any of his contemporaries. I am big enough to know it and wise enough to admit it."

One of the other men in the studio spoke up at this time, "Anyway, Sargent's too successful. The only remedy for such success is death and, as a devotee of the great Henry, I offer to do away with him."

Reid found the offhand, jocular mood of these Scottish artists much to his satisfaction, and the group talked for hours, including through dinner, where a lively controversy came up over Art Nouveau, which, as far as these artists were concerned, had more notoriety than artistic merit about it.

When their Glasgow sojourn came to an end, Reid and his wife decided to sail down the Clyde and up Loch Lomond to Inverness and the Trossachs. They walked over the Trossachs themselves, crossed Loch Katrine and skirted the lovely lakes in this part of Scotland. Then, from Callander, they took the omnibus for Edinburgh and put up at another Waverley Hotel — this time on Princess Street in Edinburgh.

The next morning they set out to visit Edinburgh Castle, the Edinburgh Art Gallery and the National Portrait Gallery, where there were numerous portraits by Raeburn and the famous frieze *Great Men of Scotland* by A. William Hole. This frieze includes Scottish historical notables from the very beginning of Scottish history to Raeburn, Scott, Burns, Wallace and Carlyle. Above the gallery is another frieze, *Great Battles of Scotland.*

From Edinburgh, the Reids went to Melrose on the morning of the ninth of August, where a coronation service was to be solemnized that day for King Edward VII. After this historic event, they set out on a leisurely trip through the cathedral towns on the east coast of England, and they wandered through the cathedrals and castles here at leisure, stopping off to see Ely Cathedral before hurrying on to Cambridge and London.

Arriving in London on the twelfth of August, they took a studio at 21 Fitzroy Street which had been engaged for them by Rex Stovel, a Toronto artist who had studied privately with Reid and had lived in The Arcade near George and his wife in the nineties. He was now attending the London College of Art and working with Gerald Moirs, the mural decorator.

The studio which Stovel had procured for the Reids was Sir William Orpen's. Various sketches by Orpen were hanging on the walls and, among these figure drawings and watercolour washes, gypsy types predominated. By this time, Orpen and Augustus John had become the two great influences at the Slade school and, by 1901, it was said that together they "swung the Slade." On a fleeting visit to the city, Orpen called on them while Reid was painting his wife standing in the doorway of the studio. She was wearing a white

gown, the background was low-toned and the colour scheme is one of the most successful of all Reid's portraits.

During the month they were in London, Reid and Mary also visited the galleries and museums again and, this time, saw the Wallace Collection. With Stovel, they visited Gerald Moirs — then principal of the London College of Art — at his studio where they met Young Hunter and his wife. Then, towards the end of their stay in London, Young Hunter invited them to visit Bourton-on-the-Hill in the Cotswolds and spend some time sketching in that vicinity.

On the twelfth of September, they left for Stratford-on-Avon and took rooms at an old public house run by a Mrs. Hathaway. The name might have been a coincidence or it may have been purposely adopted but, anyway, it added a touch of glamour.

During the next five days, they sketched in the Cotswold Hills with Young Hunter and dined at Bourton-on-the-Hill. Young Hunter, a figure painter who was exhibiting prominently at the Royal Academy at this time, had converted the stable on his property into a picturesque and spacious studio. The view from the big windows of this high-raftered barn made an ideal background for the painter, with rolling hills all round and a long-distance view showing still higher ridges beyond.

After rambling through the Cotswolds, Reid and his wife went on to see Stratford-on-Avon itself, Warwick, Kenilworth Castle, Birmingham, Chester and Manchester. They arranged their itinerary so that they could pass through Wolverhampton and finally see the famous Whistler portrait of Carlyle which had led them to Glasgow in the first place.

On seeing it, they were in no way disappointed. The handling of the theme was similar to that used in Whistler's portrait of his mother, which Reid had seen in the Louvre. One can see on the face of the great essayist the stamp of the penetrating intellect and philosophic mind of this man who wrote the voluminous and powerful *History of the French Revolution,* and delved deeply into German thought and introduced Kant and Hegel to the English public. The picture is low-toned, as is all of Whistler's work, and its subtle colour scheme gives dignity, repose and quiet strength to the face of the fiery Carlyle. Luckily, Whistler had caught this man at one of the rare intervals when his turbulent and goading spirit was at rest. It is a great portrait of a great man done by a great painter, yet, after studying the picture for some time, Reid said, "He can't be said to be as great as Velasquez, but he and Sargent are certainly the greatest of the moderns. There's a timelessness about such art."

"I wonder," asked his wife contemplatively, "if in three hundred years Whistler will still hold his place among the great portrait painters of the world? This portrait is certainly satisfying, but I wish he had just once done something in higher tone and with more concentrated colour. His work is all of a key and I feel there must be a variety of technique in the work of a great artist to make it enduring."

"It is true his painting is more confined to one type of thing than that of Giotto or Velasquez, but there is a mellowness about it which will make it enduring," hazarded Reid.

It was mid-October when they arrived in Liverpool. There they met Stovel again, who was travelling with "San Toy," a musical comedy in which he was singing. Then, after a few days in the port city, they sailed on the *Lake Simcoe*. This was not their first crossing, of course, but never in any of their earlier crossings, had Reid seen anything like the ferocity of the angry Atlantic on this stormy fourteen-day voyage. Fortunately for him, he was not seasick and so could sketch it in all its turbulent fury. In fact, the studies and sketches which he did on that trip were used as source material for the palaeontological mural representations of the primitive ocean which he completed a generation later in the early nineteen-thirties.

Chapter 14

FRUSTRATION AND FRUITION

Back once more at home Reid again threw himself into the job of putting across a group plan, this time for the decoration of the lobby of the new King Edward Hotel. Frederick Challener, Edmund Grier, Cruikshank, Edmund Morris and S.S. Tully all would work on the venture this time, and the type of decoration suggested by them was similar to that found in the Manhattan and Astoria hotels in New York with "the subject, the treatment, and the method done in the most approved modern methods."

An offer was made to the directors of the Grand Trunk Pacific to decorate the hotel. This offer included the request that, should the commission be accepted, it be done under the supervision of the architect and board of directors so that there would be thematic harmony between the architecture of the building and the pictures.

The board considered the idea favourably and each artist submitted a sketch for his panel or panels. However, a controversy arose between the architect (E.J. Lennox) and the artists on one side and the contractor and business manager on the other, since the general contractor demanded that the artists be put directly under his supervision.

The contractor, who had no artistic training or appreciation of art, apparently had more power with the board than the architect himself because, forced to choose sides, the board turned down the group scheme. The contractor then called James Dodge, a New York artist, to come to Toronto and decorate the new hotel along the lines proposed by the Canadian painters.

Dodge, of course, had no knowledge of the trouble into which he was stepping and he started working on a sub-contract with the contractor. But the contractor had no intention of permitting the decorations to assume too much prominence in the building and he began ordering Dodge about. Dodge stood it for some time, but then, when the panels were nearing completion, he threw up the whole thing and returned to New York.

The contractor had to answer to the board for this failure and so he was forced to return to the Canadian painters and ask them to finish the job. Reid, who had been the instigator of the plan, refused on principle as did the other painters who had been interested in the group scheme. The hotel was completed with the mural decorations in the lobby still unfinished.

Finally, the contractor returned to F.S. Challener with a plea. Challener finally (after much hesitation) decided to do the work if the contractor left him entirely alone. The contractor consented this time and Challener finished the panels in 1903.

Thus ended the third unsuccessful group attempt by Canadian artists. But in spite of this latest disappointment, Reid was more determined than ever that something of this nature could be successfully accomplished. So he and Franklin Brownell, William Brymner, Challener, Cruikshank, Edmond Dyonnet and Gustave Hahn turned their attention to a decorative plan for the Houses of Parliament in Ottawa.

That year the Prime Minister, at the opening of the R.C.A. exhibition, had expressed the desire that government do something substantial in the way of encouraging Canadian art and a plan was drawn up by the Royal Canadian Academy for the decoration of the federal parliament buildings. This plan, it was stipulated, would be carried out under the jurisdiction of an R.C.A. committee with the chief architect of the buildings acting as an ex-officio member of the board.

In April 1904, after numerous meetings a proposal was submitted to the government by Reid as the representative of the academy and the artists Brymner and Brownell acting for the six other artists who were to do the work. On the twenty-fourth and twenty-fifth of April, a conference was held in Ottawa at Brownell's studio with the chief architect and assistant architect present. The decision arrived at was that a complete set of sketches be made of the parliamentary rotunda or oval entrance hall and brought together in Ottawa during Christmas week.

The subject decided upon by the artists was Canada receiving the homage of her children. The key panel was to be an open-air procession with an enthroned mother-figure symbolizing the country seated in the centre of her four provincial "daughters," representing the four self-governing British colonies that combined at the Confederation in 1867. Each of these maidens would also be attended by an heraldic figure bearing the coat of arms, banner and motto of its province. A long procession — including men, women and children of all types — was to represent the populace and to show the occupations, arts and industries of the country at the time. Phases of Canadian history were to be expressed as well against a landscape background made up of forest, field, water and mountain. Finally, sculptured figures in semi-classical costumes were to be placed between the spandrels of beams and arches to blend in with the Gothic architectural style of the building.

The key panel of the series, *Ave Canada,* was to be a canvas ten feet high by seventy feet long to be done by Reid while the two side walls — each ten by thirty feet — were to be decorated by Dyonnet and Brownell, the former being a representation of harvest, the latter of industry. The entrance wall itself, which was broken by an elliptical doorway was to have three major panels. On the rounded

wall above the doorway, which is ten by fifty feet, Brymner was to do *The Arrival of Cartier* while Challener and Cruikshank were to do a scene of settlers and hunters along the flat sections of the wall to the left and right of the entrance.

When these sketches were submitted to the government, the plan was approved although the matter had to be held in abeyance — there was no appropriation available for art projects at the time.

Other projects also kept Reid busy during these years. Between 1904 and 1906, an art pamphlet was prepared by a committee of the O.S.A. that had Reid as chairman, and C.W. Jefferys, Frederick Challener, Gustave Hahn and J.W. Beatty as its other members, and the pamphlet, distributed to the schools in Ontario, was a brief summary of the movement for art education in public schools up to that time. The Guild of Civic Arts, of which Reid was a member, set out to get historical cartoons for a Cabot Exhibition but this scheme fell through. Nevertheless, a plan was drawn up by the guild for the decoration of the provincial legislature, and Reid was appointed convener of this project along with Challener, Grier, and Gustave Hahn.

These men, despite all their former failures and deadlocks, outlined a carefully planned scheme for the decoration of the ground floor of Queen's Park. Then, they submitted the following suggestions in a report:

> 1.That the various parts of the work should take the form of historical wall paintings, and symbolical compositions, ornamental designs and flat tintings to be used for borders and other spaces;

> 2. That the choice of subjects should be made with a view to picturesque aspect and dramatic situation, and so arranged that consecutive order be achieved;

> 3.That the principle be adopted that Ontario artists should execute the work, and that no more than two panels would be undertaken each year after the beginning is made;

> 4. That there should be control by a responsible committee for the purpose of giving commissions, and of supervising the work in progress — this committee to be composed of laymen interested in art and in the history of Canada, and of professional men: architects and artists not personally concerned in the work.

The subjects decided upon for the Ontario Legislative Building — thirty in number — were outlined in detail by the committee in 1907, but after being worked out so carefully by the artists, the

scheme was finally voted down by the legislative assembly. At this, Reid decided to confine himself to doing private mural commissions. Fortunately for him, he found much greater success with these than with any of his group efforts.

By this time, in fact, he had decorated several more of the Onteora studio-cottages which he had designed and built. Principal among these were the houses of Heinrich Meyn and of Maude Adams, the actress. For the former, he had made a continuous landscape frieze typical of the local countryside around the Onteora artists' colony, while for the latter, a frieze of birches was carried around a large reception hall.

At home, he had done a mural triptych for a reading room in the Queen's University library in Kingston on the Homeric theme. For it, his friend Professor James Mavor of the University of Toronto posed as a Greek philosopher.

Just after the completion of this work, Reid had also decorated the living room of Professor Adam Shortt's home in Ottawa and that of Charles Boechk in Toronto. The former shows the far-wandering Ottawa in a continuous landscape where rich meadows and tree-covered hills stretch to the horizon. The dominant colour note in this sequence was a palely tinted symphony of blue-green. The latter has as its key panel a pastoral scene with figures in a holiday mood grouped in the foreground. This landscape theme was carried across the six spaces between the windows of this oval-shaped room. Across from the key panel, two groups of figures representing hunting and harvesting added human interest to the scene.

For some time now, Reid had been bringing human figures into his scenic panels to personify the basic idea or theme which had inspired the scene in the first place. An example of this is seen in two of his fugitives of 1904-1905, *May* and *The New Day*. The former is a cool atmospheric study in which a brown-haired girl represents the month of apple blossoms while, in the latter, the painter portrayed a lovely young girl and a shrinking old woman to personify the idea of youth versus age. In his figure work generally Reid had used allegorical subjects to express natural phenomena and philosophic ideas as early as the 1870s and, with his switch to mural painting in 1889, the human element had taken over in all his work.

Although in the first years of the new century Reid had failed in all his efforts to get mural painting accepted in Canada on a co-operative basis, he had forged ahead in his own work. Thereafter, he declared himself content with private mural commissions which, given his heavy commitments at the art school and to the art association in which he was so active, were coming to him almost too fast to handle.

Chapter 15

PIONEERING IN PAINT
AND PARK

By the summer of 1906, Reid and a group of his friends living on Indian Road were considering buying Wychwood Park — a tract of land heavily wooded and overlooking the city on the hill west of Bathurst Street and north of Davenport Road — as the site for a group building project. Back in 1891, this land — including the estates of Alexander Jardine, Marmaduke Matthews (the Canadian landscape painter) and Agnes Litster — had been joined under a trust deed, fenced in, called Wychwood Park and held as building lots.

The only houses existing on the property in 1906, however, were those of Matthews to the south, and of Jardine to the west. The remainder of the park had been left in its wild state even though part of the Matthews property itself had been sold. Now Ambrose Goodman, the son-in-law of Matthews, and his law partner, E.A. Duvernet, suggested to Gustave Hahn, Eden Smith (the architect), G.A. Howell and Reid that plans be drawn up for a division of the park. The project met with the approval of all six of them.

The various parts of the park which had been sold were now repurchased through a trust company, and Eden Smith, the contractor, and Reid were the first to buy their lots. In fact, Smith began construction on his house in the spring of 1906 while Reid laid the cornerstone of his new studio-home that September. It was to be called Upland Cottage, and, late that winter, Reid and his wife moved into the still unfinished house.

Throughout the early years after the opening of Wychwood Park, building was rapid there. Reid had acted as a member of the board of trustees which controlled the distribution of the property, managed the park's internal affairs, extended the old road through it and put in a new system of street-lighting. The board had been given a free hand within its borders by the county and, indeed, for a time they even considered incorporating Wychwood Park as a separate town. By 1907, E.A. Duvernet and G.A. Howell had completed their homes and, within the next few years, Saxon Shenstone, Dr. C.T. Currelly, Professor Eric Owen of the University of Toronto and Michael Chapman were all to buy land and build there. These men were followed by Professor Edmund M. Walker, also of the University of

93

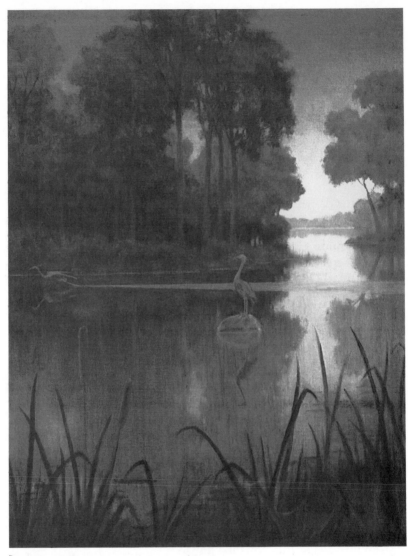

TRANQUILITY, 1906 Courtesy of the Province of Ontario

Toronto, Sir William Gage, the publisher, H.H. Love and miniaturist Mary E. Wrinch.

In the summer of 1910, Reid designed a studio-home for Mary E. Wrinch and her sister M. Agnes Wrinch. It was built on an exceptionally difficult site at the head of the ravine in Wychwood Park through which a woodland stream ran down into the lily pond at the south of the park. A long footbridge linked stream and pond and, as late as 1940, a transcript of this hundred-foot bridge is found in the painting *The Little Bridge* by Mary E. Wrinch, which is in the National Gallery of Canada and was shown in London, England. Wychwood Park, with its stream and lily-pond and nature background on her

very doorstep, was, thereafter, to be a favourite sketching ground for her, just as it was for Reid and his flower-painter wife at Upland Cottage.

In fact, Wychwood Park was to provide nature-settings and backgrounds for a number of artists in the city and Upland Cottage, with its individualized rustic simplicity, was considered, depending on your point of view, either a significant architectural landmark, or an oddity. For example, one day not long after the Currelly-home had been finished in 1910, Henry Sproatt, the architect of Hart House, stood for a long time looking across the street at Reid's. Then, turning to Currelly, he said thoughtfully:

> You have to be as good an architect as I am to appreciate how great an architect Reid is. I can appreciate that house and grasp it as a piece of work, but I couldn't have done it.

Yet it only took one generation after that for the professional art world (in having gone urban) to make a very different kind of assessment of that rural style of architecture. One day in the early twenties, when Reid was sitting at the dinner table, an artist acquaintance of his who was driving some friends through Wychwood Park on a sightseeing tour stopped her car just in front of Upland Cottage. It being a still day, her voice carried through the open windows:

"That's an artist's studio. Yes. And, my dear, it's just like a barn inside. Two-storey studios and beams and rafters everywhere, painter plaster walls, exposed plumbing and all that!"

Wychwood Park and Upland Cottage were not Reid's only preoccupations in these years. In 1906, Reid had been appointed president of the Royal Canadian Academy, succeeding Robert Harris, his former teacher at the Toronto Art School. He helped launch a campaign in the R.C.A. to bring together the National Gallery of Canada collection in a suitable building. By 1907, the academy council had drawn up a memorandum to present to Lord Grey, the governor general and titular head of the academy. In the memorandum, they asked that a permanent art commission be set up to consider all art questions arising in the country and, particularly, to look into the matter of the national collection.

This memorandum (drawn up by Reid and adopted by the council) was directed to Lord Grey early in 1907. After consideration of the request, he put the matter in the hands of the Honourable Sydney Fisher, then federal Minister of Agriculture. Subsequently, the minister suggested that a special commission be formed in accordance with the request contained in the memorandum and that a grant be made by Parliament to cover the cost of administration. Parliament ratified this outlay and, at the annual exhibition of the academy in April 1908, Fisher wired Reid that the government was proceeding with the appointment of an Advisory Arts Council

which, in agreement with the academy's own suggestion, was to contain no business representatives but be composed of laymen interested in and knowledgeable on matters of art itself. The government stated that after this, the academy should make representations to this body in all matters relating to Canadian art or to the National Gallery of Canada itself.

This new council included among its members Sir George Drummond of Montreal as chairman, the Honourable E. Arthur Boyer of Montreal as secretary and B.E. Walker of Toronto. The first move made by this council was to ask for the appointment of a competent director for the National Gallery with the authority to act conclusively on all matters which dealt with the national collection. Up to this time, there had been no full-time curator. Secondly, it suggested that the R.C.A.'s own art collection be transferred to the national museum and that all federally owned pictures be gathered there as well.

Apart from having jurisdiction over this national collection, the council was authorized to purchase works of art for the National Gallery of Canada and given an appropriation of ten thousand dollars with the stipulation that the greater part of this grant should be spent on the purchase of Canadian paintings. The question of decoration of public buildings themselves was also to be considered.

The representations of the committee were approved by the minister in charge — the Honourable Sydney Fisher — and the collection was transferred to the museum under a full-time curator. A mural decoration plan for the lobby of the Parliament Buildings was also proposed. At last, it looked as if things were beginning to move satisfactorily for Canadian art. In following years, the grant for the purchase of pictures increased from $5,000 to $100,000 dollars at which figure it was to stand until the outbreak of the First Great War in 1914 when it was temporarily discontinued.

Within the academy during the years of Reid's vice-presidency and presidency, special exhibitions were held under the auspices of the R.C.A. and co-ordinated by academy commissions — the 1906 Dominion Exhibition at Halifax, Nova Scotia and the 1907 exhibition in Sherbrooke, Quebec. Reid also went to Quebec in April to confer with Monseigneur Mathieu, Rector of Laval University, with reference to the showing of the Quebec collection of historical portraits and paintings in Toronto the following autumn.

An occasion of great moment in the art life of the country in 1908 was the celebration being arranged to commemorate the tercentenary of the landing of Champlain in Quebec. At this time, B.E. Walker (also a member of the National Battlefields Commission) was in charge of press permits for reporters and Reid approached him to see whether artists could not be given the same permissions as news reporters. Consent was granted and C.W. Jefferys, Reid and several other artists went to Quebec to make sketches of the pageant.

While there, Reid did sketches for his large historical canvas of

a later date, *The Arrival of Champlain at Quebec*. (This painting was purchased by the federal government and is now in the National Archives.) It was the artist's first straight historical subject, although since childhood he had been particularly interested in stories of the founding of the British Empire, and practically every one of the abortive group mural schemes he had been involved in had been historical in theme. When this canvas was completed, Reid decided to do more historical paintings to depict what he termed "the pageant of Canada."

The next year he and his wife (on the invitation of United States officials) attended the Lake Champlain Tercentenary celebration and, on the day of the pageant, Reid was asked to take the role of Champlain in the pageant, the actor who had been engaged for the part being unable to be present. Since President Taft was to be in attendance, the officials were very much worried by the actor's absence, so Reid accepted. After one rehearsal, he acted the part wearing a pair of high jackboots, plumed hat and belted waistcoat similar to those he had used in painting his Champlain study after the Quebec celebration.

PART IV

AFTER MANY YEARS

Chapter 16

HOME AND ABROAD

The Festival of Empire was scheduled to be held at the Crystal Palace, Sydenham, England, in August of 1910 with the Canadian section under the control of the Honourable Sydney Fisher. The pictures for it — one hundred and twenty in all — were gathered at the request of Earl Grey, the governor-general, boxed and sent to England. But King Edward VII took ill suddenly and died before the exhibition, leading to cancellation of all public functions. Rather than return the Canadian exhibit home unshown, Fisher arranged that an exhibition be held in the Walker Art Gallery at Liverpool.

The consensus of opinion was that the work was of high quality, but the critics and reviewers noted that there was no distinctive Canadian school of art anymore than there was an original American school. This assessment did not surprise the Canadian painters. Concerning this matter, Reid himself had written years before in 1906:

It [Canadian art] is only in its infancy. We have no Canadian school; we have only influences. The French and English schools perhaps have had most to do in molding Canadian art. As yet we have not developed anything distinctly Canadian, but Canadian art is bound to develop along this line and have for its ultimate aim the expression of Canadian life, sentiments and characteristics. Canadian art should represent the idea of nationality and development. It should be given imaginative treatment.

Speaking of influences, Reid's own work shown at the Liverpool exhibition was pointed out as being predominantly French in influence — especially *The Iris*. That picture was further said to show an affinity with the French aims and methods of the 1890s while, on the other hand, his figure study *A Canadian Girl* (which is a portrait study of artist Henrietta Vickers) was viewed as more distinctively Canadian in conception and execution than his other works on display.

It was his *Homeseekers*, a genre historical presentation of pioneering days, however, which brought Reid the widest acclaim. This work was a throwback to his earlier genre period. Symbolic in treat-

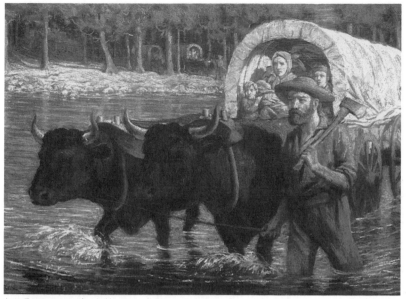

THE HOMESEEKERS, 1910 Courtesy of the Province of Ontario

ment, designed to compare the difficulties of early pioneering life with the relative ease of the later years after the hewing and building had been done, its dark foreground contrasted sharply with its sun-drenched background.

The collection returned from Britain with the imprimatur of British acceptance, which was sufficient to stimulate some interest in Canadian painting in our own land. Canadians generally, unlike Australians and New Zealanders, had never greeted their own artists with much enthusiasm or, in fact, shown much interest in any of the arts including *belles lettres*.

Encouraged by this British success, Reid and his wife left for England in 1910 to spend the summer there. They rented Upland Cottage to Michael Chapman, a young Englishman who was planning to build a house in Wychwood Park for himself and his wife, the adopted daughter of G.F. Watts, the English painter. Mrs. Chapman gave them a letter of introduction to Mrs. Watts in England.

Stopping off at Onteora en route to New York, they proceeded to the city and sailed on the *Columbia* for Glasgow on the twenty-eighth of May. In Glasgow, they stayed at the Old Waverley again and revisited the galleries, the cathedral and crypt, and the city hall to view the great frieze there.

Their trip from Glasgow to London was a literary pilgrimage of sorts. Both Reid and his wife were keenly interested in literature and never missed a chance to see literary landmarks in their travels. So, on the way from Glasgow to London, they took the opportunity to visit a number of literary shrines. They visited Burns' birthplace and spent a night at Ecclesfechan to see the home of Thomas Carlyle. On

the fifth of June, they went to Bowness and Ambleside where they made a short stopover at a quaint hostel about which Elizabeth McLenegan, a cousin of Mary Hiester Reid's, had told them. From there, they took walking trips through the Lake District as well as stopping off at the home of Wordsworth at Grasmere and visiting the Hawkeshead Grammar School where Wordsworth had been educated.

Arriving in London on the 12th of June, they put up at a boarding house at 32 York Street, Portman Square. Over the next month, they rambled about London sketching, sightseeing and wandering through the British Museum where, once again, they viewed the famous Elgin marbles and other great works of art.

A month later, on the twelfth of July, they left for the Jolly Cricketers' Hotel in Great Marlow where they visited painter Harriet Ford, who had been at the Ontario School of Art with Reid and later had visited them in Onteora. Then, they went on to stay at Compton and, while there, called on the widowed Mrs. Watts at her home, Limner's Lease. While there, they attended the G.F. Watts memorial exhibition which was being held that year in the gallery on the estate.

After a few weeks in Compton, they left for the Low Countries in mid-August. Setting off for Dover via Canterbury, they stopped to see the famous cathedral and to sketch the famous landmarks before crossing from Dover to Ostend. In Brussels, they met painter Henrietta Vickers who had sat for Reid's genre study *A Canadian Girl*. At this time, Vickers had a studio in Paris although she had moved to Tangiers in North Africa. The Reids and she visited the International Exhibition and enjoyed the opportunity of comparing the work of contemporary artists in different European countries.

Later, Reid and his wife went on to Antwerp and Amsterdam since both of them had looked forward for many years to the opportunity of viewing the works of the great Dutch painters. They toured the galleries of Haarlem, The Hague, Rotterdam, and Delft but it was the Rijks Gallery in Amsterdam, with its magnificent Rembrandt, Franz Hals, and Vermeer canvases, which most inspired them.

On the third of September, they left for Huy to meet Mother Carolyn Hiester who had come from Malaga, Spain. During their brief stay in Huy, the artists stopped at L'Aigle Noir where the abbess lived in a nearby convent.

Leaving the Hook of Holland and crossing to Harwich and Walberswick, they stayed at Beta Cottage, of which Ethel Miller — an old student of Reid's and sister of Professor Miller of the University of Toronto — had told them. The fortnight spent there provided a delightful interlude of leisurely sketching before their return to London to sail on the American liner *Haverford* for Philadelphia on the nineteenth of the month. There they met Mary Hiester Reid's cousin, Lena McLenagan Yorke, an American newspaper correspondent working for the *New York Herald*, who was home on vacation. After a fortnight in Philadelphia, they left for Toronto where on the

fifth of November, Reid resumed his teaching at the art school — a substitute having taken his classes for the first five weeks of the term.

As to Reid's own painting that winter of 1910-1911, he did the genre painting *Pioneer Plowing*, a work of a general historical nature, which was to become one of his strongest paintings to date. It was followed by *The Coming of the White Man* — a historical subject with dramatic overtones. This picture depicts the early pioneers travelling up the St. Lawrence in their stately white-sailed vessels while the Indians are seen on shore looking seaward towards the approaching ships.

For this picture, Reid had brought an American Indian model from the United States to pose for him. In fact, he posed this man in numerous positions and worked up thirteen figures of Indians standing, crouching and sitting in the foreground of the picture. When the picture was shown, it became instantly popular with the public and was widely commented upon in England and the United States as well when sent there for showings.

While Reid had been painting his historical themes, Mary Hiester Reid continued to paint her individualized still lifes. She was considered by many to be the best flower painter in Canada at this time although Robert Holmes remained the most famous wild flower painter the country had produced. Painter L.R. O'Brien, when commenting on the character and subtlety of Mrs. Reid's flowers, noted:

"Your flowers and your fruit are exquisite, but I claim that my roses have more soul."

Hector Charlesworth used to tell a story, too, which shows something of the great love Mary Hiester Reid had for her subjects. One day he saw her standing at a market stall downtown choosing peaches with great care as the disturbed vendor kept trying to convince her that the peaches she was selecting were not ripe enough for eating. She replied that their colour and shape were perfect.

"It ain't colour and shape you eat ma'am," the dealer argued. "Them there peaches is hard," the man persisted.

Mrs. Reid looked at him and laughed lightly "I don't want them to eat. Somehow a craving to paint the velvet texture of the peach overcame me."

The vendor looked at her suspiciously but sold her, without further ado, the hard, richly coloured and symmetrically shaped peaches she had selected.

In March of 1912, Mary Hiester Reid and Mary E. Wrinch held a joint exhibition at the Art Metropole. Mary Wrinch was now concentrating on her Lake of Bays landscape paintings, and one of them — *The Mill Race* — had recently been purchased by the National Gallery of Canada. These rather unconventional high-keyed plein air subjects had called down upon her attacks of both modernism and radicalism from other professional artists. But, at the same time, they received excellent press and the exhibition

brought an appreciable number of sales of the work of both artists.

Also in 1912, the Associated Watercolour Painters was formed in Toronto with its principal members being F.M. Bell-Smith, F.H. Brigden, R.F. Gagen, T.G. Greene, C.W. Jefferys, J.D. Kelly, C.M. Manly, A.H. Robson, J.E. Sampson, George Chavignaud and Reid. This represented another change in his work. Reid had used the medium for sketching in the past, but he had done relatively few large or important watercolour pictures. Now, in 1912, he was turning his attention seriously to the medium and he produced in record time *Nocturne, Brown and Gold, The Haunt of the Heron* and *After Sunset* for the first exhibition of the association held on the third of April at the Art Metropole Galleries, 241 Yonge Street in Toronto.

Chapter 17

AN AMBITION REALIZED

The existence of several small art schools throughout the province had prevented the Toronto art school from being recognized as the central art institution in Ontario, and its precarious financial situation had greatly handicapped its progress since its inception in 1872. To see the school established on a solid academic and economic foundation had been one of the great ambitions of George Reid's life from his student days there, and he had actively striven towards realizing this goal ever since he had started teaching there at the time of the first re-organization of the school in 1890.

Also, from 1900 to 1910, he and his fellow members of the O.S.A. and R.C.A. had worked energetically on the general committee overseeing the building of the Art Museum of Toronto. And, by 1910, a movement had not only been under way to have the art museum incorporated as the official museum but also to gain status for the Toronto art gallery.

That same year, Mrs. Goldwin Smith made a gift of Grange Park (which property she had inherited from the old Boulton estate) to the city as a memorial to her husband, Professor Goldwin Smith of the University of Toronto, who had died in 1906. It was to provide premises for the proposed art gallery. Grange House, however, was turned into offices along with the Toronto art school where, the following year, the Central Ontario School of Art and Industrial Design was also to be housed. Then, in 1912, a bill was presented to the Province of Ontario Legislature for the incorporation of the two art schools into one, The Ontario College of Art.

This bill — prepared by representatives of the Department of Education, various art and industrial organizations, and the directorate of the college — was introduced by E.A. Pyne, M.D., then Minister of Education, and endorsed by Sir James Whitney, then Premier of Ontario. The purposes of this new Ontario College of Art were to produce professional artists and to train teachers in both the fine arts and the technique of commercial industrial sign-painting.

With such a practical agenda, the bill passed the house and an annual grant of five thousand dollars was given by the province as well as free premises in the Normal School building. A council composed of eighteen representatives appointed by art and industrial bodies in the province and five members-at-large was put in charge of the college in August 1912 with G.A. Reid as the school's

first principal. Six departments were created to cover the many aspects of art education while new instructors were engaged and a new curriculum outlined.

During the next few years the museum continued its efforts to stimulate interest in the idea of a separate art gallery built in Grange Park. To achieve this, their committee under its chairman Dr. B.E. (later Sir Edmund) Walker, and its secretary George Reid, organized exhibitions of privately owned paintings for showing at the city's Public Reference Library. Two hundred paintings by foreign masters were brought in for it and, over the next five years, several other exhibitions of foreign and native art were sponsored by this art gallery council with the R.C.A., O.S.A., and other local associations supervising the displays.

In 1915, after the outbreak of the war, Canadian artists were busy getting together a collection of paintings to be donated to the Patriotic Fund, and Reid was on the committee for that as well. This exhibition, which also took place in the Toronto Reference Library, was highly successful and a large sum of money was realized from it, all of which was turned over to the fund. Reid also oversaw a highly successful private exhibition at the gallery of the work of Mary Hiester Reid and their old student and friend Mary Evelyn Wrinch.

Encouraged by the success of these shows, ambitious designs for the proposed gallery by Darling and Pearson were submitted to the committee. By this time, the Reference Library showings and the Museum of Art itself had been drawing attention to the idea of having a permanent gallery building to house the provincial collection. The sudden interest in art had been stimulated by the Red Cross and the art associations particularly to raise money for the Allied Patriotic Fund. In fact, in 1915, Reid and his wife had opened their home to a group of volunteers sewing for "the boys overseas." This activity formed the basis of a picture Reid did in retrospect for the big Patriotic Fund exhibition held in 1916.

That exhibition itself became a sensational success for art in Canada. At the same time, a great need had arisen among Toronto contractors for employment in the building trades, so the legislature itself approved the bill before the House for the building of the Toronto Art Gallery (or, as it was to become, the Art Gallery of Ontario). By 1917, the number of life memberships of both artists and lay-members (at a hundred dollars each) was so large that the art council, the college of art, the O.S.A. and the R.C.A. decided together that the moment for building the gallery had arrived. By 1918, the construction of the first of the gallery's planned ten sections was underway at last. This was to contain one large and two small galleries and a portion of the long corridor which would eventually unite it with the new wings as they were added. Eighteen years after the appointment of the art gallery committee, the erection of a permanent structure was underway.

Much of the credit for that whole venture must go to three men who refused to give up in the face of failure. All three had been in

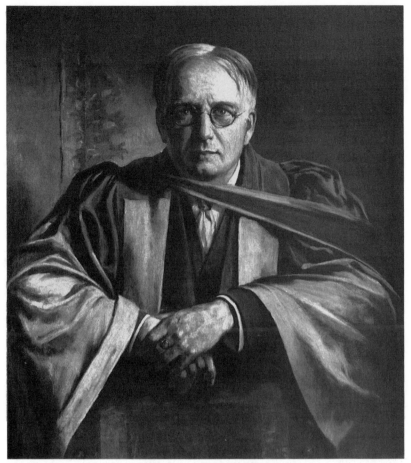

C.T. CURRELLY , 1935 Courtesy of Royal Ontario Museum, Canadiana Department

strategically strong positions to promote this venture. They were Professor Sir Edmund Walker of the University of Toronto and chairman of the Toronto art gallery committee itself; Dr. C.T. Currelly, director of the Royal Ontario Museum of Archaeology; and G.A. Reid, principal of the Ontario College of Art, honorary secretary of the art gallery council, and past president of both the O.S.A. and the R.C.A.

Several other group efforts of art lovers took place as well during the war years and one in particular goes back to Reid's early, innovative outdoor sketching classes. When taking over the principalship of the Ontario College of Art after its reorganization, he had broached the idea to the council of inaugurating an outdoor summer-school for the teaching of landscape, the human figure and animals. The proposal had been favoured by the council since a teacher's course could be incorporated into it to go along with teacher-training courses in commercial and fine arts.

Accordingly, the four-month, summer-school sessions were established with Paris-trained J.W. Beatty as resident instructor. Unfortunately, by 1915, so many young Canadian artists and art students had signed up for overseas service that the attendance began to dwindle. As well as diminishing enrollments, there was the problem of a home for the school. In 1917, the sketching school made a number of moves from the city to more rural environments at York Mills and then to Thornhill where Reid and his wife now vacationed for several weeks each session, having felt obliged to sell their New York State Onteora Club summer cottage because of the increasing difficulty and long delays in crossing the international border. That summer a permanent home unexpectedly turned up for the sketching school.

Reid and his wife had joined Dr. and Mrs. Currelly at their summer home in Canton, on the Ganaraska Watershed near Port Hope that summer. During this visit, Currelly had taken them to an old abandoned lumber mill at Lambton Flats not far from the historic Currelly home. Going through that barnlike structure carried Reid's mind back to his own boyhood days and he also had to agree with Currelly that the lovely rolling countryside around there would make it ideal as a permanent home for the summer school. The provincial art school grant to the gallery had been "frozen" for the duration of the war to save money for munitions, so money was not available for such projects, but Currelly's offer of the backing of the R.O.M. for the venture sent Reid back to the art gallery and college advisory art committee in a hurry. Agreement from the committee was immediate, and the summer school was saved, largely through the efforts of Reid and Currelly with the backing of Dr. Walker, chairman of the official art gallery committee itself.

Reid, although busy with administrative tasks and committee work, did not neglect his artistic work during the war years. There was his work for the Patriotic Fund and, like many other artists, he was commissioned by the War Records Office to do works in 1917 and 1918.

Reid's donation to the Patriotic Fund sale had included the memory transcript of a Red Cross volunteer sewing-bee which had taken place in his home the year before. For his other commissioned painting (Forging Six-Inch Shells), he also did an atmospheric study of workers in a huge dome-shaped munitions building. The effect of conflicting lights and palpitating air caused by the glowing blaze from the open furnace is achieved by skilful choice of point-of-view and a deft handling of light and shadow. In 1918, he followed it with Armistice Day, a scene of pageantry and celebration. All three of these pictures are impressionistic and atmospheric as well as historical, and mark a new point of departure in Reid's style. The artist uses the full subtlety of his technique to draw the viewer's eye into these commemorative pictures rather than merely making what might be called photographic or factual records of the scenes.

During the years since the reorganization of the Ontario College

of Art and the establishment of the summer school as well as his involvement in architecture and murals, Reid had little time for his own painting except on Sundays and over holidays. But, of late, he had been finding it more and more difficult to get models for easel pictures or murals. He had, it is true, done three semi-autobiographical figure pieces during those years by using himself and family members as sitters and the Reid and Agnew buildings as background settings. These were *An Indian Honeymoon*, *Boy Reading*, and *An Old Ontario Barn*. But the difficulty in finding models was to mark a shift in emphasis in his work. Time was to prove that this shift of emphasis in his work after 1918 was to be a permanent opening to a new phase of his career — his landscape period — in which the viewer is carried into the picture to glimpse George Reid, the human being — a complex, silent and private human being who revealed himself only through his art.

Chapter 18

A MASKED BALL

Although used to slim financing and running the Ontario College of Art at the smallest possible expense, Reid and the college council still found that there was a deficit at the end of the 1918-1919 academic year. The annual grant of five thousand dollars established in 1912 by the Department of Education had been "frozen" during the war and, as tuition fees did not really cover many of the school's costs, and they had not sufficient funds to meet the rising expenses of the school.

Reid mentioned this fact to C.T. Currelly, the chairman of the council for the Ontario College of Art, and suggested that they go to the Department of Education to see Doctor Merchant, the chief director of education for the province.

"You have to beg for a paltry few hundred dollars!" exclaimed the archaeologist. "That's preposterous. Ask for a doubling of the grant at least."

"And get precisely nothing," answered Reid to whom experience had taught caution. "You'd ruin the whole thing and get nothing."

"I doubt it," retorted Currelly with spirit. "You've been poverty ridden so long in that school you're stultified. I'll see Murray."

J.P. Murray fell in line with Currelly's plan and promised that he would back the chairman if he asked for a hundred thousand dollars.

The next Sunday morning Currelly went over to Reid's and, in characteristic manner, rushed into the problem.

"Get a pencil. We're going to talk over the art school."

"Look here," Reid answered, "I'm too busy for such nonsense."

"So am I too busy for nonsense," Currelly flung back.

After a spirited protest, Reid took up pencil and paper and worked out a modest estimate for payment of models, supplies, incidental expenses and library costs based on the number of pupils and facilities they had at the time.

"What about teachers' salaries?" barked Currelly.

"Oh, we'll just divide the remainder equally as we've always done," replied Reid unruffled.

"Sheer nonsense," exploded Currelly. "What's the use in all this kind of thing? You men put more than half-time in at that school and you should be paid on the basis of a three-thousand a year salary. Put down fifteen hundred a year for each of the instructors. Go ahead,"

he repeated as Reid sat with pencil poised, "put that down and give me the total."

It came to twenty-two thousand dollars a year. When Currelly went to see James Loudon, President of the University of Toronto, Loudon protested at the inadequate method of payment of the staff. "It's sheer madness," he said to Reid when the committee was brought together, "for the instructors in a state institution to go on so. The men are going to get a decent salary on the middle of every month or I'll have nothing to do with the business."

Reid agreed, although with some misgiving. To have President Loudon's support, however, was too great an opportunity to miss. The OCA committee began to work on this twenty- thousand-plus-a-year scheme. Then, with that estimate in hand, Loudon, Ellis, Murray, Howell, Currelly, Reid and two labour leaders approached the government. Moving upward through the bureaucracy, they finally met with H.J. Cody, the Minister of Education, who, after much deliberation, called the committee to his office. His opening remark, after an exchange of greeting, was:

"Now gentlemen, regarding your art school..."

He got no further.

"Please, please," interrupted Currelly. "May I ask you, Mr. Minister, to say my art school which you gentlemen run for nothing?"

They all laughed and, after further discussion, Cody said:

"I'm afraid, gentlemen, that I could not recommend a sum of that size be granted under the present set-up of the school."

"Very well, Mr. Minister," Currelly answered, "as Chairman of the Council, I resign everybody on it. The council no longer exists, so you are free to appoint the same men back under any category you may suggest or throw us all out and appoint others."

Cody smiled, "You have the power to do this, Mr. Currelly, and I shall await the formal resignations of the council."

That evening every man on the committee concurred in this decision and put in his formal resignation to the Chairman, which Currelly passed on to the Minister.

A few days after this, upon a request from the government, the members of the liquidated committee met again at the Arts and Letters Club and a representative of the Department of Education presented a statement from the government advising that the re-signed members of the committee be again appointed by their respective bodies. They would then be asked to work on a new council, which would include representatives from the Department of Education and would have complete control over the college.

Doctor Cody introduced a bill to this effect in the legislature as an amendment to the Act of Incorporation of the Ontario College of Art of 1912. This clause provided for a new council with twelve of its members appointed by the Lieutenant-Governor in Council, and eleven to come from art and other organized bodies. This amendment passed and the new council was given the annual provincial

grant of twenty-five thousand dollars. At last, as Currelly put it "The art school began to come into its own. It had been a charity until Cody took charge."

Other changes had their effect on the art school, too. At this time, both the federal and the Ontario governments entered upon an extensive programme of technical education, and a course in design for the textile industries was inaugurated at the college. Also a much closer correlation was sought between all branches of education, and the connection between the Ontario College of Art and the University of Toronto — an affiliation which had been worked for by Loudon and Reid — came to the fore. A proposal was made that the university establish a faculty for the higher arts and that, although this was later vetoed, the art college be affiliated with the university and be given the right to confer degrees on its graduates.

For a time all went well but, the following winter, Reid was told by the Ministry of Education that, because the school was growing so fast, thanks to its new grant, it was causing crowding in the Normal School and would have to move.

Reid was used to seeing the art school on the march but, this time, he said that the prospect of still further moving was unthinkable unless it could be to permanent quarters. In fact, a list of possible new homes for the art school had been drawn up and this was given to Reid.

"None of these buildings will do in any way, shape or form. I refuse to consider them," Reid said. "I've approached the art gallery council and asked if a specific site at the east of the Grange could not be set aside for a building which would properly house the college. If the province wants to get us out of the Normal School, let it provide funds for a suitable school building."

Funds were, in fact, available. Soon after this, C.T. Currelly was called into the Ministry of Education and told that a federal government grant of one hundred and twenty thousand dollars, originally intended for vocational training, was available for the construction of an art school.

Currelly rushed to Wychwood Park to tell Reid. Reid, in turn, went at once to see Sir Edmund Walker, who agreed to bring the matter before the gallery council.

"There isn't much time," Reid said. "We have a deadline. This money is a federal grant and, unless allocated for definite use within the next week, it will have to be returned to the federal treasury."

"What do you suggest?" asked Sir Edmund.

"That we get plans into shape and present them to the Department of Education within the week," replied Reid calmly.

"Could you do the designs yourself in that time?" asked Walker.

"Yes," replied Reid.

"Go ahead and I'll call the council as soon as you're ready," Walker said.

Almost without food or sleep, Reid worked on the plans for the new art school building. In about four days he had the drawings ready

and went to the architects of the gallery, Darling and Pearson, to explain the situation and the necessity for haste. When he asked them if they would accept and use his plans, Pearson replied, "You can do it yourself. Go ahead."

Walker now called the council together and Reid presented his plans. There was some controversy but when Henry Sproatt, LL.D., stated that Reid's plan was both artistic and practical, the designs were accepted by the council. The provincial government was approached for the hundred and twenty thousand dollars just two days before the expiration of the time limit, and the federal grant for technical education in the province was reallocated to the Ontario College of Art.

Reid, as chief architect, oversaw the building while Horwood and White acted as associate architects. The structure — which was to be sixteen thousand square feet in size — was to contain offices, small studios for instructors and seven large, well-lighted studios for drawing, painting, sculpture and applied art.

The cornerstone was laid by the then premier of Ontario, the Honorable E.C. Drury, on the twenty-first day of September 1920, and, although it had been in use since that spring, the building was officially opened on the thirtieth of September 1921. After over fifty years of wandering, the art school had a permanent home at last and much of the credit was due to the self-sacrifice and persistence of its founding principal, who had been determined that Ontario have a first-rate provincial educational art facility.

However, the joy Reid felt over the long worked-for and hoped-for college of art was tempered by personal misfortune. In 1919, Mary Hiester Reid had suffered a heart attack and her condition had grown more and more serious over the next two years. By 1920, because of increasingly severe angina attacks, she was no longer able to do sustained hours of painting at a sitting. At the peak of her creative power, her work suffered no loss from the artistic standpoint, but the quantity was necessarily cut down.

In spite of her recurrent attacks during this time, she was able to hold her place in the art life of the college where her support of, and team-work with, her husband had been unfailing for thirty years. Ever the enthusiast, her vivacity and outgoing nature continued to make her a favourite and an influence on the students. Outside the college, she continued to play a vital role in the life and work of many current artists too, including miniaturist Mary Wrinch and portrait painter Marion Long — both of whom were just back from successful sojourns in the United States and Europe.

By the spring of 1921, Mrs. Reid's heart attacks were coming with even greater frequency but, although now bedridden for days or even weeks at a time, there were still periods when she was able to entertain and to accompany her husband to school functions. Traditionally, one of these occasions was the annual costume ball held at the college. Yet, this year, realizing that standing for a long time in the receiving line to shake hands with the guests would be too

strenuous for her, she sent Reid on alone — to his great disappointment.

That night, the across the street neighbours of the Reids, Dr. C.T. Currelly and his wife, arrived at the ball with an unnamed friend whom they introduced merely as an out-of-town guest. The woman was wearing an old-time gown with beflowered poke bonnet and, when Reid — at the head of the reception line — bowed and bent to shake hands with the lady, he found himself looking into the same dancing brown eyes which had captivated him in the Eakins' sketching classes in Philadelphia thirty-eight years before. At that moment Mary Hiester's rippling laugh rang out and the mask came off her face as she passed along the line to the delight of those present.

This little ruse of hers had, in fact, been to keep her husband from realizing the reason she had not originally accompanied him. Her principal concern was always for him, and she did not want him to know that her days were numbered.

Although still only in her middle years, she, nevertheless, had made peace with herself, and accepted the nearness of death with the same intrepid spirit that had always marked her. Now the great worry of her life was the thought of George's loneliness when she would no longer be at his side, and it was to her favourites Marion Long and Mary Wrinch, who had visited her constantly since her illness began, to whom she confided her fears one day in the early winter of 1921 and offered her own solution to the dilemma. Twenty years later, during the researching and writing of this biography, Marion Long reached back into the past to tell that story in her own words:

"Mary," Mrs. Reid had begun in bringing up the matter to the English Mary, "you know you have been a favourite of George's and mine for many years now. And, when I am no longer here, he will be very lonely and will need your friendship more than ever. And, if he should ever ask you to be his wife and you can return his regard, I do not want you to refuse to marry him out of loyalty to me. It would be my wish."

Then, with one of her rippling laughs to break the emotional tension between the two of them and put Mary at ease again, she went on to describe Reid's matter-of-fact proposal to her in the early summer of 1884, which had been based on his need to give the steamship line a two-week notice so they'd hold his tickets for him.

On October the fourth, 1921, not long after that scene between the women, Mary Hiester Reid died from a severe attack of angina, leaving her disbelieving husband in a state of shock.

The winter after his wife's death, Reid threw himself into his work at the college even more completely than ever before and, at the same time, he began organizing his wife's work, which was scattered about Upland Cottage, hanging and arranging it about the walls by period and medium. He had in mind memorial exhibitions for her in Toronto and her own hometown of Reading, Pennsylvania.

He started, too, to hunt up her pictures wherever they might happen to be. This took much going through catalogues and unfiled records but he persevered until summer. By that time, he had gathered three hundred and seven canvases with the help of Marion Long, Mary Wrinch and numerous other old friends and associates of the couple. When the works of Mary Hiester Reid's were shown, they included seventy-six of her still lifes, thirty garden scenes, twelve interiors, twelve moonlight studies, various seasonal pictures and over a hundred landscapes. Two mural panels were also shown. The first — an autumn scene done for the Weston Town Hall — has a rural setting and shows a stream meandering through a field. The second — a misty Spanish landscape — was the panel at that time mounted over the mantel in the dining room of Upland Cottage.

A special memorial exhibition was also held for Mary Hiester Reid that autumn at her birthplace in Reading, Pennsylvania, and, following this, Reid presented one of her paintings — a garden scene of hollyhocks — to the Reading Art Gallery in commemoration of Mary Hiester Reid whose still lifes vibrate with life and character and who was loved by all who knew her.

Chapter 19

IN SIX COUNTRIES

Over the many months Mary Wrinch had been helping Reid to get together the memorial exhibitions of Mary Hiester Reid's pictures in Toronto and Reading, the two of them had been working together constantly. That September of 1922, a few days after his return from his current stint at the Canton summer school, he walked along the block of Alcina Avenue one early evening to the home of Mary Wrinch and her sister Agnes with a very special purpose in mind.

Following the lady into the parlour, he sat down opposite her and formally raised the subject which had brought him to the house. He announced with his characteristic matter-of-factness and aloof reserve that the two of them could be married on the Thanksgiving holiday and get in a few days of holiday travel before classes resumed.

Taken completely by surprise by this announcement and the way Reid took for granted her answer, as he had done that of the first Mary, she — dignified and aloof by nature like himself — was left speechless.

It was Reid who broke the silence and, crediting her hesitation to her friendship with Mary, he said "You will need to consider the question I see, but there is one thing I would say. If you are hesitating because of loyalty to Mary, do not. It would be her wish."

This second Mary knowing that to be the case, nodded but, nevertheless, she felt that out of deference to Mary they should wait another year or at least until the following spring. When she insisted on waiting, Reid conceded that, in deference to her wishes on the matter, he would wait "until the beginning of the Christmas holidays." So it was at the beginning of the Christmas holidays in 1922 that George Reid and Mary E. Wrinch were married quietly and left immediately for Boston on a short honeymoon to tour the galleries. After a fortnight there, during which they visited well-known sights, they returned early in January to Toronto for the beginning of the college term. Together, they then began building a new life together around their joint careers.

Reid had, for some time, felt that he would like to make a new general survey of European schools to get ideas to broaden the scope of the college. Accordingly, in the winter of 1923-1924, he outlined his plan to the college council and was granted a leave of absence for four months in order to inspect art schools while they were in

LAKE TEMAGAMI, 1922 Private Collection

session. The council had hoped to finance this trip for him and make all arrangements for his reception as an official representative of Ontario's provincial college of art, but lacking the funds to do it, Reid undertook the tour on his own responsibility.

His plan was that he and Mary visit schools of art in the United States, England, Scotland, France, Belgium, and Holland and compare them with the schools in Canada, including his own. Said he, of his plan:

> I knew I was not going among strangers. Two of the schools in my programme, the Pennsylvania Academy of Fine Arts, Philadelphia, and the Julian Academy in Paris, were each...my Alma Mater, and a large number of the schools were already well known to me through artist confreres who had studied in them and by knowledge of them through their publications..., textbooks on art, and professional work of many of the heads, and art masters....

On the fifteenth of April, he and his second wife began their survey. On the invitation of John Gordon, then principal of the Art Department of the Hamilton Art and Technical School, they inspected the Hamilton school, which was second in importance in the province to the Ontario College of Art itself.

After this brief trip to Hamilton, the real tour began. The couple entrained for Philadelphia and, the following day, they made their

LAKE TEMAGAMI, 1922, by Mary Wrinch Reid, Private Collection

way to the Pennsylvania Academy of Fine Arts. Although Reid did not find his old alma mater very much changed physically, Thomas Eakins had no longer been there and, to Reid, somehow the academy had meant Eakins. Yet so well had Eakins established his methods that the school was still running true to the system of the master. Reid also found the outdoor school of the academy, inaugurated by Eakins, was still the most completely equipped school of its kind in America.

As they wandered through the galleries, he recognized a number of paintings which had been on the walls in 1882 when he had been admitted there. He saw also the modern collection which interested him very much and he found that, even after a lapse of over forty years, the principal subjects taught in the academy were still "almost entirely painting and sculpture, with illustration and decorative painting as extension courses." Myers, the secretary of the academy, showed Reid through the classrooms. He explained that the space was entirely inadequate but that all plans for expansion were being held in abeyance until the new art museum was built in the city.

The three other Philadelphia schools the Reids visited were all technical facilities. In fact, Reid discovered that, under the Pennsylvania art education system, textiles and industrial design were studied separately from the fine arts.

Arriving in Boston on the twenty-first of April, Reid and his wife visited four art schools in that city. The school of the Museum of Fine Arts, located in a temporary wooden building on the grounds of

G.A. REID ,SELF PORTRAIT, 1936 Courtesy of London Regional Art Gallery, gift of the estate
of Mary Wrinch Reid

the museum, interested them particularly because of its special and
complete training in design. In the sphere of teacher training, the
Massachusetts Normal Art School — founded in 1811 by Walter
Smith of Leeds, England — had the most complete centralized
teacher-training plan Reid had yet seen. Like the public schools in
Massachusetts themselves, it charged no fee for its four-year course,
although students from outside of the state had to pay a fee of one
hundred dollars a year.

From Boston, the artists entrained for New York. At the Art
Students League, founded in 1875 by a radical group of painters, Reid
found that the school's early radical spirit had been maintained by
self-government. Under this system, any student, after having
passed a three month probationary period, was eligible to become a

member of the ruling council. On entering the school, too, the student was allowed to select the master with whom he or she wanted to work and to submit work to that artist for acceptance. If the work was not approved, however, the student was obliged to attend the antique class until qualified to enter the painting and sculpture classes.

While going through the Art Students League's studios, Reid met George Bridgman, a Canadian artist who'd been at the Ontario School of Art about 1880 and who, at that time in 1922, was one of the principal instructors in the league.

If the Art Students League followed in large part the laissez-faire principle, the Art School of the National Academy of Design, founded a century before, was governed by the Council of the National Academy — the United States official art body comparable to the Royal Academy in Britain and to the Royal Canadian Academy in Canada. Here, also, they found that the tuition was free and choice of instructors rested with the pupil.

Reid was convinced that the American method of teaching gave the greatest amount of freedom with the least amount of supervision, government or expense to the student. He felt that freedom was the only way to develop initiative in a student, although there was a danger that excess freedom could lead to license. However, American school also gave a thorough groundwork and a sound academic training. Another point about them that Reid admired was that nearly all were so heavily endowed that they could send numbers of students abroad every year on scholarships. Canadian schools couldn't compete there and they still didn't give their students as much freedom.

After their tour of the New York art schools, Reid and his wife set sail and, arriving in London on the sixth of May, the couple began their comparative study of English schools. The following morning they inspected the Royal College of Art and, during the next five days, they went through the Royal Academy Schools, the Slade, and St. John's Wood where so many Canadians had been trained.

Going on from London, they visited art schools in the mornings and art galleries in the afternoons in Birmingham, Liverpool, Manchester, Sheffield, Leeds, York and Newcastle — a strenuous programme indeed! Then they left for Edinburgh on the twenty-sixth of the month and, after a survey of the Edinburgh School of Art, went on to Glasgow where they visited the Glasgow School of Art, thus completing their survey of the main British schools.

Reid felt that the British system was, as he'd always believed, more conservative than the French or American schools and that it seemed to lay greater stress on composition and exercises than on painting. Despite this, he thought that practically all the student work he saw showed a high degree of completeness without loss of freedom. The British didn't go in for excessive modernism, and they gave the art student a sound basis on which to build his own art.

On the twenty-third of June after crossing to France, George and Mary resumed their tour of art schools and, while in Paris, they

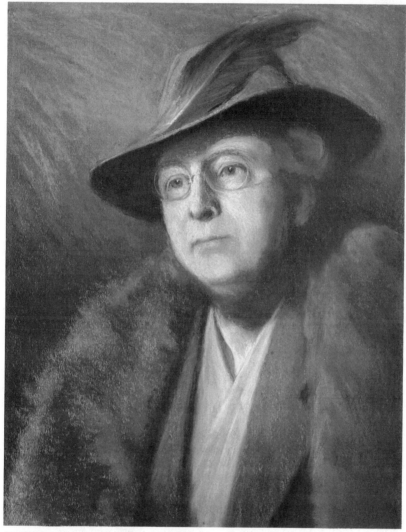

PORTRAIT OF MARY WRINCH REID , 1944 Courtesy of Art Gallery of Ontario , gift of
Rheta and Gordon Conn

visited five of the larger institutions which were in summer session
at this time.

It was the Julian which most attracted Reid, of course, and he set
out to compare the method used there in 1924 with that employed
back in 1889 when he had studied under Constant. On their tour of
the galleries there, he saw, still on the wall, the male nude with
which he had won the combined prize of the joint academies in 1889.

At l'Ecole Nationale Superieure des Beaux-Arts de Paris, the
principal art school in France, Reid saw something he considered
especially noteworthy. Painters, sculptors, architects and engravers
who graduated from here could compete for the most notable of

French art prizes: Le Prix de Rome. Awards of the Prix de Rome were made annually in each of the four sections, and these coveted prizes qualified the winners to study in the French school at Rome on a four-year travelling scholarship. Reid favoured such a plan but, in Canada, art had always been too poor for such schemes.

After their week in Paris, the artists went to Holland. They decided to visit only the schools corresponding in importance in that country to l'Ecole des Beaux-Arts in France, and so visited just the Academie Royal des Beaux-Arts D'Anvers at Antwerp and the Rijks Academie Van Beeldente Kunsten at Amsterdam. They found that, in the Dutch schools, all drawings were done in charcoal and that they showed a high degree of skill. The Dutch method, following in principle to the old world-famous Dutch method, showed great conservatism; however, at the time of their visit, an internal revolution was taking place in the Antwerp academy and new ideas were being introduced. Co-education was the main innovation at this time and joint classes of men and women, working from the nude, were being instituted for the first time in Holland.

After the tour through French and Dutch art centres, George and Mary Wrinch returned to England and, on the eighteenth of July, began a tour of small art schools in the counties. They found that almost every little town, as well as the cities, had its own school of art. The school at York particularly caught Reid's eye. He found, also, that some schools had been instituted by various towns themselves, and he selected the one in Penzance for a visit.

Having completed their extensive tour of thirty-eight art schools in six different countries, they sketched for ten days in St. Ives, Cornwall, before returning to Toronto.

Reid's report, when submitted to the council, pointed to his conclusion that the system of scholarship — which is so highly developed in Great Britain — shows a greater democracy than that found in any of the other countries. This included even the United States, in spite of the fact that American schools were more heavily endowed. In the States, though, free tuition art schools were more universal than elsewhere, although the famous British schools and the Paris and Dutch academies were also free for the most part.

The report also pointed out that the one aim from the start had been to "find the merits of many new theories developed and used in connection with recognized systems of training, and of some complete systems entirely based on new theories" even though he had realized that no "correct estimate" of these new movements could be countered at such an early stage in their development. The principal object, had been "not to go in search of new theories or to justify the system of training we have developed," he wrote, but to see whether the work of the college — so necessary in the system of education in Ontario — compared favourably with similar schools in other countries. He had come to the decision that it did.

With his mind full of new ideas for the Ontario College of Art, Reid resumed his teaching that autumn of 1924 and set to work to

translate these ideas into action. On the whole, he felt that the Ontario college stood up fairly well with the schools of the other countries and if only in numbers, it was certainly forging ahead. The attendance had jumped from one-hundred-and-eighty in 1912, at the time of its second re-organization, to four-hundred-and-ten in 1924, and now — with a permanent home of its own as well as an adequate government grant — the future looked bright indeed.

Chapter 20

A NEW MOTIF AND LIBERATION

For a dozen years, Reid had been so busy at the Ontario College of Art that his own painting had been pushed into the background. It is true that, during his summers in the Catskills up to 1917 and at the summer school in Canton every August since 1922 he had done some sketching in the country from which he had worked up several excellent pictures, but, on the whole, there had been little time for painting or sketching.

Not so the summer of 1925.

That summer, after a month of teaching at the Port Hope summer school, he and his wife set out on their first trip to Northern Ontario. The Canadian northland had fascinated the English-born Mary Wrinch since her first visit to the Muskoka cottage of historian Kathleen Lizars in 1906 and, this summer, Home Smith — the president of the Algoma Central Railway, and an uncle of Miss Lazars — had arranged for the Reids to travel "the length of the railway" on a sketching tour. Provisions also made it possible for them to stop at any point on the line they chose to paint, from the Sault to Franz through the spectacular Agawa Valley.

Faced with such a range of possible sketching sites, they chose to spend most of the month in the canyon where the Agawa Valley narrows to a gorge and the water breaks over its rocky bed. Once there, Reid threw himself enthusiastically into his sketching. Only twice before in his long career had he burst out in a new field with such enthusiasm. The first time had carried him into his early genre period of the late 1880s and early 1890s; the second had swept him into the mural period of the 1890s and early 1900s. But never before had landscape claimed his undivided attention.

Awed by the canyon's natural setting, he gave free rein to both imagination and inspiration. In fact, the sketches done at this time seem to vibrate with movement themselves, while at the same time retaining a strong decorative and atmospheric quality. The colour harmonies are higher in tone than in his earlier landscape works and, by the end of that month of feverish sketching, he had made up his mind that nothing must be allowed to interfere with his and Mary's summer sketching trips after this. That fall, however, any free hours he had left from his school duties were not, surprisingly, taken up with translating these sketches into easel paintings; another kind of painting than landscape had caught his attention.

SUMMER SHOWER , LAKE TEMAGAMI ,1925 Courtesy of the Province of Ontario

In the spring of 1923, the R.C.A. had announced an open competition for mural decoration schemes in public buildings and set aside a thousand dollars for prizes. Unfortunately, Reid, Jefferys and Challener — the leading muralists in the country at the time — had all been too busy that year to enter within the time limit given.

When the second such contest was announced in the spring of 1925, however, Reid set aside time for the project. This time, the awards were to be given on studies made to a scale of one inch to the foot and designed directly for the walls of a specific building chosen by the competing artist. Reid selected the Earlscourt Public Library in Toronto and, using his usual method, he constructed a tiny model of the hall and roughed in miniature pastel studies of the panels-to-be on it.

His theme for the series was "community life," and his specific idea was to show the relative position of learning in everyday life. A communal scene formed the subject of the key panel, and supporting it were panels showing family groups and workers in a garden, a philosopher discussing communal problems, a group listening to a reader, a nature study class and children being told stories in a library. These eight panels were to be linked by restful pastoral and woodland scenes to give unity and continuity to the scheme.

In the summer of 1925, after the studies had been submitted and before his trip north, Reid also decided to turn his hand to house building again. Upland Cottage's lot extended to the northern ex-

AGAWA CANYON , 1926 Courtesy of London Art Gallery , from R.A.McAlister via Art Gallery of Ontario

tremity of Wychwood Park, where it abutted on Alcina Avenue. Twin studio-houses designed in the same style as Upland Cottage, with an Elizabethan treatment of their gables and built of weathered timber, were added to the two studio houses already on Alcina. Completed in the autumn of 1925, each house had a two-storey artist's studio partly enclosed by a balcony patterned on the living room-studio in their own house, and each had a garden of its own.

Upon completion, these new studio-houses were in perfect harmony with Upland Cottage itself and, in years to come, artist Kenneth Forbes was to paint many of his outstanding portraits there and his beautiful and oft-painted wife Jean also produced many of her admirable flower pictures there.

In the autumn of 1923, the R.C.A. awards were announced and, of the sixty artists competing, six were chosen for awards with two thousand dollars divided among them. Reid captured first place; Charles W. Simpson of Montreal, second; and four other Montreal artists received the smaller prizes. That winter, too, Reid painted the panels themselves for Earlscourt in addition to carrying on his college work. Always excelling in figure composition, he portrayed the different aspects of the community's life story with veracity while the continuous sylvan and landscape details captured the pastoral charm of the unspoiled out-of-doors.

With this commission completed, the painter decided to lay out secluded garden plots between the two new studio-houses and Upland Cottage for his flower-loving wife. He also built a porch onto their home and continued it up to the second floor for a glassed-in sunroom. Then, he joined the two studio-houses by a long, two-storey section which included three garages at street level and two extra studios above. Trellises were set into the timbered walls and climbing vines planted to form a background for their sketches and studies.

By the summer of 1926, the completed garden included a circular pool and spraying fountain. Mary Wrinch Reid planted her flowers on a seasonal plan. Irises, daffodils, tulips, and hyacinths of spring gave place to the roses, nasturtiums, pansies, peonies, and petunias of early summer and, in turn to the flaming poppies, sunflowers and asters of early autumn.

Also that summer, Reid and Mary took off on another sketching tour when summer school was over in early August. The couple, with Mrs. Reid at the wheel of their newly acquired second-hand, Model-T Ford, set out to tour Quebec — a favourite sketching ground of hers in years past.

Reaching Belleville on their first night, they had to stay there because the car's cylinders had burned out when oil had leaked out of the engine after a stone hit the stop-cock. Then, with the scored cylinders ground and relined and new piston rings put in, they set out again the following afternoon only to be delayed by a muddy detour along an old railroad bed where they got stuck and had to wait on the side of the road until help came. By the time the car had been pulled out, the bearings were causing trouble and one hub had been broken. After another night on the road, they finally arrived in Montreal and got permanent repairs on the car.

Mrs. Reid had hoped, during this trip, to convert her husband to the beauties of the province which he had known only through Montreal and Quebec City. And, once their car troubles were finally over, Reid did begin to show some enthusiasm for the architecture

and local colour of Quebec as they drove through its characteristic hamlets.

Arriving in Quebec City, they put up at a guest home on the Governor's Garden for a few days of sketching and, from there, they went on to L'Ile d'Orleans. The individuality of that small island, where Reid's contemporary Horatio Walker had painted so many of his famous genre pictures, impressed itself on Reid. For the next week they stayed at Ste. Famille, where they both filled their sketchbooks with numerous picture ideas.

Returning to Quebec City, they toured the district, stopping at various villages along the Beaupré road but, not far from Baie St. Paul, the car broke down yet again. This time, the brake linings had burned out when the car was going down a steep, mud-gutted hill. When they arrived in Baie St. Paul, it was only in time to leave again. Back in Toronto, Reid threw himself into working on his Quebec studies and sketches and that winter turned out more than a dozen easel pictures of rural Quebec.

After this trip, another shift of emphasis became discernible in Reid's choice of medium for sketching, too. As early as the 1880s he had used water colour and pastel for studies and, in 1912, he had joined a short-lived watercolour society formed in Toronto along with Brigden, Greene, Jefferys, Kelley, Manly, Robson and Chavignaud. It had subsequently disbanded but now, in 1926, the new Canadian Watercolour Society was formed with several of the members from the earlier club at the helm and numerous younger artists like Mary Wrinch Reid on board, too. For his Quebec pictures, Reid had turned to watercolours as his chief medium. Possibly his most famous picture of these was the figure piece *Mother and Child* although his heron studies, his scenes in the Governor's Garden, and several of his Algoma landscapes also rank with his best work.

The summer of 1927, the Reids were back in Algoma but this time, they travelled by train as far north as Michipicoten on Lake Superior. Michipicoten — the old port from which iron used to be shipped to the Sault — captivated them with its dock, its quaint Hudson Bay Mission, its rocky points, and its Magpie River. That summer, the government offered artist's shacks to artists at Lowell Lake—five miles south of Temagami Village—and the couple spent a month at the camp. Among the other members of the Ontario Society of Artists who had availed themselves of that opportunity were F.S. Challener and F.H. Brigden. On their way back from Cochrane, Reid and his wife were able to go down into the Lake Shore Mine at Kirkland Lake and sketch before returning to Toronto in early September for the start of school. So enthralled had Reid been with the north that the next few months saw one canvas after another coming from his brush at accelerated pace. These ranged from quiet lake-studded stretches of forest and barren rock to flaming northern sunsets and from expanses of blue sky and metallic water to raging torrents with foaming spray.

It was one of his still atmospheric studies done after their trip

which Reid sent to the fourth annual exhibition of contemporary British art in London, England, in April of 1928. Altogether, eleven oils, one watercolour, one pencil sketch and a bronze statue were displayed there as the Canadian exhibit and, of Reid's *Quiet_Water*, an English critic wrote:

> The English public have come to associate Canadian pictures chiefly with the bold decorative style which is often poster-like ... The influence of the School of Seven is very apparent [in this showing], but quite different treatment is exemplified by George Agnew Reid's "Quiet Water" with its atmosphere of seclusion and mystery but of light instead of gloom.

In this connection, the founder of the Group of Seven, J.E.H. Macdonald, said of Reid:

> While retaining the best traditions of the old schools, with their sound basic principles of drawing, etc., Mr. Reid can appreciate and make use of what the new day has to offer. As he himself confesses, he has a preference for the more solid groundwork of the old, yet at the same time he is willing to admit a mild liking for the "moderns" within reason. Art for life's sake is a guiding principle, rather than "art for art's sake."

In the summer of 1928, the Council of the Ontario College of Art notified Reid that, in appreciation of his long and steadfast dedication to the cause of art education, they had decided to give him a year's leave of absence at full salary. That August, in starting his year of freedom to paint, George Reid and his wife Mary setout for Kirkland Lake on the Ferguson Highway right after the sketching school in Port Hope ended.

To avoid a repetition of their problems in Quebec the year before, Reid had replaced their old car with a new, low-geared Model-A. At Kirkland Lake, however, Reid decided that it would be wiser to take the train to Cochrane and Temagami than to hazard driving over any more almost-impassable rural roads. This year, again, the Honourable William Finlayson (then Ontario's Minister of Lands and Forests) had offered accommodation there to artists who would come to sketch in Northern Ontario. Arriving at their destination, the Temagami Reserve, they found it all their imaginations had hoped, and when they finally returned home in late September, both of them were looking forward to a long winter of painting from the dozens and dozens of sketches they had brought back with them.

But, again, the Canadian north was to be shortchanged that

winter by circumstances. That autumn of 1927, Reid had scarcely settled into his painting when he received a letter from E.A. Hardy, a teacher at Jarvis Collegiate Institute in Toronto:

> Dear Mr. Reid:
> The Principal of Jarvis Collegiate Institute, Mr. J. Jeffries and I have been talking quite a good deal about the possibility of having some decorations in the auditorium here. He would appreciate it very much if you could get in touch with him (Randolph 5678) and perhaps arrange to come over and have a look at the auditorium. He would like to discuss this matter with you at your convenience.
>
> With kind regards,
> Yours sincerely,
> (signed) E.A. Hardy
> (Head of the Department of English and History,
> Jarvis Collegiate Institute, Toronto.)

No matter how great Reid's interest had become in landscape over the past few summers, and how many ideas he had from his most recent trip north, mural decoration came first. And, with history almost as much of a passion with him as painting, his subconscious was already busy thinking up ideas for a decorative scheme suitable for that auditorium. What was more, with the whole winter ahead of him to do it, he could have the panels done and mounted by the time he was due to get back to the college the following autumn. Accordingly, with his usual enthusiasm and his flair for composition, he had (within a short space of time) decided on the theme he would suggest for such a decorative scheme. The subject was to be — initially, it grew larger — the discovery of the New World, a historical sequence that would carry on from Erickson in 1100 to Champlain in 1615.

When Reid met Hardy and Jeffries at Jarvis, Hardy suggested that Reid begin his work with a historical panel for the west side of the assembly hall. Their ambition was to decorate the hall completely but, at present, there was just enough money to finance the painting of one large panel.

"I'm afraid that you are beginning at the wrong end," replied Reid after studying the possibilities of the panelled walls. "I couldn't successfully do one isolated panel for this hall. Mural decoration must be an harmonious whole fitting in with the architectural design and carrying out a sustained motif. I'll work out a scheme for the decoration of the hall free of charge. And then we could choose one panel to do now. By doing that, continuity can be achieved, especially since you have in mind further decorations to be done at a later time."

Hardy and Jeffries agreed with alacrity. Accordingly, Reid began

THE DARK CANYON , 1929 Courtesy of Macdonald Stewart Art Gallery , University of Guelph

work on a tiny model of the great oblong Jarvis auditorium. He had taken the measurements of the hall while there, and he did the model to the scale of half-an-inch to the foot.

For the next few weeks, Reid steeped himself again in Canadian history, studying five different texts. By the time he had completed his research, a unified scheme for the decoration of the room had evolved in his mind, and as each panel became clearly defined in his mind, he sketched it in on the beaver board model and then developed it in oil and wax crayons.

In keeping with Hardy's suggestion, the west wall was the one selected for immediate decoration. The architecture of the school was pillared Renaissance, and the hall lent itself admirably to proportional panelling. That being so, Reid designed four subjects to

be placed between the pillars instead of one large panel. In dimension, each panel would be twenty by fourteen feet and they would include *Cartier at Gaspe, 1535; The U.E. Loyalists Ascending the St. Lawrence, 1783; The Founding of the Hudson's Bay Company, 1868;* and *Mackenzie Discovering the Pacific, 1793.*

The design, when shown to the assembled school board, was accepted as the ideal treatment for the hall, and the west wall panels were commissioned for immediate painting. This assignment was to be undertaken by the artist at a fee of fifteen hundred dollars.

By the following year, the panels were not only painted but mounted.

PART V

THE ARTIST'S METIER

Chapter 21

THE PAGEANT OF THE PAST

After their long and successful Temagami sketching trip of 1928, the Reids decided to go still farther north the following summer. Their destination was the Abitibi Canyon. The Abitibi Company was constructing a dam there and the Minister of Natural Resources, the Honourable Mr. Finlayson, suggested to the Reids that they paint the canyon before it was lost forever in the flooding of the region. So, after spending some time at Lowell Lake again, they took a train north to Island Falls and, from there, the jigger to Abitibi Canyon — seventy-five miles south of James Bay.

Adam Wildgoose, the Scottish engineer who was taking daily measurements of the water levels for the dam project, met them at the jigger and took them in along the corduroy road to the camp. Then they walked in the last five miles along a trail which six months later was to be a narrow-gauge railway bed.

The breathtaking beauty and majesty of the canyon impressed the artists and, as they could only spend three days there, they went to work without any loss of time. Even the mosquitoes and black flies, not to forget the mice that devoured their clothing at night, could not dampen their ardour. While there, they crossed the primitive rope suspension bridge swung over the hundred-and-fifty-foot canyon and climbed up and down cliffs in almost perpetual rain to sketch the different aspects of the spectacular gorge.

From Abitibi, they went to Lake Nipigon and Orient Bay before returning to Toronto about the first of October. This winter, like the one before, Reid could dedicate himself entirely to his art. For, instead of his returning to his post that autumn, the council of the college had notified him that they had found it possible to retire him on pension after his thirty-nine years of teaching in the art school. The title of Principal Emeritus was conferred upon him and a formal banquet held in his honour.

Reid received many tributes from friends and colleagues upon retirement, but of all the tributes made to the artist at that time, none was more valued than the presentation of a poem to him written by Dorothy Herriman, one of the college students at this time. The closing stanza of that lyric was to prove to be prophetic in forecasting that:

CANADA IN HISTORY , 1927-1930 Courtesy of Jarvis Collegiate , reprinted from The Journal, Royal Architectural Institute of Canada , June 1931

In days to come
A proud place be yours —
Who gathered from the old lands
Beauty old and true,
But with a dreamer's vision
Sought new beauty for the new.

ERICKSON DISCOVERS THE NEW LAND ON THE COAST OF NOVA SCOTIA, 1100
Government of Ontario from Dr. J. Peterson

Mural work again called to Reid. With the completion and mounting of Reid's four canvases that spring of 1929 at Jarvis Collegiate, the enthusiasm with which these decorations were received had been so great that the school council now began to talk of raising a fund to continue his work on the *Canada in History* frieze. Thereupon, a campaign was started by the former graduates of Jarvis Collegiate.

Shortly after that, Reid was asked to begin work on the six supporting panels and the great frieze. Among the historical panels, were "Eric, the Red, Discovery of America, 1100"; "Cabot Raising the Union Jack on the Coast of N.S., 1497"; and "Champlain Ascends the Ottawa, 1615". In addition, there were two master panels, symbolic in intent and linking the past with the present: "Patriotism", a scene of jubilant celebration, and "Sacrifice", a tribute to our heroic dead.

Over the top of the gallery, a frieze chronicling discoveries of all time records the names of a hundred and fourteen world-famous explorers, selected and approved by a committee chosen from the school's staff. The Toronto Board of Education had the walls, pillars, and ceiling of the hall redecorated, using the colour scheme proposed by the artist, and even new platform curtains were chosen to harmonize with the decorative scheme, transforming the hall into a complete and harmonious unit. Lorna Claire, an old graduate of the school and Governor-General's Medallist at the Ontario College of Art, was appointed to assist Reid in doing the heraldic designs and the lettering. She also painted an Indian encampment for placing under the gallery.

CABOT DISCOVERS AMERICA, 1497

Between the two Jarvis Collegiate commissions, Reid cleaned and retouched the City Hall murals, done from 1897 to 1899, and gilded the background of the spandrel-figures which had been painted a yellowish ochre.

During this operation, the architect of the building, the property commissioner and some of the aldermen made inquiries about the continuation of the decorative schemes. Reid told them that all the subjects had been chosen in 1897 before he had commenced doing his two panels. The matter of completing the series was considered by the council but, this was in November of 1929, just after Stock-Market Crash which led to the Great Depression, so the matter was again put on hold.

At this time, perhaps inspired by the work he had done at Jarvis Collegiate, Reid developed several historical themes for a series of twelve easel pictures, among which are *Erickson, Cabot, Jacques Cartier, The Arrival of La Salle, Early Discoverers Sailing Uncharted Seas, Champlain, Fur Traders at Montreal* and *The Humber-Lake Simcoe Carrying Place.* These paintings are all nineteen by twenty-five inches in size and, when completed, were uniformly framed as companion pieces.

In the summer of 1930, when Reid had still been working on the Jarvis commission, he and his wife missed their annual sketching trip but, in July 1931, the couple set out again on what was to be a nostalgic trip for Reid.

CHAMPLAIN ARRIVES AT QUEBEC , 1608

With Ottawa first on the agenda that summer, they went on to tour the Ottawa valley. Travelling on to North Bay and Sudbury, they crossed to Manitoulin Island on the causeway and, after touring the island, they took their Model-A on the ferry from South Bay-mouth to Tobermory on the tip of the Bruce Peninsula. From there, they continued down the peninsula to Reid's home county of Huron and on to Wingham to visit Reid's nephew Wilfrid Reid, the son of his oldest brother, John, who had died some time before.

Stopping there, Reid explained to his wife that this house with the gables was the one he had designed in 1877 when he had been apprenticed briefly to an architect in their town. It was the first of at least twenty buildings he was to design, including not only cottages and houses but a Renaissance-style church and the Ontario College of Art itself.

One day as they walked along the shore of the Maitland River with the sun flickering through the trees, Mary Wrinch Reid said:

"This is one of the most beautiful river valleys I've ever seen in Canada. I thought I knew Canadian wild flowers fairly well, but there are some here I've never seen. This spot seems familiar to me, yet I can't place it."

Reid smiled, but said nothing. Then, as they walked on, his wife continued:

"I know. It reminds me of that scene in *The Homeseekers* — the sunlit woods on the other shore there. It might be the very spot."

"It is," replied the artist. "This is the place where I made the study."

That autumn the artists also toured the Ottawa Valley and returned to Quebec. Although Reid had not formerly found the inspiration in Quebec he had in Ontario's northland, this trip gave him many subjects. On the road to Trois Rivieres, for example, they stopped at a roadway construction camp. There they spent several days enjoying the hospitality of the superintending engineer and, at this spot, Reid did his studies for *The Roadmakers*.

It was, however, the morning of their departure that the artists saw Trois Rivieres at its loveliest. In the night three inches of snow had fallen and, as they drove along the winding old road which curved through the woods, the contrast between the white ground and the flaming leaves of the trees and the pointed shapes of the dark evergreens against the bright red of the maples and bronze of the oaks, all covered with flaky snow, was tantalizingly beautiful.

The Jarvis commission and the historical series of the past four years completed, Reid turned back to landscapes that winter. He brought out the unfinished northern canvases and completed several in oil and watercolour. These powerful northern canvases were a high water mark in his life's work as a whole.

Chapter 22

FROM MOVIES TO MURALS

In the winter of 1932-1933, Reid and his wife went one evening to a pseudo-scientific film which had attracted their attention. "The Lost World," as it was called, had also drawn W.A. Parks, Ph.D., the Director of the Royal Ontario Museum of Palaeontology.

After the movie, the three met at the Yonge-Queen car stop. Getting into the crowded streetcar, the men caught hold of the straps and began talking about the picture they had just seen. From the discussion of this weird film, they fell to talking of the prehistoric world and geological questions. Parks, knowing Reid's interest in the subject, told him that he was arranging six show cases for the museum. These would cover the principal prehistoric periods and trace the Earth's early geological development and the evolution of plant and animal life.

It was not long after this that Parks telephoned Reid asking him to come to the museum to see the displays. When he arrived, Parks told Reid he wanted a series of panels to use as backgrounds for these showcases in order to link up the displays of underwater palaeontological specimens.

Reid was keenly interested in the plan and they talked it over with enthusiasm. But, although Reid knew something of the geological past of the world, his knowledge was by no means adequate to execute such a task. To overcome this, he began a course of study at once under Parks's direction. The two of them made a fine team and, during the winter, Reid made sketches and Parks discussed them with him. Each man respected the other's decisions concerning his own field of activity: Reid was in charge of designs as far as aesthetic presentation of the subject went while Parks's had control over all scientific points and the choice of specimens to be used.

The sketches for the cases were accepted by the museum's board and Reid built a scale model of one of the cases and did, in miniature, one of the studies to be developed for the series. With the approval of Parks, he then began the panels proper.

The case panels, completed by the summer of 1933, delighted Parks; and, together with the scientific displays, they give a composite picture of prehistoric life. The first depicts the Silurian landscape with its dust storms during the levelling processes. The embryonic vegetation and piscatory life of the Devonian period and of the Carboniferous age with its tropical marshy jungles follow in the

second and third. The Jurassic, with its huge amphibian and reptilian life was the subject of the fourth, the Cretaceous, with its higher development was the fifth and the Tertiary period, with its incipient mammalian life finished off the series.

One day, just after this series was completed and the cases placed in the palaeontological gallery, C.T. Currelly — who had been a pupil of Parks years before becoming Director of the museum of archaeology — remarked to Parks:

"The idea is wonderful and the panels most successful. The whole thing is right as far as it goes, but it doesn't go far enough. Too much work for too little result. After all, these are only the backs of cases. Why don't you have Reid work out a big mural series for the galleries?"

"Lack of funds is my only reason," replied Parks. "I've had such a scheme in mind for years."

In the spring of 1934, Parks again called Reid to the museum and, this time, he confided to him the idea of having a series of decorative panels for the paleontological galleries.

Reid, for his part, suggested not panels, but a frieze, a connecting frieze running around the two galleries. Parks said that a frieze would be impossible; they just didn't have the money.

Despite this rather gloomy state of affairs, Reid set to work on the frieze idea. He fashioned models of the two connecting galleries and made small sketches for the whole series. He worked on this project for a full year while studying paleontological texts on prehistoric life at Parks's suggestion. Then, in the summer of 1934, he and his wife went to Chicago to the Twentieth Century Exposition, then in its second year. The artist had, by this time, completed preliminary skeleton sketches and he wanted to see the panels done by C.R. Knight in the Graham Bell Gallery of Historical Geology at the Field Museum in Chicago.

Upon their return to Toronto, Reid took his model to Parks who, by that time, was seriously ill. During the next winter, however, the paleontologist was able to oversee the development of the studies for the whole series and occasionally to visit Reid's studio to consult on the work. All this time Parks continued to hunt for a donor to pay for the ambitious decorative project and, finally, J.R. O'Brien, chairman of the council of the joint museums, approached the executors of the Leonard estate asking that part of the estate's bequest be used for this purpose. The executors consented not long before Parks died from a heart attack. Happily, he had lived long enough to be assured that the project of which he had dreamed so long would be completed.

Work on the frieze would not, in fact, begin until 1935. In the meantime, Reid stayed busy with other projects. Reid and his wife went north again to Temagami to paint, spending the month of September in both 1933 and 1934 at the Lowell Lake shack which the government had placed at their disposal. It was after these trips that such significant oils as *Blue and Gold, The Birches, Rippled Water* and *The Path of Light* came from Reid's brush.

THE FORECLOSURE OF THE MORTGAGE, 1892 Courtesy of the National Gallery of Canada

Reid also painted replicas of two famous early pictures: *The Foreclosure of the Mortgage*, and *The Homeseekers. Foreclosure* had at one time, around 1900, been so popular that the artist had become tired of hearing about it to the exclusion of his other work and had taken it off its stretcher and put into storage. In 1905, however, F.E. Galbraith, K.C., an Orangeville lawyer and county crown attorney, had purchased it and, thereafter, it had begun a second round of exhibitions. Shown extensively both in the United States and in Canada, it had been given many and varied press notices — all of them complimentary, especially those in the New York and Brooklyn papers.

Galbraith, who had founded the Galbraith Art Academy on King Street in Toronto and devoted it to free instruction in art, had about 1910 moved permanently to London, England. In 1913, he had asked Reid if he might submit *The Foreclosure of the Mortgage* for hanging in the Royal Academy there. The picture, when hung, was widely commented upon by London critics. One reviewer at this time wrote:

> In the place of honour, for it is hung on the end wall of Gallery IV and commands a vista of five galleries, is "The Foreclosure of the Mortgage," by George A. Reid. It is an elaborate detailed study of a helpless cripple in a chair facing the cool man of business who comes to take possession. There is the tearful wife, frightened little ones, a baby in the cradle, and the aged grandmother, with every detail to emphasize the poignancy of the scene.

During the First World War, the big canvas was again taken off its stretcher and put into storage. After the war, before he had been able to get it out of storage, the warehouse containing Galbraith's complete collection had been burned and this picture, for which he had recently turned down twenty-five thousand dollars, was destroyed.

Reid, after much urging, did, in 1934, repaint the subject from black and white photographic reproductions. And, then just after the new *Foreclosure* had been completed, he learned that C.E. Burden of Toronto had the colour study which he had used for the original. He borrowed it and, on comparing it with the replica, found that there was greater luminosity in the replica than there had been in the original, due probably to the fact that the artist was, by this time, working in a higher key than he had in the nineties. Happily, the vitality of the original, which had been commented upon so widely, was recaptured in this re-creation and many who had seen both pictures were hard-pressed to say which was the greater piece of work.

Reid's other replica done at this time was *The Homeseekers* for

Perkins Bull. Bull had, by the 1930s, begun a special Peel Memorial Collection at Brampton, to which Canadian artists were asked to contribute examples of their work painted in Peel County. Since *The Homeseekers* had a setting not unlike that of Peel County, Bull asked Reid to donate the original to this collection but since it was set into the wall of the artist's studio-workshop Reid decided that he could not part with it. Instead, he painted a replica.

About this time, another of Reid's early paintings, *Music*, came back into the limelight. This was shown at the Toronto Heliconian Club, where it was hung in a conspicuous place at the side of the platform. The Gospel Brethren denomination used the club rooms on Sunday and, when they saw this graceful young male nude dominating their improvised altar, they drew back aghast. Not being able to take the painting down, they scurried about, found great sheets of brown paper and covered the canvas. Each Sunday morning thereafter *Music* was draped and each Sunday night it was uncovered.

Reid, despite his retirement from teaching, continued to take an interest in the work and struggles of young artists. The young artists of Toronto had, for some years, been becoming especially vociferous about the restrictions imposed on them as a result of the selection committees for the R.C.A., C.N.E., and O.S.A. exhibitions. In fact, back in 1926, a no-jury exhibition had been carried out in order that the younger artists would be able to have at least one picture shown at one standard exhibition a year. In 1935, Marion Long, who had been raised to academician status the year before, Mary E. Wrinch and Reid himself headed a committee of established artists who set to work to organize the showing. This committee also included John Byrne, Murray Bonneycastle, Corry Brigden, Grace Coomes, Kathleen Daly, Nicholas Hornyansky, Leonard Hutchinson, Wendell Lawson, Frances Loring, A.A. MacDonald, George Pepper, Constance Pole, Tom Roberts, Tom Stone and Florence Wyle. Three hundred and fifty-two entries in all mediums, varying in price from fifteen to fifteen hundred dollars, filled the gallery provided by the Canadian National Exhibition during the fair. Since all the pictures were hung in alphabetical order, the works of senior artists were often relegated to corners while work of youthful artists were conspicuously centred on the walls. The weather, however, was cold and wet through the two weeks of the exhibition and attendance was low. Consequently, few sales were made even though the press reports were good.

Chapter 23

THROUGH THE AGES

In 1935, Reid went to work on the huge prehistoric canvases. He asked for, and received, scientific co-operation from the staff of the University of Toronto and over the next three years he worked with experts in astronomy, geology, biology, botany and entomology. The scholarly advice he received enabled him to make the series, entitled collectively, *Through the Ages to Primitive Man*, not only an artistic creation but a historical document and, during the painting of this giant series, he showed a zest and vigour unsurpassed even in his earlier work.

The panels told the story of three billion years in the evolution of the universe and furnished a scientific record of the theories accepted in the mid-thirties on the creation and development of the world. The portrayal of the different prehistoric ages was in every detail as accurate as was scientifically possible at the time and every leaf and minute form of life was built up from the study of either actual fossils or photographs of them.

Within a year the artist had completed the first nine canvases. The two introductory panels were "A Typical Spiral Nebula in Ursa Major," which shows the nebula as it revolves in the night blue, and "A Region of the Milky Way Near Orion and Taurus" which shows these two stars against a background of blue and silver and the smoky white of space where numerous well-known constellations appear in definite form. These were followed by the seven astronomical panels, three of which were entitled "The Birth of the Solar System"; three, "The Earth-Moon System"; and one, "Clouds and Rain."

In the trilogy "The Birth of the Solar System," the artist's first panel shows the sun against a diffused blue background dotted by stars as it was in Reid's words, "approached by another star, and tide action begins." In the second panel, creamy white emanations emerging from the molten ball of the sun appeared against the blue of infinite space as "with the closer approach of the two stars, tide action becomes violent." In the final transcript of the unit, "matter thrown from the sun...is seen pouring from the sun, attracted outwards."

Following the same idea, "The Earth-Moon System" shows how this system was formed. The first panel shows the moon to the left high up in space, while the earth, surrounded by a wide halo, appears

CREATION OF THE EARTH , 1934-1938 part of Through the Ages to Primitive Man ,
Courtesy of Royal Ontario Museum , Palaeontological Department , from privately owned pastels

to the left below. In the next panel, "the cooling earth and moon" are depicted with tumbling masses of vapour and gases being thrown off by the earth. In the last of this series "the earth, with its atmosphere and satellite the moon" — now cooled from molten flame to silvery blue — is seen bathing the moon in the sky above it with light.

Concluding the astronomical panels was the narrow upright panel showing "The sun's heat, acting on the earth's atmosphere" and producing the phenomena of massed cumulus clouds, blue-green vapours, yellow sunrays and rain. Then carrying on from there, was the transitional panel "The Primary Ocean," which carried the creation on from astronomical to geological times, revealing how "Early in the earth's development, moisture from the water-laden atmosphere fell and formed the oceanic waters." This is a great marine painting and, in it, the artist has given a powerful presentation of mighty ocean currents and white-capped waves. In depicting this turbulent action, Reid went back to his own 1896 studies of the Atlantic in storm to inject a sense of motion into this reconstruction, which carries the earth's vegetation about five hundred million years ago. This work shows volcanoes and the nuclei of barren continents emerging from seas where "Life began through the Cambrian" — the Cambrian age with its grey rock formations.

Passing from geologic to palaeobotanical times (in "Ordovician Period"), primitive types of life are seen, such as the orthoceras with its tentacles and conical shell. Widespread seas, teeming with shellfish and seaweeds, invaded the continents in this period.

On the North American continent in "Silurian Period," "Primitive water-life continued to develop while almost barren lands were subjected to the ever-present erosional forces and tumultuous torrents of water thundered over a river bed between cliffs of stone." And in the panel "Devonian Period," covering the era which occurred about three hundred million years ago, Reid showed "Shellfish and primitive fish...in the warm waters" as "plant life emerged to spread over lowland areas."

The delicately foliaged tree-ferns and proto lepidonendrons, the curving streams, hills and steaming mists of this time were followed in the next panels by "giant club mosses, typical of the early coal age of Nova Scotia" (in "Lower Carboniferous Time") with its deep vista of greens, blues and browns and trunks of trees on which are reflected the yellow rays of the sun. These were followed by the era, put forth in "Upper Carboniferous Time," when "plants were transformed into coal — three hundred million years after the Precambrian period." The artist depicts these by "widespread swamps with dense plant growth and giant insects" as they existed in eastern North America, England and Europe.

Through the next four successive periods in the life history of the universe, Reid traces the evolutionary processes up to early modern tree and plant forms and to vertebrate animals. In the reptilian era, shown in "Permian Life," bizarre forms of primitive reptiles and "early coniferous trees...typical of [permian life] in North America" are represented in a woodland scene while the great reptiles of the Triassic age are seen amid luxuriant foliage.

In "Jurassic Life," the nature of that world is elaborated by "huge plant eating dinosaurs" which frequented the swamps, "flesh-eaters...among gingkos and cycads" and by reptiles which dominate land, sea and air. "Toothed birds" nesting in gingko trees and seas teeming with ammonites are also represented.

The two restorations entitled "Cretaceous Life" show, respectively, the earliest beech, birch, maple and willow trees and huge dinosaurs, some of which were twenty-nine feet in length, and other "terrestrial life...as found in Alberta, Canada." The reptiles and ammonites, strange flightless birds, and plants approached modern form and, delightful tonal backgrounds in blues, greens, pale gold and pearl place these life forms in the environment in which they developed in ages past.

Passing from reptilian to mammalian life, the artist (in three successive panels) brings the world's calendar up to a million years ago when reptiles were displaced by primitive mammal forms which led to prehistoric man himself. And, in the "Late Eocene Life" canvas, the primitive mammals which "replaced the reptiles of earlier times, and many now familiar plants" appeared while "huge uintatheres move down the cliff...as the small horses of that era watch from the opposite bank" and, on the shore of the lake, herds

of migrating uintatheres are seen as blue hills rise in the distance.

In "Miocene Life," mammals and plants are depicted as having assumed a more modern aspect. Here, the sabre-toothed tiger lies in wait to pounce upon the oreodonts grazing in the meadow and early four-tusked elephants and camels are glimpsed in the background among the trees.

In the panel "Late Pliocene Time," the characteristic life of this geological period in North America is illustrated by a massive elephant with young challenging a sabre-toothed tiger. A stream falls over a cliff and other elephants proceed down the river as a herd of horses stands on the opposite shore and glyptodons move beyond and lead the eye to take in the foliage and the skyline.

Nine successive panels trace the evolution of prehistoric life through the Pleistocene era. This period was introduced by "A tropical scene, similar to the present day, showing ancestors of the chimpanzee and boa constrictor" and then continued with three other animal scenes. In the first of these, the artist presented a prairie-like expanse of country in which "a herd of musk oxen [was] attacked by a pack of wolves along the southern border of the great ice sheet" while in the second and third are seen "the clumsy hippopotamus [which] frequented and wallowed in the swampy jungles" and "the woolly mammoth as they appeared browsing in the woods of Ontario during an interglacial period."

Illustrating the Glacial or Ice Age (the end of the Pleistocene period only fifty thousand years ago) are bison which "though now verging on extinction were among the most abundant mammals of the time," and reindeer which were also "among the animals familiar to the caveman, representations of which are often found in the caves."

The caveman himself is reproduced by the artist in the last three Pleistocene panels. This sequence concluded the frieze with a continuous landscape. In the triptych, "Cro-magnon man and contemporary life of the ice age in Europe are shown," and, in the mouth of a cave — similar to those found in southern France and northern Spain — two men are busy at the carcass of an ibex, while a third points to a herd of woolly mammoths in the stream below the rocky cliff. On the slopes of the opposite hill, herds of horses rush around a point and bears stand at the mouth of the cave as, behind these representations, an ice-cap stretches the length of the canvas.

In the autumn of 1938 the great frieze, which carries through the twenty-four periods of prehistoric life, was completed and, the following year, mounted on the ceiling and walls in the paleontological galleries. The thirty-four panels followed the master plan worked out by the artist and W.A. Parks stood as a concrete realization of the dream which had motivated the first director of the Royal Ontario Museum of Palaeontology. It was the only scientific scheme of such proportions in the country and a perfect symphony in form, colour and design.

These panels were the ultimate combination of art and science. They were the creation of one artist's hand, brain, heart and imagination working in unison not simply with one mind but with the most advanced scientific thinkers of the University of Toronto and the Royal Ontario Museum in the 1930s.

Chapter 24

AN EDUCATOR'S DREAM

In the late 1930s, it was a reconstruction of his own life in Canada's past, not the Creation or the landscape of Northern Ontario which preoccupied Reid. As an example, he set out to make a scrapbook of his own life and work.

Included in this five-hundred-page book of press clippings and reproductions of work saved over sixty years and now arranged chronologically, are original sketches, designs and studies. Approximately fifteen hundred pictures are mounted in this "Book of Reid," and among them, we find pioneer compositions, designs for posters and magazines, small studies which he had saved with the idea of building up compositions around them, original Spanish, French and British small oils, pen-and-ink drawings, watercolours and pastels and the proposed plans made for the decoration of the entrance hall in Toronto's City Hall.

With this reference book completed, Reid also brought out, cleaned and retouched many of the canvases which had accumulated in the storeroom off his studio over the years. This accomplished, the idea struck him that — having been involved in practically every art movement in the country since the 1870s — he should get all that chronicled too. And, at this, he decided he must seek a researcher and biographer to do the job.

That decision led to the commissioning of this official biography, which was completed two years later in 1942. After it was completed, Reid, his wife and his biographer set to work on the catalogue-raisonné of Reid's life work.

By the time the catalogue was finished with its more than one thousand pictures, it became evident that almost half of them were still in his studio and storeroom, so a new project began taking shape in his mind. In the early years of his career (from the 1880s to 1910) Reid had sold practically everything he painted except small studies which he had kept as material for easel compositions and some favourite figure paintings which still hung in Upland Cottage. After he had taken over the running of the art school, however, the only pictures sold — other than mural commissions of course — had been those shown at current art exhibitions and bought at the Reid studio.

He had been too much occupied to bother about sales during his teaching years, and he had never used a commercial art dealer as had so many of his contemporaries. He both gained and lost by not

having turned his pictures over to dealers for sale. He had undoubtedly sold fewer paintings than he would otherwise have done but, on the other hand, the public had not become so accustomed to one kind of work from him that it demanded pictures of only that type, as can often happen to artists.

Apart from this, his only concern had been to be represented in all the current exhibitions. During the years of his large commissions in the mural field, he had made little attempt to sell easel pictures although — in his northern landscapes — he had burst out with an enthusiasm which was unprecedented even in his career.

At all events, when he had begun to go through the storeroom in the late thirties, he had found over one hundred large canvases and three or four hundred small sketches and studies. Now in the 1940s, he decided that something must be done with this aggregation, especially the larger canvases measuring thirty by forty inches and over. Possibly because of his preoccupation with murals, Reid had always preferred to work on large canvases and, for the contemporary private market, large canvases had lost their saleability.

Reid had worked with successive departments of education at Queen's Park from the 1880s and now he decided that the government itself would be the right owner for historical canvases such as *The Coming of the White Man, The Foreclosure of the Mortgage, The Homeseekers, Welcome to Champlain, Niagara, The Discoverers* and *Abitibi Canyon*.

With his plan in mind, Reid visited Queen's Park one day to talk to the Premier. The original idea, the donation of historical works, soon grew into a mammoth project and, within the next two years, the complete transfer of Reid's huge collection was accomplished. These pictures were distributed to schools across the province and, once distribution had been completed in 1944, Premier Drew, with due gratitude for this magnificent gift, wrote to Reid:

Office of the Prime Minister

Toronto 2, May 2nd, 1944

Dear Mr. Reid:

My attention has been drawn to your truly magnificent gift of four hundred and fifty-nine of your paintings. May I express to you the gratitude of the Provincial Government for your generosity and my own appreciation of this public-spirited act which places at the disposal of the people of Ontario such splendid examples of our own native art. The larger canvases will be placed in the Parliament Buildings, where they may be seen and enjoyed by the public. The medium-sized canvases will be sent on permanent loan to the teacher-training institutions. It is proposed to use the collection of small paintings,

watercolours, pastels, etc., to form travelling exhibitions available to the schools of the Province. In this way, it is hoped that the benefits of your gift may be enjoyed as widely as possible. I hope that this disposition of the paintings will commend itself to you. With renewed thanks for your gift to the Province, and with the kindest personal regards, believe me, Sincerely yours,

GEORGE A. DREW

G.A. Reid Esq., R.C.A.
Toronto, Ontario

Chapter 25

ART FOR LIFE'S SAKE

In the speech which Mr. Reid had given at the Ontario College of Art at the time of his retirement in 1929 is found the creed which he had followed from boyhood. In it he described himself as:

> Beginning as a radical in art and a devotee of Eakins of Philadelphia, who, though academic in reality, broke the hitherto hard and fast rule that drawing should precede painting and taught a large school about thirty years to combine the two, the painter modelling in clay as well as painting for the purpose of learning to feel the form from all points of view, and the sculptors painting the appearance of things so that the vision might be refined to the last degree. For three years I studied in this way, drawing with the brush about in the same way that the sculptor feels form with his fingers shaping the clay. I came to realize, however, that this break with tradition was only a trifling matter, and, while a great truth, was only a part of the greater one that no one way to do things is the only right way.

> I have, however, arrived at the belief that all representation in art must rest on some solid foundation, and I would state this to be included in the two aspects of representation: anatomy and perspective. The term anatomy must be made broad enough to cover all forms and their structure, and perspective to include all visual relations of form and their color and tone. I can conceive these factors being used in endless variation to serve the artist for all flights of the imagination.

> In the early nineties, I met the great furor that greeted the doctrine Art for Art's Sake, and denied its validity. About twenty years after it was coined in Paris as "L'Art Pour L'Art," I was overjoyed to find that Caffin, the American art writer, had used the same variation of the expression that I had been

using for many years and named one of his small books on art, *Art for Life's Sake*. I had full confidence and still have that art is a form of human expression and should be untrammelled by specious definition. The ban put on the story or subject picture was the outcome of the doctrine, and the ultra critics condemned all such equally because they said art should not preach or teach. I have from the first rejected such doctrines because I esteem all art expression, from pure illustration to abstract symbolism and ornament as legitimate art.

Appropriateness and right relation seem to be the full and complete requirement for good art, but why demand art which is all good? That being a human impossibility. And what constitutes preaching or teaching in art? These, after all, are only words expressing perhaps a temporary human development. Similarly I have questioned the critic's condemnation of the term, photographic, because human vision and reality are merely corroborative, and the photograph is a corroboration of nature. The use of the things determined by the vision is a matter of purpose in art, and right relation is necessary for coherence and common understanding. Relativity, I believe therefore, to be the great mother truth in art as it is in science.

When Impressionism came I experimented with it, and found it both, as to vision and technique, worthy of respect but only a phase of art to be considered a healthy movement. L'Art Nouveau, also a movement in the full accent of its time in the nineties, was a disturbance of moment. The attempt to depart entirely from historic ornament was too drastic however for suffering humanity to bear, and it died of inanition. Post Impressionism, Cubism, Futurism, Vorticism, Expressionism have arisen of late years as efforts to cast off the academic. Futurists claim that they alone have succeeded, and this by abjuring the static image and giving a mingling set of impressions in one picture. It is confusion, worse confounded. Now although it seems to be a paradox, I wish to say to you that I am both a believer in the academic and in modernism. I claim for the academic the power to grow, because it has the power to assimilate all good thought through research and experiment. The academic was never static, although at times it may appear so. It moves with the

mind of man. When I say that I also believe in modernism, perhaps it is with a slight interpretation. All that is named modernism is not necessarily modern, but only the old cry for something new at any cost. Abrupt attempts to change the course of human thought to attract attention causes art to fly away, leaving only folly as the residue.

Perhaps the most revealing insight he ever gave into his own self was put forth in the following paragraph:

The fine arts should be regarded as the crowning glory of all the arts, equally necessary and useful to man, who in his desire to reach the perfect existence, with the joy of life as the spring of his impulses, draws from nature about him every element possible which will contribute to his pleasure and satisfaction. This is the faith which is within me, but, the difficulty of knowing one's self is so great that it is a very complex matter.

For fifty years out of his then sixty-nine, Reid had been one of the outstanding artists of the country and active in almost every artistic movement which had affected Toronto or Canada since the 1890s. From this vantage, let us glance at the more than a thousand pictures done by him during his professional career and attempt some evaluation. To do this we must take his output over the years according to the categories into which his work fell — mural, genre, figure, historical, portrait and landscape.

First — Murals: In order of importance (by his own choice) Reid's mural decorations must take precedence to all his other works, including as they do at least ten major friezes in Toronto and Ottawa public buildings not to mention overmantel panels and mural schemes done in schools, universities, museums and libraries throughout the province. These commissions carried him from the Toronto City Hall panels and the church and cottage decorations in Onteora Park, New York, to his massive 34-panel palaeontological frieze designed for and mounted in two of the Royal Ontario Museum's galleries in the 1930s.

Second — Genre: Next in importance in his repertoire are his genre representations of pioneering life in the rural Ontario of the 1890s. Although Reid had started out as a portrait-painter in the late seventies and early eighties, it was through his communal life studies that he first came to notice in the art world both in Toronto and at the World and Empire Exhibitions in Paris and Chicago in the early nineties. In London, Paris, Chicago and New York especially, the homely picturesque quality of Reid's genre works, his individualistic style and the special qualities of his interpretation of Canadian life were commented upon widely, for nowhere does one find more candour or simplicity in presentation than in his work.

From *The Flute Player*, with its pre-Raphaelite touch, and *Call to Dinner*, his first genre picture, through *Spinning, Drawing Lots, Resting, Logging, The Story, Forbidden Fruit, The Berry Pickers, Mortgaging the Homestead, Family Prayer, Lullaby* and *The Visit to the Clock Cleaner* to the great *Foreclosure of the Mortgage*, the artist did epics of farm life and family life which are both studies of character and historical records of pioneer Canada. The one that stands above them all, however, is the famous, 1893 Gold Medal winner, *Foreclosure of the Mortgage* which, as late as 1913, was considered in London to be the incarnation of early pioneering life in Canada.

Thirdly — Portraits: Reid's portraits, which had preceded the five other types of paintings in the early eighties were closely associated with his genre work and his historical paintings, especially when they were closely related to the life of the people — his own people in his own country. From the numerous media he used for them, we can see that he had no trepidation (even at the inception of his career) in exploring new fields which caught his fancy or of directly attacking any difficult technical problem which faced him. Those early portrait commissions also served a practical purpose in paying his way to art schools in Toronto and Philadelphia.

Fourthly — Historical: It was the historical theme which truly stirred Reid's imagination, and it was such commissions as the Champlain, Jacques Cartier and First War Munitions series of 1916 that revealed this clearly.

Fifthly — Figure: In sharp contrast to these precise and factual historical constructions is the figure work in which he gave free rein to the strongly romantic but severely disciplined side of his nature. It was in such pictures that his own childhood memories, idealism and dreams found expression. Two characteristics of this figure work are, (i) the fact that these paintings show a thorough knowledge of human anatomy just as his animal studies of still earlier years had shown an intimate knowledge of animal morphology; and, (ii) the fact that the figures themselves stand out with clearly defined outlines against the background almost as if they had been sculpted. The appearance of the third dimension in his painting is traceable back to his modelling in clay while at the Pennsylvania Academy of Fine Arts, and the scientific knowledge of anatomy which marks his figure studies was certainly due to the anatomy lectures and dissection clinics held in the academy there.

It was Reid's figure work, too, which had first brought him notices at the Paris Salon and in New York with such pictures as his *Dreaming, Adagio, A Modern Madonna* and *Evening Star* in the nineties. Furthermore, such improvisations formed the bridge between the work of Reid the easel painter and Reid the muralist.

Sixthly — Landscape: In the 1920s, for the first time in his life, landscape became an end in itself for Reid, a spontaneous response to the scenes of awe and wonder he saw in Northern Ontario. In a sense, it had been his large mural commissions done concurrently

with them which had been the stimulus to lead him into his landscape period. But, with his intimate knowledge of nature, particularly of the Ontario countryside, landscape itself had, early on, furnished backgrounds for his portraits and figure work. Nature had also performed a definite integral function in the mural frieze, leading the eye from one scene to the next and from one time sequence to another.

After his marriage to Mary Wrinch in the early 1920s, his summer holidays had been given over to sketching and exploring his own province beyond the confines of South-Central Ontario, and these new pictures are marked by the imprint of mood, atmosphere and imagination of some of his early figure studies in the nineties.

Reid's early landscapes had been strong, virile and essentially clear-cut, realistic representations of natural beauty. His later works, however, are different. Less tonal or atmospheric than the earlier landscape work, they reveal a possible change in the artist's approach to his subject matter. Contrast and dramatic accent mark them particularly.

Foremost among the landscapes of this decade are *Evening, Montreal River, The Agawa Canyon, Michipicoten Bay, Black Spruces, Cumulus Clouds, Agawa Valley, Trout Brook, The Dark Canyon, Orient Bay, Abitibi Canyon* and the *Snake Fence*.

Of these, the *Dark Canyon* and the 1930 *Abitibi* are the most powerful, but even his early landscapes such as *In the Gloaming, The Village of the Valley* and *Afterglow* are tonal studies of mellow vistas which carry the eye both to and from the focal point of interest in such a way that one feels as well as sees the picture. This power of suggestion in the work of art, the ability of the artist to inspire emotion in the viewer, was the gift of the Impressionists to the art world, and it is the quality which marked the work of practically all the traditional painters of Reid's day. Reid himself had striven always for broad effects and his powers of suggestion and atmosphere had from his earliest days drawn the viewer into the picture or panel to make it live for him or her.

Although Reid's principal achievements were in the oil medium, his use of water colours, began at the age of ten when Young the bookseller gave him his first set of colours and brushes. In the years after that, he had used watercolour less and less but, in the twenties, all that changed when the second Mary drew him into the watercolour society with her. Over the next twenty years, pastel, watercolour, Raffaeli oil (oil crayon) and charcoal as well figured quite prominently in his work.

In Reid's preliminary studies for important easel pictures and mural panels, one sees the artist at perhaps his most idealistic; in improvising them, there is a freedom and spontaneity which is often lost in the easel composition or mural panel with their greater demands for precision and the synthesis of design. But, in whatever medium or field of art in which he was working, his paintings as a whole show clearly his catholicity of taste.

VALE! WYCHWOOD PARK

Almost twenty-five years had passed since the day I lost myself in the vagaries of Wychwood Park on a snowy afternoon in February 1937 when I had first come to interview George Reid about Homer Watson. Now again, I was sitting in front of the big stone fireplace in the inglenook at Upland Cottage.

Over the years, I had dropped in at Upland Cottage whenever I'd been in the city but today — a bleak November afternoon in 1961 — was special for me since I had brought my sons — 15-year-old Michael and 11-year-old Brian — to meet Mary Wrinch Reid. As usual, she urged me to stay for dinner but I felt this would be an imposition with three of us. However, she insisted and, once the boys had gone off to help her get dinner and set the table, I began browsing around the studio and gallery to my heart's delight.

The room was still pervaded by that friendly atmosphere — that feeling of unhaste I had sensed upon first coming into it a quarter of a century before — only, this time, I saw not objects which roused my curiosity but rather artifacts which conjured up memories in my mind. Each article in that studio-living room had a proper niche in the life sagas of George Reid and his two Marys.

My excursion in nostalgia was soon over, however, with the boys reappearing to say that dinner was on the table. After dinner, Mary and I came back to the living room to chat while the boys cleared up the dishes. That done, they roamed through the house hunting up all the pictures and objets d'art they'd heard me talking about for years or, mostly, just keeping themselves amused while we women enjoyed ourselves reminiscing about former days.

Over the next half-dozen years, whenever I was in the city, I would phone Mary and drive up to see her for an hour or two. In those years, I knew it was a great financial struggle for her to keep that enormous house going. But, in devotion to George's memory, she could not fail him. His dream before his death in 1947, had been that the property be maintained as a permanent sketching ground for the students of the college, so she hung on.

The last time I phoned Mary was the autumn of 1978, but it was impossible for me to get up to see her that day. However, I assured her I would be back again within a month and would see her then. She seemed unduly disappointed at that and said in a trembling sort of voice, completely unlike her, "Will you?"

answered and told me the sad news — Mary Wrinch Reid had been buried three days before. My heart sank and I chided myself for being too late in making that last call.

Never had Mary allowed anyone to know her exact age and I, perhaps more than anyone, was completely amazed when her obituary notice informed us that she had been ninety-one years old. That meant she'd been eighty-three years old in 1961 when she'd made dinner for me and the boys — I'd thought she was only in her active seventies then as I am now!

In 1981, when the Ontario Heritage Foundation unexpectedly awarded me an expense grant to bring out new updated editions of my biographies of muralist George Reid and landscapist Homer Watson, my first call was to the Ontario College of Art. There, however, I was told that the college council had sold the Reid's Upland Cottage for use as a private home. The reason given for the sale was that the cost of renovating, modernizing and adapting the house for use by the college would have been $50,000 and, art in Canada is always on poverty row, the college had not been able to make the necessary expenditure. Accordingly, on Mrs. Reid's death, the board had put the house up for sale along with all the art and artifacts therein.

But the sale of the house itself — if sale there had to be — gives us what is almost a happy ending to the story since (under the loving care of its present owner) the house has been restored to its original state. The majority of the art and artifacts including the painter's scrapbooks were either sold or given to the Art Gallery of Ontario and the Guelph and London galleries. The central panel from *Ave Canada*, long a fixture in Reid's studio, was transferred to the National Gallery of Canada and restored at the expense of the Ontario Heritage Foundation. The Ontario College of Art took the money from the sale of Upland Cottage and placed it in a special bursary account for students. Mr. Reid's name has not, as yet, been put on that bursary in recognition of his magnificent gift, but we hope it will still be done.

When I was informed of the exhibition of Reid's historical work being held at the Art Gallery of Ontario in August 1986, it was my hope not only that this biography would appear by late August this past summer but also that reproductions of Reid's outstanding mural decorative schemes would become available to the public at the same time. Reid himself always considered his figure and mural work as his true milieu and a search was undertaken to locate publicly owned Reid pictures and murals. Accordingly, the galleries and the owners of his five major decorative series were approached in the hope that they too would have brochures of their murals ready for display and sale at the A.G.O. exhibition. Those five institutions and the works they had were:

(1) The New York State Onteora Club series 1905-1910;

(2) *Hail to the Pioneers* — the plan for the abortive Toronto City Hall series 1897-1899;

(3) *Community Life* 1925-1926 — Earlscourt Public Library, City of Toronto;

(4) *Canada in History* 1927-1930 — Jarvis Collegiate

Toronto; and
(5) The mammoth 34-panel creation of the universe,
Through the Ages of Primitive Man 1934-1938 — Royal
Ontario Museum, Toronto.

Of these, we discovered that the Onteora Club murals have been carefully preserved as have the Jarvis Collegiate series, both of which had been commissioned directly from the painter and both of which have recently been restored. The Toronto City Hall panels have survived but have not yet been restored. There the happy story ends, since, when approached on this matter, the Toronto Library Board reported that:

> In the remodelling estimates of the Earlescourt Branch Library, the (Metropolitan) Toronto Public Library Board's Library and Finance Committee on November 13, 1963 passed the resolution that:

> All walls plastered and painted off white semi-gloss except end walls in both libraries which are to be warm beige. All woodwork to be painted out with the walls. The present murals to be painted out.

In fact, even the pastel studies for the series done by the artist have been mislaid or lost.

Before the destruction of the frieze, the board had at least published photographs of the series in a historical circular as a permanent record of the commission, and I am still hoping that a descriptive brochure will yet be published for distribution.

In spite of that Earlscourt Library disappointment, the one series which I had expected would certainly have been preserved intact was the thirty-four-panel series at the Royal Ontario Museum. This was Reid's magnum opus and the crowning achievement of Dr. Parks' lifetime of research.

When I wrote the museum for permission to reproduce the series in the official life of the painter, however, their reply was as follows:

> The complete studies of *Through the Ages of Primitive Man*, in oil to scale are in the Archives. Since the renovation of the Royal Ontario Museum the thirty-four panel murals are not accessible at this time. Nineteen have been conserved and stored, but the remainder could not be taken from the walls and have been covered.

Among the covered panels are parts of the early geologic Earth-Moon segment of the *Creation of the Earth* series but, luckily, photographs of seven of the 1932-1934 original pastel studies from which they were painted have been provided from private collections. They will be found along with the other historical and prehistoric panels in this

160

biography. It is a comfort to know that somewhere, sometime, at least the fifteen fossil and dinosaur pictures may be yet resurrected and displayed as they should be.

In one of Reid's scrapbooks, there is a booklet with descriptive paragraphs written by the artist and photographs of the entire frieze as it was in 1938 when he had finished mounting the panels on the walls and ceilings of the galleries. This could be brought out for general circulation.

After the Earlscourt Library and Royal Ontario Museum disappointments, I was overjoyed two years ago to find that at least one educational facility in Toronto was mindful of the historical and artistic merit of Reid's work. Jarvis Collegiate has not only retained the *Canada in History* mural series, its Old Students' Club had it restored and refurbished for the school's one hundred and seventy-fifth anniversary.

The Ministry of Education was unable to finance the photographing of this series for reproduction but happily, photos of the originals, replete with descriptions done by the artist, were discovered in the microfilm of the frieze in the Reid scrapbooks by a curator at the National Gallery of Canada, Charles Hill. The brochure including them was a copy of an article written by Reid for the Architectural Society of Ontario in 1938 and could still be reproduced by the A.G.O. — they have photographs of the originals in their Archives.

Even now, as this book is appearing, I am getting leads from week to week on the whereabouts of Reid's pictures and murals to swell the catalogue listings.

I hope that this partially updated list of Mr. Reid's publicly owned pictures will inspire some of the new generation of scientific art historians to undertake the serious study of the artist's work as a whole. The scope of G.A. Reid's vision and the magnitude of his contribution to the art and educational life of the country places him in a prominent position in our country's history.

CATALOGUE RAISONNE OF THE WORKS OF G.A. REID, R.C.A.

PART I

Updated List of Publicly-Owned Pictures Accessible for Viewing

Mr. Reid, in going back to his scanty old records, exhibition-catalogues and the "recesses of memory" discovered to his surprise that he had sold more than five hundred pictures over the years. These were in addition to the half-dozen major mural commissions he had done, the 454 pictures donated to the Ontario education department, and the pictures still in his collection. It is of this accumulation that he wrote:

> Had I known through the course of my life that I should be called upon for an accounting, I might not have become such a trial to my biographer, Miss Muriel Miller, who has so deftly fitted together the puzzle called my life. The story is here released, with skill, cleverness and an understanding mind, from the tangle of memories by which it was bound. When Miss Miller began the course of her search for accurate memoranda on the cataloguing of my work, I found myself at a loss to produce records which anything like approached completeness. Due to the variety of enterprises in which I have been actively interested, I had never taken time to make notes of the passing of my pictures into other hands. The only methods of dealing with the situation in which we found ourselves were reference to exhibition catalogues and my probing into recesses of memory — the latter, after the lapse of so many years, proved to be a somewhat elusive undertaking. Miss Miller's great ability for literary organization and her inexhaustible patience have resulted in the following lists and, for the omissions, I can only ask the forebearance of owners whose paintings have been

left unlisted and hope that they will notify us concerning their pictures so that the omissions may be rectified in the next edition of the biography.

Sincerely yours,

G.A. REID
Wychwood Park, Toronto

Implied in this letter from the artist is copyright- permission for subsequent editions of the biography the purpose of which was implicit. With Mr. Reid and his artist-wife Mary E. Wrinch being such private persons, it was not Mr. Reid's wish that certain personal matters be made public during his lifetime.

Included in these reservations was his gift of the work of half- a-lifetime to the Province of Ontario which the three of us had just completed cataloguing in 1942. Also, certain very pertinent and historically valuable facts from the private lives of himself and his English and American Marys were to be inserted "in the next edition of the biography." So, in bringing out this new edition of the artist-commissioned biography of the painter, this implied copyright- permission given by Mr. Reid was re-stated by the Trustees of his and his wife's estates. In 1985, too, the pictures remaining in the collection were donated to Canadian galleries and public institutions insofar as they have been traceable after more than forty years. And the artist's copyright-permission has been granted to me and my publisher for reproduction from the originals. To quote from the current Trustees of the Estate of George A. Reid, copyright permission was extended as follows:

To Muriel Miller,
1228 Kenneth Ave.,
Peterborough, Ont. K9J 5P9

Re: Copyright G.A. Reid and Mary E. Wrinch

On behalf of the estate of Mrs. Rheta Conn we grant pemission to Muriel Miller and her publisher to reproduce pictures from art work donated by Gordon and Rheta Conn.

Sincerely,
Mr. & Mrs. Karstoff,
Trustees of the Estate of Mrs. R. Conn
June 18, 1986

As in the original edition of the biography, ownership of the privately-sold and commissioned-works by the artist in private collections still remain unchanged in the present catalogue-raisonne as the

historical records they are. But, in working up the new edition of my Reid and Watson official biographies, it struck me that the present whereabouts of as many pictures as possible by the artists which are accessible to the public should be given in their present locations. In attempting to provide such a list, form-letters were sent to the client-galleries affiliated with the National Gallery and all public owners listed in the original Reid edition.

The response I received from the galleries was phenomenal with so many of them showing real interest in the venture. I want to thank the curators and their staffs for making it possible for me to prepare an updated list of at least part of the publicly-owned Reid paintings across Canada and in New York State. Not simply, in fact, did the galleries co-operate wholeheartedly in this matter but the business establishments, clubs, and societies approached also made searches of their premises. To them all, I give my thanks.

UPDATED LIST OF PUBLICLY-OWNED REID
PICTURES ACCESSIBLE FOR VIEWING

**BRAMPTON CENTENNIAL SECONDARY
SCHOOL**, Brampton, Ontario
The Homeseekers Fording the Credit River
72 x 108" 1934

MACDONALD STEWART ART GALLERY,
Guelph, Ontario
Champlain Dreams of Way to Cathay
40 x 50" 1931
Dark Canyon
40 x 40" 1929
　　　　(From artist, 1943)
Golden Autumn
40 x 50" 1936
　　　　(From Ontario Agricultural College)

DELTA COLLEGIATE, Hamilton, Ontario
Harvest 34 x 80" 1892

MCMASTER UNIVERSITY, Hamilton, Ontario
Call to Dinner
72 x 108" 1887
　　　　(From C.R.T. Patterson to Moulton
College, Toronto)
ART GALLERY OF HAMILTON, Hamilton,
Ontario
Paintings in Oil
Forbidden Fruit
31.1 x 49.2" 1889
　　　　(Gift of the Women's Committee)
Portrait of Mrs. G.A. Howell
24.5 x 18.3" 1921
　　　　(Gift of Oriana Investments Ltd.)
Study in the Park (framed with 4 other paintings)
2.8 x 3.9" 1889
　　　　At the Window
4.1 x 3.8"
　　　　　Studio Study
2.9 x 2.4"
　　　　　Landscape
5.2 x 4.2"
　　　　　Early Autumn
4.2 x 4.2"
　　　　(From Mr. and Mrs. J.A. McCuaig)
Study of a Woman/Portrait
20.4 x 22.2" 1889
　　　　(The Galbreaith Collection, permanent
loan)
Other Mediums
Birches Herridge Lake (print/etching)
9.1 x 12.1" 1930
Edge of the Wood
10.7 x 13.4"
In the Luxembourg Gardens (print/etching)
12.5 x 15.1" 1931
　　　　(From Mr. H.G. Smith, 1966)
Island of Pines (print/etching)
6.1 x 4.7"
Island of Pines (print/etching)
7.7 x 8.9"
　　　　(Donated by Society of Canadian Painter-
Etchers and Engravers)

Lake Temagami (print/etching)
15.8 x 12.8" 1933
Le Petite Eglise, Isle d'Orleans (print/etching)
13.6 x 20.7"
　　　　(Anonymous Gift)
Lombardy Poplars (print/etching)
7.1 x 5" 1909
Moonlight (print/etching)
12.72 x 15.9"
　　　　(From Gordon Conn-Mary E. Wrinch
Trust, 1969)
Moonlight (print/etching)
10 x 12"
Mother and Child
15.3 x 11.4"
　　　　(Gift from Gordon Conn)
On the Bridge (print/etching)
12.7 x 15.04"
Prospectors (print/etching)
12.8 x 15.4" 1928
Prospectors (print/etching)
12.8 x 16.8"
Red Pines, Lowell Lake (print/etching)
14.6 x 11.7" 1939
Rocks and Pine (print/etching)
6 x 4.5"
Shingle Making (print/etching)
12.4 x 15.9"
The Bend of the River (print/etching)
12.2 x 14.81930
Twilight (print/etching)
10.7 x 13.5" 1921
　　　　(Gift of Mr. John Morris Thurston)
Twilight in Algoma (print/etching)
12 x 10.6" 1927
Twilight in Algoma (print/etching)
17 x 12.8" 1933

AGNES ETHERINGTON ART CENTRE, Queen's
University, Kingston, Ontario

Mrs. Oliver Mowat
39.7 x 28.5" 1890
　　　　(From Mrs. R. Fraser)
Tannerville, Catskills
8.1 x 9.2" 1912
　　　　(From Gordon Conn Trust)

KITCHENER-WATERLOO ART GALLERY,
Kitchener, Ontario

The Prospectors (etching)
10.2 x 12"
　　　　(from Gordon Conn Trust, 1962)

Untitled (drypoint)
14.4 x 11.5"
　　　　(From Gordon Conn Trust, 1962)

LONDON REGIONAL ART GALLERY, London, Ontario
Paintings in Oil
Adam Reid
24.4 x 23.1" 1886
Agawa Canyon
67 x 36.6" 1926
　　　　(From Art Gallery of Ontario)
Canada Receiving the Homage of her Daughters
24.4 x 73" 1904
Discoverers Sailed the Uncharted Sea
30.5 x 21.8" 1930
Mrs. Adam Reid
24.4 x 23.1" 1886
Nude Leaning on a Stool
24.3 x 14.2" 1889
Nude Study
24.4 x 18.3" 1896
Portrait of a Model
24.4 x 20.3"
Portrait of Mary Hiester Reid
24.4 x 18.3"
　　　　(From Mary Wrinch Reid through Mr.
Gordon Conn, 1950)
Rippled Water, Temagami
40.6 x 30.5" 1931
Seated Nude Study
29.5 x 15.2"
Self Portrait
20.1 x 16.2"
　　　　(From estate of Mrs. Mary Wrinch Reid,
1970)
Study for Toronto City Hall Mural (4 panels) 1897
Study for Mural "Science"
30.3 x 40.6" 1896-7
Study of Head and Torso
20.3 x 14.2" 1889
The Bather
20.3 x 16.2" 1936
The Flute Players, 1886
24.4 x 18.3" 1944
Other Mediums
Hattie (charcoal)
13.7 x 9.2" 1880
Northern Lake (etching)
12.2 x 10.2" 1938
　　　　(From the Print Fund)
Study for Entrance Mural, Toronto City Hall
(collage)　　8 x 65" 1897
　　　　(From Mrs. Mary Wrinch Reid through
Mr. Gordon Conn, 1950)
Twilight on the Agawa (etching)
12 x 10"　　1933

NIPISSING UNIVERSITY COLLEGE ART COLLECTION, North Bay, Ontario
Paintings in Oil
Brown and Gold
24 x 48"　　1908
In the Orchard
16 x 20"　　1920
Indian Honeymoon
53 x 40.5" 1914
The Berry Pickers
50 x 66"　　1890
White Birches, Northern Lake
18 x 24"　　1929
Wine Bottle

O'NEILL COLLEGIATE AND V.I, Oshawa, Ontario

The Coming of the White Man (chalk pastel)
12 x 18"　　1912

PUBLIC ARCHIVES, Ottawa, Ontario

Arrival of Champlain at Quebec, 1608 (crayon)
17 x 24.5" 1909
Champlain (pastel)
25 x 30"　　1916
Fur Traders at Montreal (pastel)
17.75 x 23.75" 1916
Fur Traders at Montreal
18 x 24"　　1915
Jacques Cartier Erects a Cross, 1534 (pastel)
19.5 x 26" 1916
Lamplight Watch (pencil/crayon)
6.8 x 5"
The Return of the Indians from the Massacre at Long
Sault on the Ottawa, 1660 (crayon)
20.5 x 24.5" 1916

NATIONAL GALLERY OF CANADA, Ottawa, Ontario

Paintings in Oil
Adagio　　30 x 50"
　　　　(From Bernard D. Kane, New York, 1978)
Afterglow 22 x 40"　　1906
　　　　(From the artist, Toronto (R.C.A.), 1908)
Agawa River, Algoma
30 x 25"　　1945
　　　　(From Mary Wrinch Reid, Toronto, 1965)
Armistice Day, Toronto
48 x 66.25" 1918
Casting 9.2-Inch Shell Blanks
24.75 x 30"
Charging and Running-Off Electric Furnaces
48 x 66"　　1918
Charging Open-Hearth Furnaces
25 x 30"
Copy after Velazquez, Portrait of a Dwarf with a Dog
56 x 42"　　1896
　　　　(From Mr. and Mrs. Michael Bonnycastle,
Toronto, 1980)
Dreaming 64 x 48" 1889
　　　　(From Royal Canadian Academy, 1890;
exhibited Salon, 1895)
Forging 6-inch Shells, Toronto
48 x 66.13"
Forging 9.2-Inch Shells
48 x 66"　　1918
Head of a Man
7.25 x 6.5" 1889
　　　　(From G. Blair Laing Ltd., Toronto, 1964)
Mortgaging the Homestead
50.5 x 83.5" 1890
　　　　(Royal Canadian Academy, Diploma
Work, deposited 1890)
Portrait of Mary Hiester Reid
30 x 25"　　1885
　　　　(From Mary Wrinch Reid, Toronto, 1965)
The Foreclosure of the Mortgage
6.75 x 10" 1892
　　　　(From Robert Burn Bond, Toronto, 1965)
The Village in the Valley
30 x 40"　　1914
　　　　(From the artist, Toronto, R.C.A. 1914)
The Arrival of Champlain at Quebec
73 x 109.5" 1909
　　　　(From the artist, Toronto, 1909)
Vacant Lots
22 x 36　　1915
　　　　(From the artist, Toronto, R.C.A. 1915)
Women Operators
48 x 66.25" 1918

Other Mediums

Algoma Lake (watercolour)　　14 x 30" 1926
　　　　(From G.A. Reid, 1927)

Armistice Day, Toronto (pastel) 24 x 18.25"
1918
Armistice Day, Toronto (pastel) 11.8 x 13.6"

Lowell Lake, Temagami (watercolour)
20 x 14" 1930
 (From G.A. Reid, 1930)
Munitions and Munition Workers (pastel)
 1918
 (19 studies; 17 here)
 Casting Steel Billets 11.8 x 13.5"
 Charging and Running-Off Electric
Furnaces 11.8 x 13.75"
 Charging Open-Hearth Furnaces
11.8 x 13.6"
 Forging 4-Inch Shells 11.8 x 13.75"
 Forging 6-Inch Shells 11.8 x 13.75"
 Forging 9.2-Inch Shells
11.8 x 13.6"
 Moulding 4-Inch Shells
11.8 x 13.75"
 Nose and Tempering 75 mm. Shells
11.75 x 13.8"
 Nose and Tempering 75 mm. Shells,
Hamilton 11.8 x 13.75"
 Nose-Boring 9.2-Inch Shells, Toronto,
11.75 x 13.8"
 Nose-Boring and Cutting Off 9.2-Inch
Shells, Toronto 11.8 x 13.6"
 Ore Piles and Smelting Furnaces
11.8 x 13.6"
 Rolling Steel Billets 11.8 x 13.6"
 Shell Piles 11.75 x 13.75"
 Shipping Room for 6-Inch Blanks
11.8 x 13.75"
 The Heat 11.8 x 13.6"
 The Merry-Go-Round: Placing Plug in
Base of Steels 11.8 x 13.75"
 (From Canadian War
Memorial, Ottawa)

ART GALLERY OF PETERBOROUGH, Peterborough, Ontario

Paintings in Oil

A Spanish Castle 40 x 50" 1926
Magpie Falls 16 x 20"
1936
 (From Peterborough Teacher's College,
1973)
The Village Byway 30 x 40" 1915
Winter Sunset 18 x 24"
1915

LAURENTIAN UNIVERSITY, Sudbury, Ontario

Lake Algoma 12.2 x 14.1"
 (Donated anonymously through Ontario
Heritage Foundation)

ART GALLERY OF ONTARIO, Toronto, Ontario

1917
41 x 52.25" 1917
 (Gift from Canadian National Exhibition
Association, 1965)
Decorative Panel (The Stony Stream)
26.5 x 142.5" 1911
 (Gift from Gordon Conn-Mary E. Wrinch
Trust, 1970)
Decorative Panel (Symphony in Greens)
20 x 144" 1909
 (Gift of the Gordon Conn-Mary E. Wrinch
Trust, 1970)
Gossip (The Spinners) 60 x 40"

1888
 (Gift of the Academy of Medicine,
Toronto, 1964, from J.F.W. Ross Collection) Head of
a Woman 13.75 x 9.5"
 (Gift of Mary Wrinch Reid, 1957)
Mary Heister Reid 30.25 x 25.5"
1898
 (Gift of Mary Wrinch Reid, 1954)
Mother and Baby 7.5 x 6"
 (Gift of Mary Wrinch Reid, 1957)
Notre Dame, Paris 9.2 x 13.5" 1888
 (Purchase, 1983)
Nude Study 15.75 x 12.5"

 (Gift of Wm. A. Drake, Roche's Point,
Ontario, 1968)
Portrait of William Chin 40.2 x 30.3"
1911
 (Gift of G.A. Reid to commemorate
Chin's long
 association with the Grange, 1934)
Ragged Birches 40.25 x 30.25"
1929
 (Gift of the Government of the Province
of Ontario, 1972)
Self-Portrait 36 x 30"
1936
 (Gift of the Reuben Wells Leonard Estate,
1966)
Self-Portrait 36 x 30"
1936
 (Gift of Mary Wrinch Reid, 1954)
The Blue Print 40 x 30"
1919
 (Gift of the Canadian National Exhibition
Association, 1965)
The Old Orchard 17 x 21.25"
1935
 (Gift of the Gordon Conn-Mary E. Wrinch
Trust, 1970)
The Pink Tree 14 x 11.9"
1900
 (Gift of Mary Wrinch Reid, 1954)

The Rye Field 17.75 x 24"
1893
 (Gift of Mary Wrinch Reid, 1954)

Twenty-One Oils from the G.A. Reid Scrapbook
 Studies for Decorations (Weston Town
Hall)
 (Volume I, Reid Scrapbook,
page 98)
 Study Portrait in the Colarossi Academy
12.7 x 10.7" 1889
 (Volume I, Reid Scrapbook,
page 128)
 Composition Julian Academy, Paris
9.8 x 12.8"
 (Volume I, Reid Scrapbook,
page 129)
 The Sword of Demacles, Julian Academy
10.2 x 16.2"
 (Volume I, Reid Scrapbook,
page 130)
 Cluny Museum, Paris, 1888
5.8 x 4.6"
 (Volume I, Reid Scrapbook,
page 140)
 Cluny Museum, Paris, 1888
6.8 x 4.8"
 (Volume I, Reid Scrapbook,
page 140)
 Mrs. Parten, Ontario, 1892
7.1 x 4.8"
 (Volume I, Reid Scrapbook,
page 175)

Sketch portraits of GAR and MHR
22 x 36"
 (Volume I, Reid Scrapbook, page 228)
 (pictures never returned)
Central Figure of Canada
12.4 x 9.4"
 (Volume I, Reid Scrapbook, page 275)
Study for larger picture (Sherp) 5.3 x 5.9"
 (Volume I, Reid Scrapbook, page 296)
Oil Study 5.8 x 8.4
 (Volume I, Reid Scrapbook, page 297)
 Gift of Mary Wrinch Reid to
 the E.P.Taylor
 Reference Library, 1957,
 transferred to
 the painting collection, 1982)
Yellow Woods
12 x 14" 1938
 (Gift of Mary Wrinch Reid, 1954)

Other Mediums

Autumn (watercolour)
5.6 x 35.6" 1901
 (Gift of the Gordon Conn-Mary E. Wrinch
 Trust, 1971)
Autumn Light (pastel)
11.6 x 13.5" 1939
 (Gift of Mary Wrinch Reid, 1969)
Evening Clouds (watercolour)
5.6 x 36" 1901
 (Gift of the Gordon Conn-Mary E. Wrinch
 Trust, 1971)
Portrait of Mary Wrinch Reid (pastel)
23.4 x 17.4" 1944
 (Gift of Rheta and Gordon Conn,
 Richmond Hill, 1975)
Study for Decorative Panel, "Music" (chalk)
16 x 5.75" 1906
 (Gift of Mary Wrinch Reid, 1954)

GOVERNMENT OF ONTARIO, Toronto

A Summer Reverie
36 x 22" 1903
Arrival of La Salle at Mouth of the Humber River, 1681
19 x 25" 1930
Cabot Discovers America, 1497
19 x 24" 1927
Cartier Discovers the St. Lawrence and Reads a Charter
 From New Testament to Assembled Natives, 1534
19 x 25" 1929
Champlain Arrives at Quebec, 1608
19 x 25" 1932
Champlain Writes Memoirs in the Great Bear Lodge while Men Sleep with their Feet Towards the fire
19 x 25" 1908
City and Country
30 x 36" 1893
Discoverers (7 panels)
48 x 96 x 20" 1930
 (Gift from Sigmund Samuel, LL.D., Toronto)
Erickson Discovers the New Land on the
 Coast of Nova Scotia, 1100
19 x 25" 1930
Jacques Cartier Erects a Cross
19 x 25" 1930
Landscape
11.5 x 10.5 1887
Reading (pastel)
24 x 18" 1900
The Short Portage - The Carrying Place, La Salle on the way over the Humber River to Holland River

and on to Lake Simcoe
11.75 x 34.5" 1930

CENTRAL HIGH SCHOOL OF COMMERCE, Toronto, Ontario

1917 (pastel)
19 x 25" 1917

CORPORATION OF THE CITY OF TORONTO, Toronto, Ontario

Hail to the Pioneers
7' x 17' 1897-9

EARLSCOURT PUBLIC LIBRARY, Toronto, Ontario

Community Life (9 panels)
1925-6
Cultivation of a Garden
8 x 15'
Family Group
8 x 7.5'
Family Group
8 x 7.5'
Nature Study
8 x 20'
Philosopher
8 x 20'
Sylvan Landscape
8 x 70'
The Community
8 x 30'
The Reader
8 x 20'
The Story Hour
8 x 30'
Community Life (pastel)
14 x 12" 1925

JARVIS COLLEGIATE, Toronto, Ontario

Canada in History, (12 panels) 1927
An Indian Encampment
Cabot Raising the Union Jack on the Coast of Nova Scotia, 1497
Canada in History
Cartier at Gaspe, 1535
Champlain Ascends the Ottawa, 1615
Eric the Red, Discovery of America, 1100
MacKenzie Discovering the Pacific, 1793
Patriotism
Sacrifice
The Discoverers
The Founding of the Hudson's Bay Company, 1668
The U.E. Loyalists Ascending the St. Lawrence, 1783

METROPOLITAN TORONTO LIBRARY BOARD, Toronto, Ontario

Toronto Bay, 1886
21 x 53" 1887
Canadian National Exhibition, No. 1
12 x 14" 1921

ONTARIO COLLEGE OF ART, Toronto, Ontario

G.A. Reid, Self-Portrait
20 x 16" 1936
J.P. Murray
20 x 16" 1936
J.E.H. MacDonald, R.C.A.
20 x 16" 1936

ROYAL ONTARIO MUSEUM, Toronto, Ontario

Portrait of Charles Trick Currelly
1935
Six Ages of Palaeontology (panels)
473 x 69.25" 1934
Six Ages of Palaeontology (pastel)
30 x 34.5" 1934
W.A. Parks (pastel)
24 x 18" 1934
Through the Ages to Primitive Man
 (34 mural panels forming continuous
 frieze around two galleries)
30 x 144' 1934-8
A Spiral Nebula
The Milky Way
Birth of the Solar System, Nos. 1-3
The Earth-Moon System, Nos. 1-3
Clouds and Rain
The Primary Ocean
Primeval Time
Ordovician Period
Silurian Period
Devonian Period
Lower and Upper Carboniferous Time, Nos. 1-2
Permian Life
Triassic Period
Jurassic Life, Nos. 1-2
Cretaceous Life, Nos. 1-2
Late Eocene Life
Miocene Life
Late Pliocene Time
Pleistocene Life, Nos. 1-9
Through the Ages to Primitive Man
 (34 studies in oil to scale)
1937

UNIVERSITY OF TORONTO, Toronto, Ontario

Family Prayer
40 x 50" 1891
Music
91.8 x 28.3" 1899
Professor William Arthur Parks
40 x 30" 1936
River at Dusk (watercolour)
11.8 x 18.5" 1900

ART GALLERY OF WINDSOR, Windsor, Ontario

Algoma Country-Sketches (3 pencil sketches)
Book of mounted pencil and ink sketches and
studies
 (Gift from Mrs. G.A. Reid, 1961)
Cap Tourmonte, Quebec, 1926 (ink and wash)
10 x 13.75" 1926
Cathedral, Quebec City (pencil)
13.25 x 8.75"
Cobalt (pencil)
12 x 10"
Cobalt-Bilskery (pencil)
8.5 x 11.75"
Decorative Landscape (etching)
4 x 11" 1914
End of Day (etching)
5.5 x 8"
Finlayson Point - Lake Temagami, 1928 (pencil)
7 x 12" 1928
Five Studies for a Mural (paintings in oil)
15 x 52"
 (From Gordon Conn, Toronto, 1959)
Isle of Orleans, Quebec (pencil)
5 x 12.25"
Landscape (untitled etching)
10 x 12"
Moonlight (etching)
10 x 12"

Northern Ontario Village (etching)
9 x 12"
Northern Shack (etching)
9 x 12"
Northern Tree (crayon)
12 x 9.75
Oxen and Driver, Ile d'Orleans (pencil)
5 x 12"
Rocks and Pine (etching)
5.75 x 4.5"
Shingle Making (etching)
8 x 10"
Small Industry - Northern Ontario (crayon)
8.5 x 11.75
Sparse Landscape (pencil)
10 x 11.75"
The Bend in the Stream (etching)
7 x 10.25"
 (Gift from Mrs. Reid, 1959)
The Edge of the Wood (etching)
7 x 10.5"
The Prospectors (3 small pencil sketches)
The Prospectors (etching)
8 x 10"
Three Drawings (pencil study for mural)
12 x 19"
 (From Mrs. G.A. Reid, Toronto)
Three Figures (charcoal)
23.5 x 18.5
Twilight in Algoma (etching)
8 x 10" 1934
Twilight on the Agawa (etching)
10 x 12"

WINGHAM LIBRARY, Wingham, Ontario

Algoma Canyons (pastel)
Indians Bartering Furs Outside Fort Montreal (oil)
20 x 16" 1902
The Cow Pasture (oil)
14 x 10" 1925
The Pink Apple Tree (pastel)
14 x 12" 1900

GLENBOW MUSEUM, Calgary, Alberta

At the Window
32.4 x 40.8" 1888
Study of a Head
11.6 x 13.4" 1889

**CONFEDERATION ART GALLERY, Charlot-
tetown, Prince Edward Island**

The Newsboy
19.6 x 13.5" 1880

CANADA HOUSE, London, England

Logging
44 x 72" 1889

McCORD MUSEUM, Montreal, Quebec

Autumn and Winding Stream (oil painting)
7 x 18" 1910
Hay Wagon, 2 Horses (engraving)
Letter Book
1886
 (From T.R. Lee)
North Ontario Farm (engraving)
1936
Oxen Ploughing (engraving)
Pioneer Shingle Makers (engraving)
Portrait, James de Mille (engraving)
Sketchbook of G.A. Reid
2.8 x 2.25" 1888

(From Gordon Conn, 1966)
Vaughan Bath Room Decorations (pencil and wash)
1936

NORMAN MACKENZIE ART GALLERY,
University of Regina, Regina, Saskatchewan

Dawn
30 x 40.2" 1925
 (Gift of Regina Council of Women)
Mitchell Lake, Algoma
29.6 x 40" 1926
 (Gift of Regina Women's Educational
 Club)

NUTANA COLLEGIATE, Saskatoon, Saskatchewan

Goldenrod
30 x 40" 1924

WINNIPEG ART GALLERY, Winnipeg

Blue and Gold - Temagami Forest
40 x 50" 1928
Governor's Garden
20.3 x 22.8" 1931
 (From G.A. Reid, 1943)
The Brown Hat
24.6 x 18.4" 1925
 (From Morris Gallery, 1981)
The Story
48 x 66" 1890
 (From Hugh F. Osler Estate, 1947)
The Treaty Line
31.7 x 55.1" 1933
 (From Carol Elliott, 1972)
Very Dark Day
41.8 x 37.3" 1891
 (From Mrs. A.B. Bicknell, 1955)

UNLOCATED WORKS

Among the Antiques
1885
 (Owner: Annesley Hall, University of
 Toronto)
Armistice Day, No. 2 (pastel)
24 x 18" 1918
 (Owner: National Gallery of Canada,
 Ottawa)
Breeze Ripples
18 x 24" 1928
 (Owner: Commercial and Technical High
 School, Thunder Bay, Ontario)
Dawn (circular)
120" 1921
 (Owner: Town Hall, Weston, Ontario)
General View of the Pageant at Quebec
9 x 61" 1908
 (Owner: Public Archives, Ottawa)
Morning
40 x 30" 1916
 (Owner: Central Public Library, Regina,
 Saskatchewan)
Mowing, Island of Orleans (watercolour)
14 x 20" 1932
 (Owner: Edmonton Art Gallery,
 Edmonton, Alberta)
Professor George Crawford
48 x 40" 1933
 (Owner: Riverdale Collegiate, Toronto,
 Ontario)
Professor George Dickson (pastel)
24 x 18" 1900
 (Owner: Public School, Hamilton)
The Clouds
40 x 50" 1904

 (Owner: Edmonton Art Gallery,
 Edmonton, Alberta)
The Homeric Method
1903
 (Owner: Queen's University)
The Scroll of Life
1899
Mother and Child 4'x 8'
Philosophers 4'x 8'
Landscape Triptych 4'x 56'
 (Owner: Trinity College, University of
 Toronto)
The Woodland Brook
24 x 72" 1919
 (Owner: Humberside Collegiate,
 Toronto, Ontario)
Trout Brook
22 x 30" 1928
 (Owner: Oakwood Collegiate, Toronto,
 Ontario)

CATALOGUE RAISONNE
OF THE WORKS OF G.A. REID

PART II
THE PROVINCE OF ONTARIO
REID COLLECTION
GIFT

In the spring and summer of 1944 when Mr. Gaitskell — the Provincial Supervisor of Art in Ontario — and his staff were allotting the Reid pictures for distribution to the offices in the legislative buildings, provincial normal schools and Ontario's collegiates, he wrote:

> In recent years departments of education, both here and abroad, have tended to place considerable emphasis upon art instruction in general education. These departments believe that very desirable outcomes should result from a better programme of art education in state schools. It is realized, of course, that few children will become artists, but it is hoped that every child may be given the opportunity to enjoy the thrill of creation and to appreciate intelligently and with sensitivity the aesthetic achievements of mankind.
>
> Those interested in education look forward to the time when widespread appreciation of fine things will have even greater effect upon industrial production. Moreover, it is anticipated that this appreciation, becoming part of the national consciousness, will be more generally felt in home decoration, architecture and even town planning.
>
> With the shorter working day, people will enjoy longer hours of leisure. Art and craft activities, as a vital part of school life, should give the child interests which may become absorbing and productive hobbies in adult life.
>
> At one time it was popularly believed that those interested in art were personally a little odd. Today we realize that suitable art experiences develop more complete personalities. It is felt that art instruction should increase a child's ability to criticize himself and to receive graciously the just criticism of others. A child engaged in art has opinions of his

own, which he is free to express, but his growth in sensitivity should teach him also to respect the hopes, ideas and opinions of others. In sum, art experiences help to develop a better citizen of a democracy.

Through the use of one hundred and sixty-five small sketches and studies in oil, donated by G.A. Reid, Esq., R.C.A., the Ontario Department of Education has been greatly assisted in an experimental programme of art appreciation which is being developed in its elementary and secondary schools.

These paintings, having been divided into eleven exhibits of fifteen paintings each, are being sent to various inspectoral areas throughout the Province. Accompanied by cards bearing appropriate comments and one copy of the biography with each exhibit, the artist's works are used by the teacher in the classroom not for isolated appreciation study, but rather in connection with pupil production. Children, after first attempting landscape and other work of their own, are afforded the unique experience of having as part of their intimate environment several small masterpieces by one of Canada's eminent painters.

By C.D. Gaitskell, M.A.
Provincial Supervisor of Art in Ontario

Since the closing of the former normal schools in the province and the reorganization of the Ontario school system, the whereabouts of up to two-thirds of the Reid government pictures (as reported by Premier William Davis in January 1985) had been cloaked in uncertainty in forty years. However, new hope for the lost had surfaced when Miss Fern Bayer — Curator of the Ontario Government Art Collection—brought together her 1984 catalogue of the provincial collection listing the pictures still remaining in the Reid gift. This generously illustrated catalogue, shows the breath and scope of Mr. Reid's work as muralist, figure, historical, genre, portrait-painter and landscapist in the half dozen mediums he used over his seventy years as professional and exhibiting artist.

Also, this search for publicly owned Reids was further accelerated by virtue of the fact that, in 1983, the Ontario Heritage Foundation awarded me a grant to bring out new updated editions of my Watson and Reid biographies. And, now that the Reid life is in press, replies from collegiates and educational institutions all over the province keep bringing to light formerly unreported and unaccounted-for pictures in the collection. These have been turning up

in vaults, attics, store-rooms, and (horrors!) basements of schools throughout the province.

This rediscovery of the lost paintings in the ongoing search is proving very worthwhile. Finders of more of these pictures are asked to report such to Ms. Bayer or to me in care of my publisher, Summerhill Press of Toronto. For, although the paintings in the collection may remain on extended loan to schools and universities in the province, ownership of the pictures is still with the Ontario government, as designated by the donor. We ask the schools and Boards of Education to continue their efforts in the hope that many more "finds" will be made in Ms. Bayer's ongoing search for unreported pictures.

PROVINCE OF ONTARIO REID GIFT COLLECTION

A Bend in the Magpie
10 x 12" 1927
A Life Study
12.25 x 8.5" 1889
A Mountain Village (Tannersville, New York)
10 x 12" 1892
A Summer Shower
10 x 12" 1925
Across the Dyke, Walberswick
8 x 10" 1910
Across the Bay, Lake Nipigon
12 x 10" 1929
Adam Reid: Father of the Artist
9 x 10" 1911
Afternoon
24 x 72" 1913
Afternoon Clouds, Port Hope
10 x 12" 1927
Afternoon Clouds, Onteora, New York
10 x 12" 1914
Afternoon Haze
12 x 14" 1938
Agawa Canyon
12 x 10" 1925
Agawa Canyon, Algoma
12 x 10" 1926
Among the Daisies
24 x 18" 1903
An American Village
10 x 12" 1914
Angel Panel
12.5 x 45" 1910
Arm of the Lake
12 x 10" 1929
At Rice Lake
10 x 12" 1928
Autumn Birches Among Rocks, Michipicoten
12 x 10" 1927
Autumn Contrasts
12 x 14" 1939
Autumn on the Don
40 x 40" 1941
Autumn, Temagami Forest
10 x 12" 1929
Barrow Bay, Bruce Peninsula
10 x 12" 1936
Before the Storm (untitled)
30 x 25" 1942
Birches on the Beach
10 x 12" 1932
Blossoms in the Valley
9.25 x 9.75" 1912
Breakers, Lion's Head
10 x 12" 1931
Breezeswept Lake
40 x 30" 1933
Bridge at Jumping Caribou
12 x 10" 1934
Canadian Northland
10 x 12" 1934
Cedar Woods Near Port Hope
10 x 12" 1927

Champlain Market
10 x 12" 1926
Champlain Street
10 x 12" 1926
Cherub Panel
12.5 x 45" 1911
Church in the Valley
9.5 x 9" 1916
Clover Fields, Humber River
10 x 12" 1922
Clover, Port Hope (Clover)
7.75 x 11.5" 1925
Contemplation
12 x 10" 1906
Dark Canyon
20.25 x 13.75" 1929
Dark Woods, Green, Radiant
10 x 12" 1931
Dawn in the Willows
12 x 14" 1917
Dorset Sawmill
10 x 12" 1936
Dorset Through the Trees
10 x 12" 1936
Dorset Village
10 x 12" 1937
Dorset Village and Bridge
10 x 12" 1936
Edge of the Wood
10 x 12" 1925
Elm Trunks, Near Norval
12 x 10" 1921
Evening, Lake Temagami
18 x 23" 1941
Evening, Montreal River
40 x 30" 1929
Evening Shadows
10 x 12" 1930
Evening Sky (untitled)
8.75 x 12.75" 1921
Fiery Autumn
12 x 10" 1935
Fire Swept Rocks
10 x 12" 1929
Glimpse of ... Port Hope
10 x 12" 1926
Governor's Garden (Garden in Quebec)
10 x 12" 1926
Harvest Fields
12 x 10" 1925
Head of a Nun
12 x 10" 1885
Henrietta Vickers, Artist
36 x 22" 1894
Herridge Lake, Ferguson Highway
10 x 12" 1929
Hills and Clouds, Catskills
10 x 12" 1914
Hills in the Distance
10 x 12" 1911
Homeseekers
17 x 25" 1910

Homeseekers
72 x 108" 1910
In the Park, Quebec
25 x 30" 1927
Johnny Cake Bay (Lake of Bays)
10 x 12" 1936
Kirkland Lake, The Mines
10 x 12" 1928
La Petite Eglise, Island of Orleans
10 x 12" 1926
Lacy Willows, Toronto Environs
10 x 12" 1933
Lake Mindemeya
10 x 12" 1931
Lake Through the Birches
22 x 36" 1916
Lumber Piling (Algoma Searchmont)
12 x 10" 1927
Magpie Falls, Michipierth Harbour
10 x 12" 1927
Michaelmas Daisies
10 x 12" 1937
Mortgaging the Homestead
11 x 17" 1890
Mouth of Abitibi Canyon
10 x 12" 1929
Norah Blake (pastel)
28 x 20" 1910
Notre Dame Des Victoires
12 x 10" 1926
Oaks in Autumn
25 x 30" 1908
Oat Harvest
8 x 9" 1912
On the Terrace, Quebec
12 x 10" 1926
Ontario Pasture
10 x 12" 1927
Ottawa River
10 x 12" 1931
Overlooking the Pond
6 x 9" 1922
Pines and Birches
12 x 10" 1934
Port Hope Mill Pond
10 x 12" 1925
Portrait of S.M. Jones, Not the Evangelist
15.25 x 11.4" 1893
Quiet Inlet
10 x 12" 1928
Quiet Water
30 x 40" 1920
Racing Water
10 x 12" 1936
Rapids on the Ganaraska
10 x 12" 1927
Reading the Bible
30 x 40" 1930
Red Pines, Lowell Lake, Temagami
12 x 10" 1934
Reflections
10 x 12" 1934
Rice Lake Shore
10 x 12" 1929
Ripening Fields Near Port Hope
10 x 12" 1925
Ripening Fields, Port Hope
12 x 10" 1927
Rocks and Surf, St. Ives
10 x 12" 1924
Rocks and Water
10 x 12" 1934
Sawmill Interior, Searchmont
10 x 14" 1927
Shingle Makers
30 x 40" 1926
Snake Fence, Hope Bay, Bruce Peninsula
10 x 12" 1931

Snake Fence, Hope Bay
30 x 50" 1934
Sous le Cap
12 x 10" 1926
St. Ives Harbour
10 x 12" 1924
Streak of Sunlight
10 x 12" 1916
Study for Sunshine and Shower, Belfountain
10 x 12" 1931
Study for Ragged Birches
12 x 10" 1929
Study For Woodland, Temagami
10 x 12" 1929
Study for Temagami Forest
10 x 12" 1928
Study for Sunset on Lake Temagami
10 x 12" 1934
Stunted Maples
10 x 12" 1927
Sunlight in the Woods
10 x 12" 1911
Sunset on Lake Temagami
24 x 18" 1929
Tannersville Village
10 x 12" 1914
Temagami 10 x 12" 1927
The Bay, Dorset No. 2
10 x 12" 1936
The Brook at Evening
30 x 25" 1922
The Cloud, Catskills
10 x 12" 1915
The Clover Field
10 x 12" 1927
The Coming of the White Man
72 x 108" 1912
The Cumulus Cloud
12 x 10" 19910
The Drinking Place
14 x 12" 1895
The Edge of the Wood
12 x 14" 1935
The Ferguson Highway
10 x 12" 1928
The Foreclosure of the Mortgage
72 x 108" 1935
The Garden Path
12 x 10" 1908
The Harbour, Tobermory
10 x 12" 1931
The Little Bay, Nipigon
10 x 12" 1929
The Lone Beech, Pioneer Roadway
12 x 14" 1928
The Marshes, Port Hope
12 x 10" 1924
The Meadow Brook Near Woodbridge
10 x 12" 1924
The Northern Entrance to Orient Bay, Nipigon
10 x 12" 1929
The Old Apple Tree
12 x 10" 1914
The Onteora Trail
12 x 10" 1915
The Picnic 25 x 30" 1932
The Prospectors
40 x 50" 1933
The Rippling Stream
10 x 12" 1927
The Sawmill at Dwight (Lake of Bays)
10 x 12" 1935
The Torrent
10 x 12" 1936
The Treaty Line
12 x 22" 1933
The Valley of the Agawa
40 x 50" 1932

The Valley Beyond
12 x 32" 1913
The Waterfall
10 x 12" 1927
The Wheelbarrow
5 x 9" 1905
The Woodcutter
52 x 41" 1907
Through the Heavy Timber
12 x 10" 1932
Through the Woods, Onteora
10 x 12" 1915
Trading Lake, Dorset
10 x 12" 1935
Tranquility
52 x 41" 1906
Tree Boles
12 x 10" 1932
Trout Brook
10 x 12" 1925
Turquoise Water
10 x 12" 1931

Upland Pasture
30 x 25" 1926
Valley of the Agawa #2 (untitled)
18 x 24" 1935
Virgin Falls, Lake Nipigon
10 x 12" 1929
Wheat Harvest
10 x 12" 1935
Wilson Lake, Temagami, Study
12 x 10" 1929
Wolfesfield Garden
10 x 10" 1926
Wood Trail
12 x 10" 1934
Woodland Path
12 x 10" 1914
Wright Hargreaves Mines
10 x 12" 1928
Young Birches
12 x 10" 1914